LOST EAST LOTHIAN

*

LOST
EAST LOTHIAN

Craig Statham

BIRLINN

First published in 2011 by
Birlinn Limited
West Newington House
10 Newington Road
Edinburgh
EH9 1QS

www.birlinn.co.uk

ISBN: 978 1 84158 965 7

British Library Cataloguing-in-Publication Data
A catalogue record for this book is available
from the British Library.

Design: Mark Blackadder

Printed and bound by Gutenberg Press Limited, Malta

CONTENTS

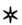

Introduction XI

CHAPTER 1 Defence and Attack 1
 Roman Fort, Inveresk 3
 French Fort, Dunbar 3
 Traprain Law 4
 Chesters Hill Fort, Athelstaneford 5
 Broxmouth Fort, Dunbar 5
 Tantallon Castle, North Berwick 5
 Dunbar Castle, Dunbar 8
 North Berwick Castle, North Berwick 10
 Bass Rock Castle, North Berwick 11
 Preston Tower, Prestonpans 12
 Elphinstone Tower, Tranent 14
 Signal Stations 16
 Drill Hall, Tranent 16
 Garleton Rifle Range, Kae Heughs, Haddington 17
 Penston Aerodrome, Gladsmuir 18
 Q-sites, Whitekirk/Halls, Spott 18
 Underground Chamber, Janefield Wood, Prestonkirk 19
 Anti-glider Poles 20
 Anti-tank Defences 20
 Flamme Fougasse, Dunbar 21

CHAPTER 2 Palaces, Mansions and Larger Houses 22
 Herdmanston House, Saltoun 23
 Haddington Palace, Haddington 25
 Dunglass House, Oldhamstocks 26
 Amisfield House, Haddington 29
 Belton House, Dunbar 31
 Hallis Wallis, Inveresk 33
 Bothwell Castle, Haddington 33
 Stoneyhill, Inveresk 35

Preston House, Prestonpans 36
'Old' Newton Hall, Yester 40
Pencaitland House, Pencaitland 41
Bankton House, Prestonpans 42
Lochend House, Dunbar 44
'Old' Gosford House, Gladsmuir 45
Wallyford House, Inveresk 46
Ormiston Hall, Ormiston 47
Newhall, Yester 51
Thurston House, Innerwick 52
Seacliff, Whitekirk and Tyninghame 53
Clerkington House, Haddington 55
'New' Newton Hall, Yester 57
Glasclune House, North Berwick 58
Stair Park, Tranent 60

CHAPTER 3 Villages, Streets and Houses 63
Villages 63
 Bothans, Yester 63
 Whittingehame 64
 Longniddry, Gladsmuir 64
 Seton, Tranent 65
 Cuthill, Prestonpans 66
 Smeaton Village, Inveresk 68
Streets and Houses 68
 Hardgate, Haddington 69
 John Knox's Birthplace, Giffordgate, Haddington 72
 Davie Dobson's House, Tranent 73
 Farmer's House, Nungate, Haddington 74
 Pigeon Square, Tranent 75
 The Inkbottle, Cockenzie and Port Seton 77
 Eden Cottage, Musselburgh 78
 Cuthill House, Prestonpans 79
 Alt Hamer/Aldhammer House (168 High Street), Prestonpans 80
 Land o' Cakes, Prestonpans 81
 Castle o' Clouts, Prestonpans 82
 Bankfoot House, Prestonpans 83

CHAPTER 4 Health and Welfare 84
St Lawrence Leper Hospital, near Haddington 85
Yorke Lodge (Cottage Hospital), Dunbar 86
Smallpox Hospital, Haddington 87
Hopetoun Unit, Haddington 90
Baro Graveyard, Garvald 91
Castle Gordon, Musselburgh 92

CHAPTER 5 Industry, Agriculture and Trade 93

Industry 93

New Mills Cloth Manufactory, Haddington 95

Brunton's Wire Works, Musselburgh 95

Customs House, Dunbar 99

Beltonford Paper Mill and The Maltings, West Barns 100

Mellis's Soap Works, Prestonpans 101

Saltworks, Prestonpans 102

Morrison's Haven Pottery and Bankfoot Pottery, Prestonpans 103

Kirk Street Pottery and Watson's Pottery, Prestonpans 104

Belfield's Pottery, Prestonpans 104

Newbigging Pottery, Musselburgh 106

Brick Works, Wallyford 107

Seafield Brick and Tile Works, Belhaven, Dunbar 107

Sea-fish Hatchery, Dunbar 109

Carberry Colliery, Inveresk 110

Fleets Colliery, Tranent 112

Woodhall Colliery, Pencaitland 113

House o' Muir Colliery, Humbie 113

Coffin House, Haddington 114

Agriculture 115

East Mains Farm Chimney and Cattle Court, Saltoun 115

Millknowe Farmhouse, Stenton 117

Trade 118

Morrison's Haven Harbour, Prestonpans 118

Mercat Crosses, Haddington 120

Tron, Haddington 121

Slaughterhouses, Haddington 122

Gimmers Mill Bridge, Haddington 123

Auction Mart, Haddington 124

Hayweights, Musselburgh 125

Pringle's, Haddington 126

Prestonpans Co-operative Society, Cuthill Branch, Prestonpans 127

Musselburgh and Fisherrow Co-operative Society, Smeaton branch 128

Oak Tree Café, Haddington 129

Golden Signs, Haddington 130

CHAPTER 6 Tourism 132

Royal Hotel, North Berwick 134

Belhaven Spa, Dunbar 136

Marine Hotel, North Berwick 138

Roxburghe Marine Hotel, Dunbar 141

Steamboat Pier, North Berwick 143

Swimming, Boating and Bathing Ponds, Dunbar 146

Hotel Belle Vue, Dunbar 149

Swimming Pond, North Berwick 151
Gullane Branch Line and Railway Station 153
Redcroft Hotel, North Berwick 154
Beach Huts, Gullane 156
Tantallon Hall, North Berwick 156

CHAPTER 7 Sport and Leisure 162
Bowling Greens, Musselburgh and Haddington 164
Whale Inn, Cuthill, Prestonpans 164
Racecourse and Gallops, Gullane 166
King's Arms, Haddington 167
Star Inn, Haddington 168
Ba' Alley, Haddington 168
White Swan Inn and Rifle Arms, Haddington 170
Haddington Golf Course, Garleton Hills 170
Luffness Old Golf Club, Aberlady 171
Cricket Pitches, Haddington 173
Foresters' Hall, North Berwick 174
Hedderwick Hill Golf Course, Dunbar 175
The Scratcher, Prestonpans 176
Victoria Ballroom, Dunbar 177
Cinemas, Haddington 178
Smeaton Welfare Institute, Inveresk 181
Prestongrange Welfare Institute, Prestonpans 181
Prestonlinks Welfare Institute, Prestonpans 182
Swimming Pool and Pond Hall, Port Seton 182
The Playhouse Cinema, Dunbar 184
The Playhouse Cinema, North Berwick 184

CHAPTER 8 Education 187
Schaw's Hospital/Miss Mary Murray's Institution, Prestonpans 188
Elphinstone School, Elphinstone, Tranent 190
Kingside School, Whittingehame 190
Public School, Tranent 192
Preston Lodge High School, Prestonpans 193
Public School (Grey School), Prestonpans 195
Primary School, Tranent 196
Cuthill School, Prestonpans 197

CHAPTER 9 Religion 198
St Patrick's Chapel, Gullane 199
Parish Churches of St Andrew, North Berwick 200
The Monastery, North Berwick 202
The Abbey, Haddington 204
St Michael's Church, Inveresk 205
Parish Churches, Gladsmuir 206
Parish Church, Tranent 207

Parish Church, Dunbar 208
St Peter's Episcopal Church, Musselburgh 210
Methodist Chapel, Haddington 212
Methodist Chapel, Musselburgh 212
St Martin of Tours Roman Catholic Church, Tranent 213

CHAPTER 10 Miscellaneous 215
County Jail, Haddington 215
Thorn Tree, Prestonpans 216
Willow Cathedral, Oldhamstocks 218
Doocot, Aberlady 219
Water Fountain, Tranent 221
Tramways 222
Gosford POW camp, Aberlady 225
Amisfield POW Camp, Haddington 227
Setts, Haddington 227
Fingerposts 228

Conclusion 229
Bibliography 231
Index 234

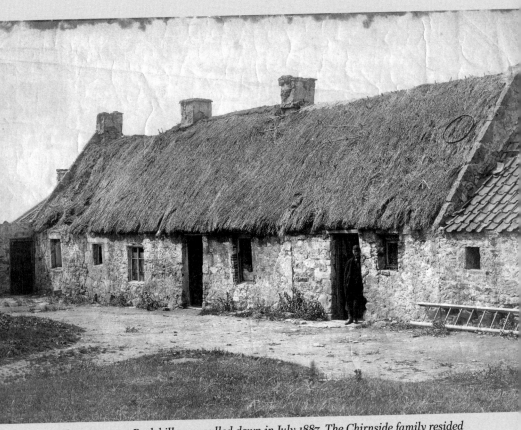

The cottages at Boglehill were pulled down in July 1887. The Chirnside family resided there and would serve tea to the many picnic parties that frequented the scenic setting. (© East Lothian Local History Centre)

INTRODUCTION

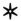

I do not live in East Lothian. I live in the neighbouring county of Midlothian. I do, however, work in East Lothian. This allows me the pleasure of travelling to Haddington each day, past farm houses and rolling fields filled with round bales of hay at harvest time and covered in snow during the winter. Each morning I wend my way through the idyllic village of Pencaitland, past its market cross, past Trevelyan Hall, across its sixteenth-century stone bridge and past the church and graveyard, past the old school and war memorial. As the Local History Officer for the county I am well aware this is not an anomalous scene; across East Lothian scenes such as this delight the eye. Entering the town of Haddington one is quickly met by a quintessential model of what all Scottish towns should, in my opinion, aspire to. It is not a lone example.

There are various reasons why the county as a whole has survived, to a great degree, the unthinking hand of the 1960s town planners, but tribute must be paid to perhaps the primary reason as early as this introduction – Frank Tindall, the former County Planning Officer. No book about lost architecture and structures in East Lothian would be complete without mention of Tindall. He fought relentlessly, at times risking his own job, to conserve and restore the county's aesthetic beauty, but was pragmatic enough to understand that not everything could, or should, be saved. Haddington town centre, Gullane sand dunes, countless farm buildings, Bankton House – that these still exist in a form that is aesthetically pleasing, or indeed in some cases exist at all, is testament to Tindall and his team. These tie in, to a great degree, with Dr Ian H. Adams' assertion that 'conservation is not about the past but about the future'. Whilst this statement may be open to argument, the point is at least partly valid – surely if we are to conserve the past we should utilise it in the present and future. Much of what was saved by Tindall is still in use today.

It became clear soon after beginning to research this book that I could not possibly cover every structure that has been lost to East Lothian; the *Industry, Agriculture and Trade* chapter in itself could have filled a book. My first task, therefore, was to create a number of themes around which chapters would be formed. This done, I then laid down three criteria for choosing the lost buildings and structures that would grace these pages. First, the types of buildings and structures within a chapter would be as wide-ranging as possible, reflecting the diversity of the theme. For example, the *Tourism* chapter includes hotels, railways, swimming pools and a spa. Second, the building or structure would have to have enough available research material to facilitate a reasonably substantial history to be written. This was adhered to on most occasions, although for some, such as the Smeaton Co-operative store, I was determined to ensure its inclusion despite a lack of source material. Other histories, such as that of the Wallyford Co-operative store, proved too elusive. Lastly, I tried to achieve a geographic spread, drawing examples from across the county.

Two important points must be noted before the book proper begins. The first is in respect of the county name. East Lothian was once called Haddingtonshire. The question has often been asked of me, 'When was the name East Lothian first used?' and my answer, unfortunately, is always that I do not know. It was certainly being used informally in the nineteenth century. The local newspaper changed its name from the *Haddingtonshire Courier* to the *East Lothian Courier* in 1972. Perhaps the most formal change came during the restructuring of the local authorities in 1975 with the name East Lothian County Council being chosen. This book, in an effort to avoid confusion, will always refer to East Lothian. The second point to be noted is in relation to the town of Musselburgh which was once within the county of Midlothian. In 1975 the old town councils were abolished in favour of county councils and the resultant boundary changes saw Musselburgh move into East Lothian. As such I had to decide whether to include any pre-1975 information from the town. I have included it, not least because the town's history is so fascinating, but also because of the wealth of research materials and quality of images available.

Before we enter East Lothian's lost past it is necessary for me to make mention of those numerous individuals and groups without whom this book would have been a much weaker affair. I should also say, however, that any mistakes (and I have no doubt there are some, despite my best efforts to eradicate them) are my own. Thanks first to George Arnot and the members at Prestongrange Bowling Club who, after months of my attempting to clarify the histories of Bankfoot House and Prestongrange Miners' Welfare, answered all

my queries in a single evening, and also offered me the use of a unique painting of the former. Many thanks must also go to Sheila Millar, my colleague at the Local History Centre, not only for allowing me to use the centre's images, but for her continued support. David Connolly, archaeologist, proofed some text for me and suggested some changes (which I incorporated). Jack Tully-Jackson also proffered a number of images and answered any questions I put to him. Likewise, George Angus was happy for me to use some of his images and cleared up some tricky points about buildings in Haddington. Andrew Spratt, custodian of Dirleton Castle, kindly allowed me the use of two of his wonderful paintings – the website I found them on is listed in the bibliography. Douglas Seaton kindly allowed the use of an image of Glasclune House – his website is also listed in the bibliography. Thanks must also go to Robert Fairnie for his help in translating a particularly awkward Scots phrase. There were also a number of people who offered suggestions and were impossibly helpful when I visited or phoned them, including (in alphabetical order) Mark Beattie, Bob Cunningham, Joy Dodd, John Fergie, Harry Stephen and Sally Turner. James Dickson of the Scottish Reformation Society and Roberta Hazan of St Dunstan's Collections & Archives were both particularly helpful in sourcing photographs for me. If I have missed anyone who has given help I offer my apologies; it was certainly not my intention to offend.

Finally, whilst I am the Local History Officer for East Lothian, this book is a private undertaking and as such any failings must fall to me. The Local History Centre (soon to be located at the John Gray Centre in Haddington) is always willing to deal with queries and help with research and genealogy.

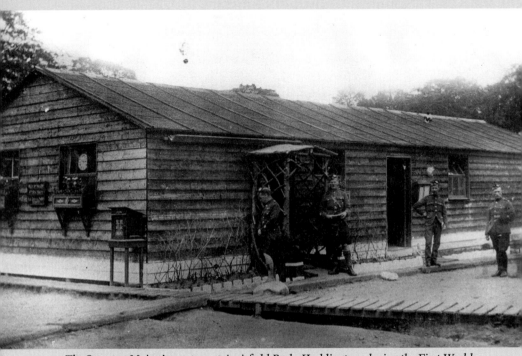

The Sergeant Majors' quarters at Amisfield Park, Haddington, during the First World War (© East Lothian Local History Centre)

DEFENCE AND ATTACK

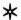

Man has always felt the need to defend himself against those intent on invading his territory or razing his property. What changed in the seventeenth century was the means by which this defence was achieved. As devices of attack advanced, defence, by necessity, improved in tandem. Thus we see a gradual move from hill forts to castles to tower houses. In turn these were superseded by defences capable of meeting the threat from the weapons of the twentieth century.

The earliest forms of defence detailed here are hill forts. Many hill forts, as denoted by their name, are situated on high ground. They exist on high points across much of the county with the largest numbers prevalent on the routes through the Lammermuir Hills. Not all are in high areas, as is proven by the low-lying Chesters and Broxmouth forts. Indeed, there may well have been any number of forts in lower areas that have been wholly removed by cultivation. Many of them may have been more about creating an impression rather than purely as a means of defence.

The defences of hill forts changed as needs required. Early in their evolution, around the time of the Bronze Age, forts were open and undefended. Defences became ever-stronger until, paradoxically, they regressed to undefended settlements around the time of the Roman occupation.

The strategic importance of East Lothian, situated on the main thoroughfare from England, left it susceptible to attack. The castles of East Lothian were battered during the Wars of Independence. The Rough Wooing of the 1540s, brought on by the Scottish Parliament's rebuffing of the proposed marriage between Mary, Queen of Scots and the son of King Henry VIII, saw castles and tower houses throughout the county hammered and brought under siege by English forces. A century later Oliver Cromwell's invading army once again laid the hand of destruction upon the county.

Tower houses became popular during the fifteenth and sixteenth centuries. All the primary elements deemed necessary for a castle were incorporated into a tower house – storage area, hall and private quarters – and built one above another. Topping them was a parapet walk inside which could be added further sleeping quarters. Unlike castles they have stood the test of time relatively well; although many are now ruins others remain inhabited, sometimes having been incorporated into a newer building.

The defences of most towers were not particularly aggressive and it has been argued that they were the home of the landowner rather than a means to deter attackers. In the post-Treaty of Union period, tower houses became obsolete as the threat from the south all but disappeared (save the riposte to the brief Jacobite flourishes).

The Napoleonic Wars at the beginning of the nineteenth century facilitated the building of three sets of barracks in Haddington to house around 2,000 troops. So great was the fear of an invasion at this time that a signal station was erected on the top of Skid Hill, north of Haddington, to provide an early alert. Relations with France improved little over the next 50 years and in 1859 volunteer battalions were created throughout the country to obviate the threat of invasion.

The twentieth century brought the threat from Germany during the First and Second World Wars. In the early days of the Second World War German invasion seemed a very real possibility – East Lothian, with its coastline, was at the forefront of plans to thwart any attempt to breach Scottish shores. Home Guard units were set up and the county was filled with all manner of defences, the sole purpose of which were to slow any possible German advance, be it from the sea, from the air, or on land. There was also a need to defend against attacks which were already taking place and as a result airfields were erected at East Fortune, West Fenton and Penston.

The county is littered with the remnants of defence – from Roman times through to the Second World War. Remnants of the county's castles still stand, albeit a pale shadow of their heyday grandeur. A successful strategy to draw tourists to them has aided in their ongoing conservation. Tower houses have stood the test of time relatively well. Those that are gone succumbed to the rigours of the cannonball, the elements or the developer.

ROMAN FORT,
INVERESK

Around AD 80 the Romans made their way into Scotland. On the east coast they built a road, known as Dere Street, stretching from York to the eastern end of the Antonine Wall. Soon after he became emperor in AD 138, Antoninus Pius sent troops towards the Forth to seek a spot to build a fort. The chosen site would, almost two centuries later, be known as Inveresk, a small hamlet just outside Musselburgh. It would be the only Roman fort in the area now known as East Lothian.

Although the hidden remains threw up clues to their existence for hundreds of years – in the sixteenth century Thomas Randolph described tiles that would have been used in a Roman bath-house – it was not until after the Second World War that Sir Ian A. Richmond uncovered evidence detailing its exact whereabouts. Using a combination of trench excavations and calculations based on previously discovered Roman forts, he wrote a thesis proving its location beyond doubt. West facing, it would have measured around 183 metres by 146 metres and housed a cavalry unit of 500 men. Within its walls, he argued, would have been a headquarters, a commander's house, officers' quarters, barracks, workshops and granaries.

The site may have continued to function after the Antonine Wall was abandoned. Evidence from other sites in the wider vicinity have led him to argue that the fort was abandoned around AD 180.

FRENCH FORT,
DUNBAR

The Auld Alliance between Scotland and France, an attempt to obviate any threat to either nation from England, first came into being in 1295. Over the next 250 years virtually all monarchs on both sides renewed the treaty (only Louis XI failing to do so). One aspect of the treaty was that at various times French troops were garrisoned in Scotland.

In 1988 archaeologists working in the Castle Park area of Dunbar found the remnants of a French fort, it having garnered attention in Miller's *History of Dunbar* which pre-dates the excavations by almost 160 years. Building work is thought to have begun in late 1559 and excavations revealed a large courtyard flanked by buildings. It was likely built in the *trace italienne* style. Also called a star fort, due to its distinctive shape, this type of defence was considered

almost impregnable in the sixteenth century. Its construction would not have been substantial; it was probably made of earth. The fort's lifespan was, however, a short one – the Treaty of Edinburgh, an attempt to end the Auld Alliance with France, was signed in 1560 and the structure was ordered demolished in this document: 'Next, all the men of war to be removed . . . sixty in Dunbar, whose new fortification shall be also, before your army depart out of Scotland, demolished.'

TRAPRAIN LAW

As one drives along the A1 past Haddington towards East Linton what comes into view is the location of one of the most important archaeological sites in Scotland. Sitting over 700 feet above sea level, the oval-shaped Traprain Law fort has housed settlers for at least 6,000 years, including during the Bronze and Iron Ages, and throughout the Roman occupation.

The fort consists of four phases of development. The series of ramparts are known as 20-acre, 30-acre and 40-acre, outlining the rough areas they encompass. None date earlier than the Iron Age. The Bronze Age development covered around 10 acres. Around 700 BC stone ramparts were added making the area of coverage around 20 acres. It reached its largest state, roughly 42 acres, around AD 300 but was later reduced in size. The settlement on Traprain Law was sufficiently advanced to have a row of houses, a street and a square.

The area's importance grew when the Romans arrived, around AD 80, and the Votadini took it as their capital. It has been argued that relations between the Votadini and the Romans were good. Several sources suggest the likelihood that a treaty was drawn up between the two groups, with evidence presented that there were no Roman forts in the land east of Inveresk, and many of the archaeological finds in the area were Roman in origin suggesting trade or reward. However, David J. Breeze contends that it was common for the Romans to control an area by threat rather than direct occupation.

During excavations in 1919 a hoard of silver was discovered, unequalled in size and quality at any other site in Scotland. Weighing around 770 ounces, it included bowls, flagons and cutlery, and had been deliberately cut up and hidden around the fifth century AD.

CHESTERS HILL FORT,
ATHELSTANEFORD

The irregularly oval Chesters Fort, lying a mile south of Drem, measures around 900 feet by 500 feet at its outer points, likely having expanded in size over time. There are remains of six ramparts in the north and five in the south. A number of low mounds are evident in the interior of the fort, as are the remains of over 20 hut circles. Many of these measure over 12 metres in diameter. It was probably constructed in at least two separate phases.

The defences of the fort are, perhaps unsurprisingly given the early phase of fort evolution described above, poor. It sits beneath a 50-foot-high cliff, leaving it susceptible to attack from above. It is likely that the fort was occupied when the Romans were ensconced in the area.

During the Second World War an observation post and gun emplacements were sited at the fort. Their removal led to excavation work which revealed little other than the traces of two walls.

BROXMOUTH FORT,
DUNBAR

Broxmouth Fort was, in the Bronze Age, open and undefended. By the early Iron Age its defences grew as its inhabitants became concerned at possible encroachment from a growing population on prime cultivation land. Timber palisades were replaced by a stone wall and concentric earthen ramparts were added. Around the time of the early-Roman occupation the fort became, once more, undefended. The fort was probably abandoned before the Roman occupation.

TANTALLON CASTLE,
NORTH BERWICK

Just east of North Berwick and north of Auldhame, looking out across the Firth of Forth towards the Bass Rock, is perhaps the most impressive castle in East Lothian. Tantallon Castle was built with red sandstone in the mid fourteenth century by William Douglas, who clearly had defence in mind. Protected on three sides by 100-foot-high sheer cliffs, its one 'vulnerable' side was protected by a curtain wall 50 feet high and 12 feet thick. It was not insurmountable,

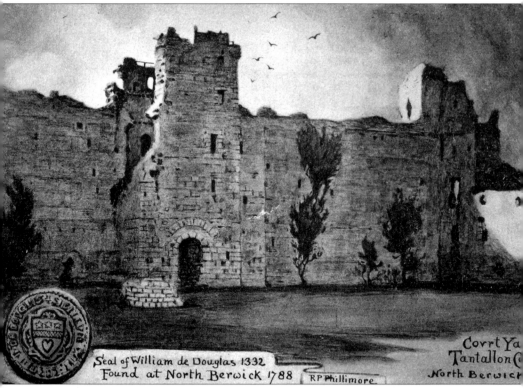

Seal of William de Douglas 1332
Found at North Berwick 1788 [RP Phillimore]

Covrt Ya
Tantallon(
North Berwick

Reginald Phillimore Phillimore was an artist based in North Berwick in the early twentieth century. His postcards, such as this one of Tantallon Castle, are highly sought after. Most include a main scene around which sits one or more inset details (© East Lothian Local History Centre)

however, despite the nineteenth-century poet William Topaz McGonagall's assertion:

> In time of war received many a shock,
> And it's deemed impregnable and built on a perpendicular rock

The death of James, 2nd Earl of Douglas and Mar, at the Battle of Otterburn in 1388, led to a division in the House of Douglas as two factions – the 'Black' and 'Red' Douglases. The following years saw attempts by both to gain the upper hand. Perhaps the strangest episode was borne of this fight. In the 1420s King James I imprisoned the Duchess of Albany in Tantallon. He then gathered her husband, son and father in Stirling Castle and proceeded to behead them. The heads were taken to Tantallon where they were thrown into the Duchess's cell.

She was forced to sign a document that outlined that the murders were just. King James then seized her lands. When James was murdered the Duchess seized her lands back.

In 1491 James IV laid siege to the castle after the Red Douglases struck a deal with Henry VII of England. The castle was taken with little damage being done. In 1528 the forces of James V attacked a second time and failed to achieve victory despite the fact that, as detailed in Sir Walter Scott's *Marmion*: 'The King went in person against it, and for its reduction, borrowed from the Castle of Dunbar . . . two great cannons . . . Thrawn-mouth'd Meg and her marrow'. Of the bombardment one contemporary wrote that the castle 'was never ane hair the war [worse]'.

James V eventually gained control of the castle after the signing of a treaty. Soon a substantial rebuild was underway, but it was not completed until around 1543. Many of the chambers in the curtain wall, as we shall see, were filled with masonry. It was believed that these works would leave the castle 'unwinabill in tymes comming to ony enemies that would come to persew it'.

In 1651 the castle was once again under attack, and 'was randred to [Oliver] Cromwell after he had battred at wall the for 12 dayes continually with grate canon', against a force of only '91 officers and soldiers'. The structure was much damaged during this attack and it was never returned to its former glory. It did, however, remain habitable until it was sold to Sir Hew Dalrymple in 1699. The remains continued to decay over the following century.

By 1887 Sir John Dalrymple and Walter Hamilton Dalrymple were intending works on the castle as it was deemed to be dangerous. They also planned to construct a bowling green in the grounds. Early the following year renovations began, with advice coming from architects Mr Peddie and Basil Champneys. Work was undertaken to open up the rooms and stairs which James V had built up to strengthen the curtain wall. A major crack in the central tower was repaired, but found not to be dangerous as it was in a chimney not the main wall. Labour was intensive as the 350-year-old lime had hardened. When the work was underway it was visited by the respected architects MacGibbon and Ross who were 'astonished at the results already accomplished'.

In 1924 the state took over the remains and soon upgraded the castle even further with one image showing extensive scaffolding on one wall. Today it is looked after by Historic Scotland.

DUNBAR CASTLE,
DUNBAR

Whilst large portions of Tantallon Castle have survived the ravages of war and time, the same cannot be said of Dunbar Castle. The red stone castle sat on the road leading from England to Edinburgh. As a result of this the castle was, for many centuries, viewed as a primary target by any invading force intending to impose its will on Scotland. The castle was likely erected after the lands of Dunbar were granted to Patrick, Earl of Northumberland, by Malcolm Canmore in 1072, although it has been argued that it was erected by the Picts. Northumberland was known as Cospatrick, and his heirs as the Earls of Dunbar and March. The castle first comes to our attention during the Wars of Independence when Margaret Comyn, wife of the 8th Earl, opposing his political leanings, took the castle for the Scots. As a result a force was despatched from England to lay siege; the following battle was fought on 28 April 1296 with the result being a resounding victory for the attackers. Margaret Comyn's son, the 9th Earl, offered succour to King Edward II on his retreat from the Battle of Bannockburn. He should, however, be renowned for his political vacillation as he continued to offer allegiances to both sides at various times, dependent on which served his interests best. In 1334 he renounced his support of England. The castle was left in the charge of his wife

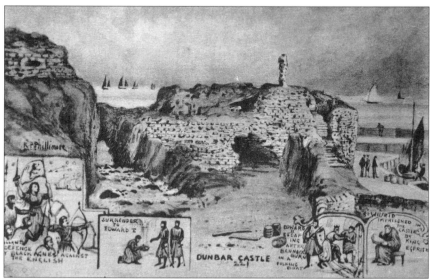

A hand-drawn postcard showing the remains of the castle in later years was drawn by R.P. Phillimore. Below it are a number of scenes from the history of the castle, including its defence by the renowned Black Agnes (© East Lothian Local History Centre)

Countess Agnes Randolph, better known as Black Agnes of Dunbar. The English, under the command of Montague, Earl of Salisbury, laid siege to the castle and pounded its walls with stones thrown from battering machines. In a scornful gesture, Agnes dusted the walls with her white handkerchief. This act would, 550 years later, elicit a poem:

> See, with a mocking smile, Black Agnes stand,
> And, high upon a battlemented wall,
> Behold her demoiselle, with towel in hand,
> Obedient to the jibing dame's command,
> Dusting the stone struck by the English ball.

In an attempt to capture the castle Montague called up a vast military engine called The Sow. Seeing this, Agnes yelled from the battlements:

> Beware Montagow
> For farrow shall thy sow

She then proceeded to launch a rock which destroyed the engine. Montague continued the siege by land and sea and the garrison was almost at a point of surrender when Montague's men were defeated by a Scottish force sent to relieve the defenders.

Agnes's son, the 10th Earl, was endowed with the same fickle nature as his forbears and this resulted in his lands being forfeited and the castle and its lands being passed to Alexander, Duke of Albany.

In 1488, in an effort to stop its being used by invading armies, the castle was demolished. Soon thereafter it was rebuilt by James IV and was certainly believed sumptuous enough to house Mary, Queen of Scots three times in the latter half of the sixteenth century.

By 1790 little remained of the structure, but one extant wall retained three separate crests above a doorway – the central one being that of George, 11th Earl of Dunbar. Some of the structure was lost in the building of the entrance to Victoria Harbour in 1842 and the weather has caused further deterioration. James Miller, in his 1859 *History of Dunbar* gives a detailed description of the remaining structure:

> The body of the building appears to measure one hundred and sixty-five feet from north to south. The south battery, which Grose supposes to have been the citadel or keep, is situated on a detached

perpendicular rock, only accessible on one side, seventy-two feet high, and is connected to the main part of the castle by a passage of masonry, measuring sixty-nine feet. The interior of the citadel measures fifty-four by sixty within the walls. Its shape is octagonal.

In 1897 props were put into the castle, appending those already in place. It was certainly viewed as unstable around this time with one visitor to the town noting that 'the action of the sea or the power of the wind will sooner or later . . . bring down enough of Dunbar Castle to endanger the life or limbs of its inhabitants'.

NORTH BERWICK CASTLE, NORTH BERWICK

Like many medieval castles the one at North Berwick started life as a wooden motte and bailey. In the early fourteenth century it was occupied by the Earl of Pembroke's troops as retribution for its owner, Michael Wemyss, siding with King Robert the Bruce against King Edward I in 1306. They deserted it in 1314,

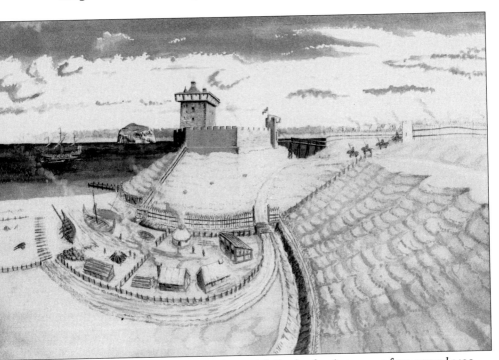

A painted reconstruction of North Berwick Castle, showing a scene from around 1400 (© Andrew Spratt)

in the aftermath of the Battle of Bannockburn, as the 'Black' Douglas approached. The motte and bailey was replaced later in the century when the new owners, the Lauder family, built a stone tower with barmkin in its stead. It is not clear why North Berwick Castle disappeared but Spratt surmises that it was likely as a result of the previously mentioned conflict over Tantallon Castle in the late fourteenth and early fifteenth centuries. It was not in use by the 1420s as the Bass Rock Castle was considered a more secure site. Spratt further asserts that the remains may have been used as a quarry. No visible remains exist of North Berwick Castle, only the name 'Castle Hill' holds any clues.

BASS ROCK CASTLE,
NORTH BERWICK

The Bass Rock sits just off East Lothian's coastline, north-east of North Berwick. Unlike most Scottish castles the history of the Bass Rock Castle is a very short one. It is unclear exactly when the castle was built, but certainly the Rock itself was housing prisoners by 1645 when James Ogilvie was transferred

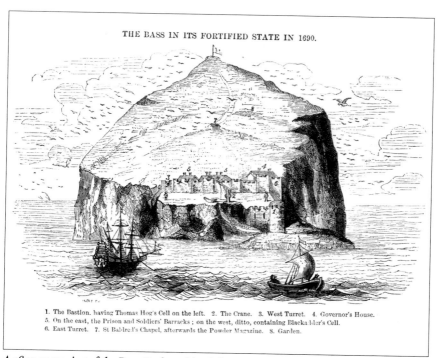

THE BASS IN ITS FORTIFIED STATE IN 1690.

1. The Bastion. having Thomas Hog's Cell on the left. 2. The Crane. 3. West Turret. 4. Governor's House.
5. On the east, the Prison and Soldiers' Barracks ; on the west, ditto, containing Blackadder's Cell.
6. East Turret. 7. St Baldred's Chapel, afterwards the Powder Magazine. 8. Garden.

A 1690 engraving of the Bass Rock and its defences and prison (© East Lothian Local History Centre)

there from the Tolbooth in Edinburgh. The fortress did exist by 1651 when the public records of the Church of Scotland were kept there. It was, however, of minor importance; by 1657 only 18 soldiers were stationed there.

In 1671 the island was purchased by the Earl of Lauderdale for the sum of £4,000 and he was using it to imprison a number of Covenanters from as early as 1673 until 1687. Thereafter it hosted a garrison under John Graham of Claverhouse, supportive of James VII, when they were forced to surrender in 1690. In 1691 four of Claverhouse's officers locked their captors out of the castle, took it over and held it for three years, capitulating only when offered favourable terms.

These men, Covenanters and Jacobites, would have seen a very different island to the one that exists today. When they landed there they would first have been confronted with the bastion, or watch tower. Attached to this structure were a series of cells that were described by Archbishop Sharp as 'a place in the Bass worse than any other'. On ascending past the bastion, prisoners would come to a crane that was used to hoist goods onto the island. Behind this was a terrace of buildings – the prison, barracks and governor's house. A path extended from these buildings upwards to the powder magazine, which once served as St Baldred's Chapel. The castle was dismantled in 1701.

PRESTON TOWER,
PRESTONPANS

Preston Tower was built by the Hamilton family around the 1450s, one of a series of ten towers running from Innerwick, near Dunbar, in the east to the Isle of Arran in the west. At this time it was four storeys tall. Its defences are vividly described by Andrew Spratt:

> Directly above the doorway was a wooden lean-to hoarding, its outline can still be traced today. From here items could be dropped and if the hoarding itself was damaged it was simply unbolted and dropped to block the entrance and then the second defensive overhang at battlement level was used. Anything could be used, from boiling oil and boulders, to incendiary pig carcasses packed with goose grease which exploded on impact – a kind of medieval napalm. Even something as basic as sand could be super-heated until white

Opposite. Preston Tower, Prestonpans (© East Lothian Local History Centre)

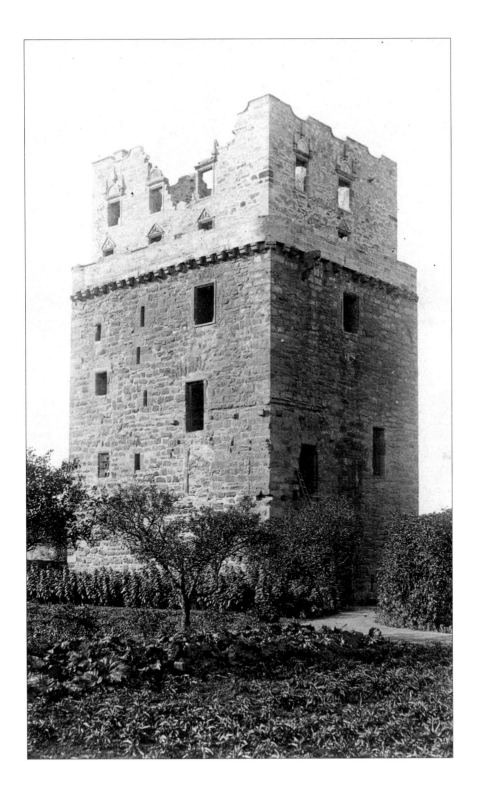

hot and then dropped on besiegers. It didn't kill the knights but got into their helmets and chain mail joints thus distracting them to either fall off their siege ladders or attempt to pull off their burning helmets leaving their heads vulnerable to attack.

However, the widespread introduction of gunpowder and cannon was making small towers obsolete. This is attested to in 1544 when the Earl of Hertford burned the structure during the Rough Wooing. Oliver Cromwell's troops repeated the feat in 1650. The third and last time the building was burned came as the result of an accident in 1663.

As with many of East Lothian's tower houses, the basic structure of the building still exists today, although much decayed. Still visible is the 1626 L-shaped addition above the battlements added by Sir John and Dame Katherine Hamilton – their initials, SIDKH, are still visible in the window lintels. In 1969 the remains were purchased by the National Trust for Scotland and are currently under the guardianship of East Lothian Council.

ELPHINSTONE TOWER, ELPHINSTONE, TRANENT

Elphinstone Tower was a tower house situated two miles south of Tranent. It is likely that it was erected in the mid fifteenth century by Gilbert Johnstone. In 1546 the Protestant reformer George Wishart was brought from Ormiston Castle by the Earl of Bothwell and imprisoned in the tower. He was thereafter moved between Edinburgh Castle and Hailes Castle, before being removed to see Cardinal Beaton at St Andrews and finally burned at the stake. A fissure running from bottom to top of the western wall is said to have appeared after Wishart's imprisonment – a sign of God's anger.

A three-storey mansion house was added to the eastern side in 1697 but this was removed in the summer of 1864, bringing down 'the anathemas of some Edinburgh antiquarians'. One letter writer to the *Scotsman* noted that despite being 'deserted and somewhat dilapidated-looking [it] presents an imposing façade to the east'. In 1865 a new building – Elphinstone Tower Farm House – replaced the recently demolished mansion house and a heraldic panel from this house was incorporated into the new building.

The tower house was an oblong structure 50 feet by 35 feet, with walls 12 feet thick. Its three storeys rose to a height of 58 feet. On the ground floor was a vaulted chamber. A staircase (which still exists) led to the first floor which

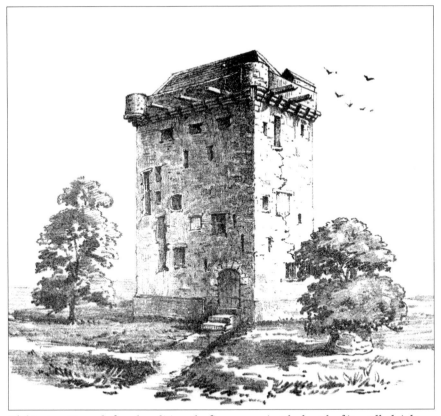

Elphinstone Tower before demolition, the fissure running the length of its wall plainly visible (© East Lothian Local History Centre)

was dominated by a banqueting hall and also included a small apartment. The second floor contained two apartments and was topped by battlements, adorned with a number of gargoyles, to carry off superfluous water.

The building seems to have gone into a rapid demise in the latter half of the nineteenth century. In 1864 a newspaper report describes it as being in a 'perfect state of repair' but only 16 years later Groome's *Gazetteer* noted that it was a 'weel-preserved ruin' whose roof had recently been re-slated.

During the Second World War it was used as a Royal Observation Corps post. By the 1960s there was a real fear that the structure would collapse due to subsidence caused by the many mine workings beneath. At the request of the tenant a number of farmhands partially demolished the building leaving only the lowest storey. When exactly this happened is unclear but it was certainly after Nigel Tranter visited the structure in 1962, and before a 1975 Ordnance Survey report that described it as 'partially demolished'.

SIGNAL STATIONS

In the early nineteenth century, when Napoleon threatened Britain, signal stations were set up at high points throughout the land. On the advent of any invasion these would communicate with each other to warn of the impending fight. In East Lothian they ran from Knockenhair in the south, through Black Castle, Pencraig Hill, North Berwick Law and the Garleton Hills (Skid Hill). The stations continued on towards the nation's capital.

Each station had a tall mast, fixed to the ground by ropes. On this were raised large balls with wooden ribs and a tarpaulin exterior that would allow communication, much like semaphore. None of these stations remain.

DRILL HALL, TRANENT

By 1859 it was clear to the War Office that Britain's defensive strength was, due to many forces being garrisoned throughout Europe, seriously depleted. Had a conflict materialised, and there was certainly tension with France, the forces left to defend Britain's shores would have been unable to cope. This led to the creation of a Volunteer Force. This force existed until its disbandment in 1903. The remnants of this force and the various militias and yeomanry units were amalgamated in 1907 and the following year saw them formally brought together as the Territorial Force, the forerunner of the Territorial Army (TA). The old Volunteer Army had built halls in many towns. In East Lothian, Volunteer Halls were built in towns such as East Linton (1875), Dunbar (1878) and Aberlady (1882). After the disbandment of the Volunteers and the creation of the Territorial Force similar halls were built to accommodate them in Prestonpans (1910) and Tranent (c.1912). Much of the evidence that the Volunteers and Territorial Force were once an important part of everyday life for many people still remains – the halls at East Linton, Aberlady and Prestonpans are still used by the local communities. Demolished is the Drill Hall at Well Wynd, Tranent. It was erected around 1912, on land purchased by Territorial Force Association. Its two storeys were topped by stone turrets. In later years a single-storey brick-built hall was added. The building was used by the Territorials, in one guise or another, until 1967 when it was sold to Tranent Town Council. The hall was used by the local Catholic Church in 1969 as they awaited the building of a new premises. Despite having sold the building the TA continued to use the hall until the mid 1980s.

Fears about the hall's future were being expressed in 1984, although it was still being used by youth and community groups. It was, for example, used to store the ramps of the Scottish Skateboarding Association, and Jason J. Thomson recalled having 'built a wee half pipe in there'. By 1989 it was becoming clear that the district council considered it surplus to requirements as the Town Hall and the Loch Centre, opened in May 1985, provided adequate community amenity in the town. Plans were mooted for various projects to utilise the building, including a snooker club, offices, sports hall, light industry and a shop. By 1993 the East Lothian Housing Association was showing interest in building houses on the site and this came to fruition in 1996. The hall was demolished in July and August of that year. Whilst the demolition was underway a four-foot-wide shaft was discovered; after much conjecture that it was the old town well, it was found to be a mineshaft. The shaft was filled in.

GARLETON RIFLE RANGE, KAE HEUGHS, HADDINGTON

Gone are the rifle ranges to the north of the Garleton Hills where the Volunteers would hone their skills and set them in play against opposing teams. At least five ranges existed here at one time. Little is known of the range but

The targets at the Garleton Rifle Range are clearly visible in this extremely rare image (© East Lothian Local History Centre)

it was certainly in place as early as 1862 when it hosted a rifle competition. It is unclear when it was removed but it was still in place in 1944 when it hosted a shooting match between the Haddington Home Guard and Haddington Miniature Rifle Club.

PENSTON AERODROME, GLADSMUIR

There were three aerodromes in East Lothian at the time of the First World War. Neither West Fenton (later utilised as commercial units) or East Fortune (Museum of Flight) were completely demolished. Penston Aerodrome, however, has been almost completely erased from the land – only a guard house, a series of pillars and concrete flooring survive in what is now a heavily wooded area. Much of the site of the aerodrome buildings has since been planted with trees, whilst the remainder is now used for agricultural purposes. Lying south-east of Tranent, next to Butterdean Wood, it was a 106-acre site (around 900 yards by 700 yards) that hosted two aeroplane sheds, a workshop, an ammunition and bomb store, a wireless hut and an array of outbuildings. Opened late in the war, having originally been based at Turnhouse, it served as a base for 77 Home Defence Squadron. It was felt that Penston's proximity to the coast provided greater defence against attacks from Zeppelins. In April 1918 land to the south of the aerodrome was taken over to house a detachment of the Women's Auxiliary Army Corps.

In May and November 1920 the structures and substantial materials were sold off. These included a brick building 136 feet by 60 feet by 36 feet, a number of huts, 12 smaller brick buildings, a hangar, boiler and furnace. That the brick buildings were sold rather than demolished suggests that there were initially thoughts of using the site in other ways. That the site is now virtually clear is evidence that this almost certainly didn't happen.

Q-SITES, WHITEKIRK/HALLS, SPOTT

The switch by the Luftwaffe to night bombing during the Second World War opened up the opportunity to deceive German pilots. Drem was an important fighter base and required a high degree of protection. This was achieved, in part, through deceptive means by erecting a series of lights in a field near

Whitekirk; these mimicked the lights of a real airfield. Set up in the summer of 1940 it was immediately successful, drawing German bombers to offload their payload. There was no blatant attempt to attract German bombers, indeed the lights of the Q-sites were turned *off* as bombers approached, just as they would be at a real airfield. The site's success was its undoing after local residents claimed that eventually the village of Whitekirk was going to be hit by a stray bomb. As a result the site was moved to Halls, near Spott, and it continued to fool German airmen, albeit to a much lesser degree than at Whitekirk. Some remnants of the Spott site still exist. There is little doubt that the Q-sites saved lives; every bomb dropped at Whitekirk or Halls was a bomb less likely to be dropped at East Fortune.

UNDERGROUND CHAMBER,
JANEFIELD WOOD, PRESTONKIRK

In 1940, when the threat of invasion was at its peak, resistance groups, known as Auxiliary Units, were set up to wage guerrilla warfare on any invading force. Although part of the Home Guard, these units operated independently and, indeed, were unknown to the Guard's commanding officers. They worked

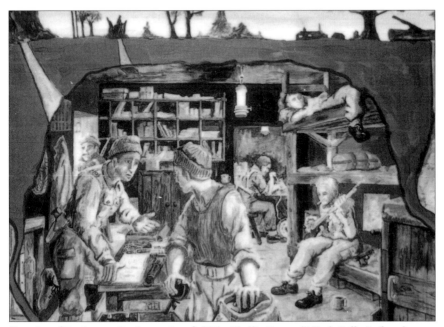

'Interior of Resistance Bunker at Janefield' by Phyllis Fraser (© Jack Tully-Jackson)

out of hidden underground chambers built by troops brought up from England and swiftly returned south when the work was completed. The operational base of the East Linton Patrol was beneath Janefield Wood. Accessed via a brick shaft, the 20 foot-by-12 foot chamber was made of corrugated iron, air being provided by vents. Inside were six bunk beds and the weapons required to repel any invaders. The Auxiliary Units were finally disbanded in November 1944 when the threat of invasion had disappeared, and the chamber became obsolete. The story of this secretive resistance does not end there; in October 1974 the underground chamber at Janefield was discovered when the shaft cover rotted away. The bunk beds, along with shelving and a cupboard, were still inside. Also inside was 200 lbs of gelignite stored in jars and metal boxes. The Army Bomb Disposal Unit was called and blew up the explosives over the next two days. The hole was filled in.

ANTI-GLIDER POLES

East Lothian's long, flat beaches would have provided German gliders and aeroplanes with ready-made landing strips during World War Two. To obviate this possibility anti-glider poles were placed on beaches across the length of the county. These were simply poles stuck into the sands capable of severely impeding any attempts to use them as landing strips. Many were removed in 1944, when the threat of invasion had disappeared, and the beaches were required to train Allied troops for the forthcoming landings at Normandy.

ANTI-TANK DEFENCES

There were a number of different types of anti-tank defences, all based on a single theme. For example, 1,000 Dragon's Teeth were installed at Thorntonloch and anti-tank cubes at Levenhall, Aberlady Bay and on Longniddry Golf Course. The largest number, 1,300, were at West Barns. As with the anti-glider poles, many were removed in 1944 to allow for troop training. However, some did survive beyond the war. Around 200 were removed from Levenhall in 1960. The anti-tank cubes at Aberlady Bay were not removed until September 1963. They were extracted like teeth and the six- or seven-ton blocks were moved to Cockenzie to protect the sea wall at the newly built power station. A small number still survive today.

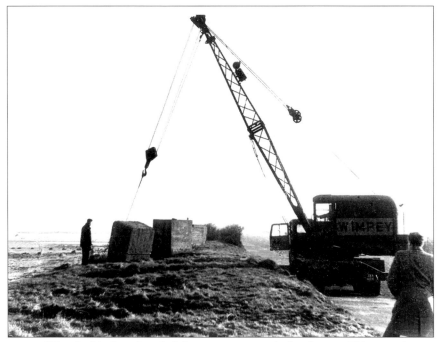

Many of East Lothian's anti-tank defences were removed after the war. This example shows the blocks being removed from Longniddry (© East Lothian Local History Centre)

FLAMME FOUGASSE,
DUNBAR

One means of slowing invasion from the sea was the flame fougasse, or flame trap – part of what was called petroleum warfare. Placed at the entrance to Dunbar Harbour it would, in the event of a German seaborne invasion, have sprayed petrol across the harbour mouth from perforated pipes. The concoction was actually only 40 per cent petrol and the rest gas oil, a mixture that would burn anything it touched for ten minutes. The system was tested but according to Tully-Jackson was soon out of control and the fishing boats had to be moved to the inner harbour. This was the only such system based at a harbour, but there were 45 similar systems on the county's roads. These would have sprayed petrol on an enemy vehicle and be lit manually by the intro-duction of a fire source such as a Molotov cocktail.

PALACES, MANSIONS AND LARGER HOUSES

After the signing of the Treaty of Union, the threat of English invasions and subsequent razing of buildings disappeared. As a result the need for strongholds to defend against attacking armies became unnecessary – as Sonia Baker puts it, 'houses could be built outwards as opposed to upwards'. Although many mansions did exist before the treaty, for example Lochend and Wallyford, vast numbers were built after the signing – country piles from which the great and the good could oversee their affairs.

East Lothian provided everything a landed gentleman could ask for: close proximity to the nation's capital, trading ports and healthful sea air. Large houses, once the preserve of the landed gentry, began to be built by a wider circle of men – businessmen such as Captain James Fall of Dunbar, who had profited from access to the empire, and industrialists such as David France of Belhaven whose wealth was forged in the Industrial Revolution. By the mid nineteenth century East Lothian was becoming a premier tourist resort, driven by the arrival of the railway. Men of money headed to the county in great numbers, attracted by the golf and the sea air, and built wonderfully large mansions such as Glasclune and Stair Park, in which to house themselves permanently or, most often, when on holiday.

In some cases architects were drawn from beyond East Lothian, but frequently 'home-grown' talent was used. Francis Farquharson, William Burn, J.W. Hardie, David Bryce and the Whitecross family all contributed to the profusion of mansions and large houses dotted throughout the county.

The loss of many of these great buildings is to be lamented, but can be forgiven as their demise was down to natural forces such as fire and flood. We should not be so forgiving to those lost due to neglect. Dry rot, arson and the lack of respect shown by First and Second World War soldiers were among the many reasons for their eventual disappearance. Worse still are examples of

wanton architectural vandalism where houses in relatively good condition were demolished simply because their owners could not afford, or refused to pay for, their upkeep, most commonly evidenced by roofs being removed to avoid paying Roof Tax. The most obscene example of this is Thurston House which was in a good condition when demolished in 1952.

HERDMANSTON HOUSE, SALTOUN

Herdmanston House, ancient seat of the St Clairs, was, according to the *Courier*, 'as curious a compound of the ancient and the modern in architecture as can well be conceived'. The northern section was 'unrelieved by a single point or promontory or ornament of any kind, the only feature of the front elevation being a profusion of common-looking windows. In contrast the southern wing was built around a strong keep dating from the eleventh century. At places the walls of the 60 foot-by-30 foot wing reached a thickness of 8 feet. Directly underneath the attic, which had been raised to create bedrooms, lay the old castle's great hall. It once ran from end to end but in more recent times had been partitioned with stone walls to create three apart-

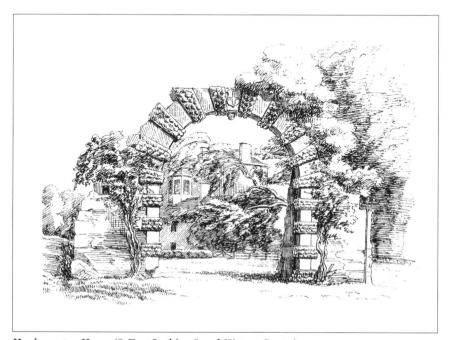

Herdmanston House (© East Lothian Local History Centre)

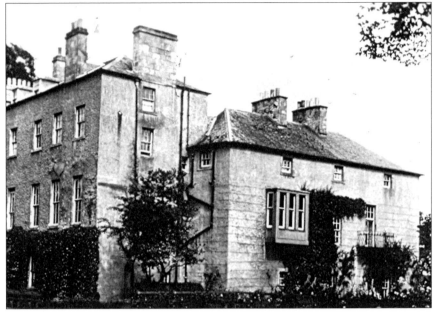

Herdmanston House in the late nineteenth century (© East Lothian Local History Centre)

ments; from west, a morning room, dining room and ante-room. Little is known of the house until the nineteenth century other than the odd detail – in 1548 'it played a part in Lord Grey of Wilton's invasion' and 200 years later it was plundered by the Jacobite army.

In 1877 the tenant, Mrs Congreve, employed a decorator by the name of Lockhart Dobie who ensured an elegant design for the three rooms. A year later fire tore through the newly decorated southern wing. The fire began in the attic space, allowing time for the paintings in the lower floors to be saved. Soon after they were extricated the roof fell in. Fortunately, the solidity of the building, allied with a lack of timber in the structure, meant that the fire's spread was slow. This allowed time for the arrival of the fire brigade who were further aided by the close proximity of the River Tyne. A hose was placed on the surviving roof and water was sprayed onto the corridors to arrest the fire's spread. Its survival was due in great part to luck – a heavy stone structure, a lack of timber in the build and limitless amounts of water within pumping distance. Other houses detailed in this book suffered similar fires and ended up razed to the ground as such luck was not on their side.

During much of the 1930s and into the 1940s the house was empty – uninhabitable in the later years according to the Valuation Rolls. With the Second World War came the need for large houses capable of housing troops

and the building was once again pressed into action. Its inhabitants were officers of the large contingent of Polish troops in East Lothian. By 1946 the house was derelict and a letter to the *Courier* by Historicus lamented its sad state. He or she declared, 'chaos reigns supreme. The fine old house and grounds are completely neglected.' In 1947 James S. Richardson, the Inspector of Ancient Monuments, concurred:

> window glass all smashed, iron balusters and hand rail of main stair destroyed and removed . . . door lockplates and handles removed and marble mantelpieces torn out and lavatory basins broken.

He suggested that the best course of action would be demolition of the modern part of the house. For the next seven years discussions continued, focusing mainly on which parts should be retained. Frank Tindall fought to preserve what he felt were the 'picturesque' parts of the building, namely the old wing and an iron balcony. The modern part was demolished by October 1953 leaving only the twelfth- or thirteenth-century central structure. The old section of the house was never upgraded after it was saved. In 1961 the remaining portion of the house was in complete ruin, partly roofed with timber.

In February 1969, Provost G.F. McNeill, Admiral Sir Peter Reid and the local farmer visited the site. They found a structure with unsafe chimneys that was attracting local children. It was also overrun with vermin. As a result the building was scheduled to be demolished at 2 p.m. on 25 May. It was given a ten-minute reprieve when two onlookers wandered past the marked limits. Fate, however, could not be avoided. As a lone piper played *Flowers o' the Forest* 250 lbs of explosives, laid by the 104 (City of Edinburgh) Field Squadron of the Royal Engineers, did their work. They were set off in stages as it was thought that the full blast would damage the nearby chapel of St John the Evangelist and Herdmanston Mains Farmhouse. The final chimney breast fell at 3.15 p.m.

HADDINGTON PALACE, HADDINGTON

John of Fordun, the fourteenth-century chronicler, wrote that a palace once graced Haddington. The town was certainly viewed as an important one as early as the reign of King David I. He granted it burgh status in 1128 and 11 years later gifted it to his daughter-in-law, Princess Ada. After her son William

A woodcut by Adam Neill showing the remains of Haddington Palace in 1833

the Lion, King of Scots, acceded to the throne in 1165, he is believed to have erected the palace and spent much time there. In this building, on 24 August 1198, was born Alexander II, future King of Scots. In 1216 the town was razed by English forces and it is likely that the court began to use the town less frequently, preferring the safety of towns further from any marauding English army. In 1242, in an effort to hide the murder of Patrick, 6th Earl of Atholl, the building was burnt down.

In 1833 a number of buildings in King Street (now Court Street), on the site of the present County Buildings, were demolished. John Martine detailed the emergence of 'several elegant and well-proportioned Saxon pillars and arches, a vault and some arched passages', believed to be the remnants of Haddington Palace. Fortunately, Adam Neill, grandson of the publisher of the county's Annual Register, sketched the structure and the subsequent woodcut was published the following year. The remaining structure was demolished soon after it was revealed.

DUNGLASS HOUSE, OLDHAMSTOCKS

On the East Lothian border, on the western bank of the Dean Burn, once sat Dunglass House. As with many mansion houses it was borne out of an earlier keep. In later years Martine would describe this part of the house as 'a labyrinth of dark, damp, underground cellars and passages, which extend a

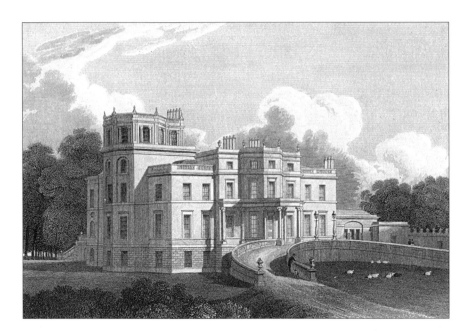

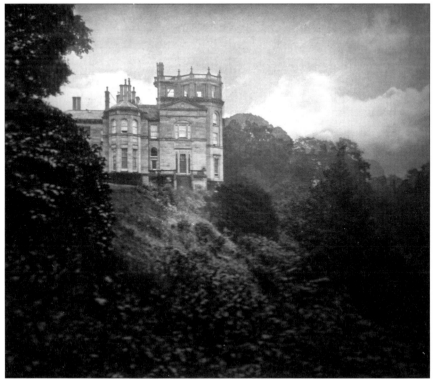

An engraving and photograph of Dunglass House. The engraving dates from 1850, the photograph from around 1883 (© Colour image: East Lothian Local History Centre)

considerable way under the lawn and policies to the westward'. The core of the house was built in the mid fourteenth century by Sir Thomas Home. By the sixteenth century it was held by the Douglases. From 1532–48 it was destroyed three times by the English, the last by Edward Seymour, the Protector Somerset, who ordered it pulled down (although the thickness of its walls meant that this proved an onerous task). It had been rebuilt by the beginning of the seventeenth century when King James VI and his retinue stayed there. In 1640 the Earl of Haddington and others, supporters of the Covenanters, took the castle to watch over the nearby garrison of Berwick. Whilst reading a letter to up to 80 of his men in the courtyard a powder magazine exploded, bringing a wall down on top of the gathered group and killing them all. It is said that the explosion was caused by a dwarf page who thrust a red-hot ladle into a barrel of gunpowder. All that remained of him after this deed was 'ane arme, holding ane iron spoune in his hand'.

Around 1680 the house was purchased by Sir John Hall. The lands would remain in his family for almost 250 years. In 1760 Richard Pococke visited and described it as a 'good house' with a 90-foot-long gallery. Twenty-seven years later it was visited by the poet Robert Burns who described it as 'the most romantic sweet place I ever saw'. When Sir James Hall took over the house he came into an inheritance and used this to build a new house in place of the old, sometime after 1810. The architect was Richard Crichton, who was commissioned by Sir James Hall, a principal exponent of Gothic architecture. Crichton's design was influenced by Hall and the artist Alexander Nasmyth, who had produced a model and sketches of possible designs (one Gothic, one classical). Many changes were made over the years and the last, by Mitchell & Wilson, was undertaken a year before it was sold. At this time it had five public rooms; the upper floors looked out over the Forth.

In 1919 the estate was purchased by Francis James Usher and remains in the family to this day. Around this time it had six public rooms, 20 bedrooms and dressing rooms, a billiard room and accommodation for servants. The interior design was eclectic in the extreme – from a tower where Hall had kept a large telescope, to marble bearing 'grotesque scenes', to Oriental wallpapers. For much of the period of the Second World War the house played host to the senior school of Donaldson's School for the Deaf, evacuated there to avoid its students falling victim to German bombs. The present owner, Mark Usher, has noted that the house was demolished in 1946 due to its being 'too large and an uneconomic proposition'. It was probably only partially demolished as a photograph dating from 1956 shows it still standing, albeit a ruin without a roof. The Usher family built a smaller, more manageable house.

AMISFIELD HOUSE,
HADDINGTON

It is likely that a house existed at Amisfield, at the eastern end of Haddington, long before the one shown and detailed here. Certainly Adair's plan of 1682 suggests this is the case and, if drawn anywhere near to scale, it was as impressive as any other in the area. It is likely that this house was demolished around the middle of the eighteenth century.

One of its owners, Colonel Sir James Stanfield, was reputedly strangled by his disinherited son, Philip, in 1687. After the act the body was thrown into a well in the grounds and it was initially thought he had drowned. Suspicions grew and the evidence against him mounted; when his son touched the body it is said to have bled. This, in the summary justice of the seventeenth century, signified that he was guilty. As a result he was hanged in Edinburgh and his head 'spiked' at Haddington. The well at Amisfield was supposedly haunted by the ghost of the colonel. In 1713 the house was purchased by Francis Charteris, a man renowned for his wild ways. A heavy gambler, he was also convicted (and later pardoned) for raping a servant, earning him the epithet The Rape-Master General. It was Charteris who renamed the house and grounds Amisfield, after his place of birth in Dumfries and Galloway. On his deathbed,

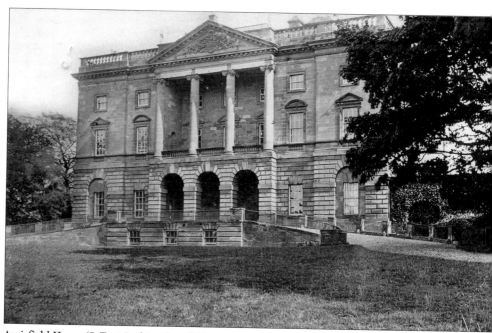

Amisfield House (© East Lothian Local History Centre)

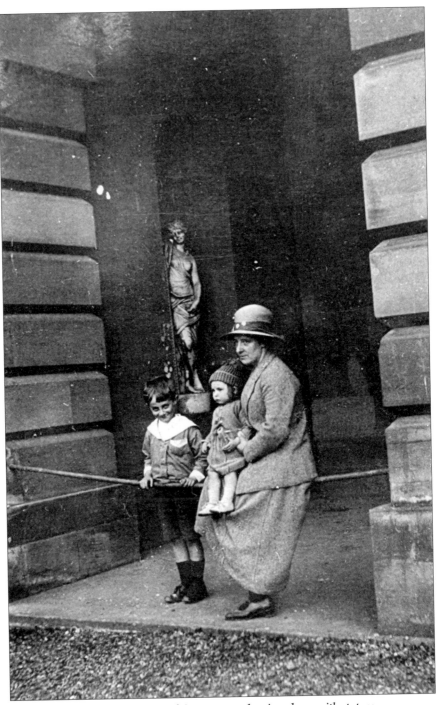

Amisfield House. A rare close up of the entrance showing alcove with statues
(© George Angus)

his impending end hastening his fear of divine retribution, he offered £30,000 to anyone who could prove that there was no such thing as hell. So despised was he that his coffin was covered in dead animals.

In 1755 Charteris' grandson, also called Francis, oversaw the erection of a new house in a Palladian style, from plans by Isaac Ware. Inside were five public rooms, 20 bedrooms with dressing rooms, a kitchen, laundry and rooms for servants. In 1760, only five years after it was erected, Richard Pococke described a 'fine galery' on the second floor and noted that there was a bowling green in the grounds. Wings were added in 1785. Photographs of the interior of the house and close-ups of the exterior are rare. One of each is known to exist and both reveal an alcove in which stand statues.

At the beginning of the First World War it was offered by its owner, the Earl of Wemyss, to the Admiralty as a hospital. Whether it was ever utilised as such is unknown but it certainly housed officers of the 1st Regiment of the Lothian and Border Horse, and the 4th (Res.) Battalion Royal Scots. The non-commissioned men were housed in huts in the grounds. But the house's days were numbered. In 1921 some of the house's antiques were sold, including eight carved walnut settees and a Sheraton secretaire. It was announced in 1924 that the house was to be demolished, and by April 1925, after it had been purchased by Richard Baillie, only the façade of the building remained; the rooms behind having being reduced to rubble. The stone was removed to be used in the building of Preston Lodge High School (1925), the clubhouse at Longniddry Golf Club (1920s) and the Vert Hospital (1930). At this time a sawmill was erected behind the house to utilise the wood extracted from the building. The Earl of Balfour said of its demolition, 'I am one of those who mourn over the loss of a beautiful specimen of our domestic architecture.' The façade of the building was to remain in place for a further three years. From 1932 the grounds have been used by Haddington Golf Club, and during the Second World War played host to Polish soldiers and then prisoners-of-war from Germany and the Ukraine.

BELTON HOUSE, DUNBAR

Belton House once stood three miles south-west of Dunbar, and was described by the *Courier* as 'one of the most secluded and beautiful of the many fine country seats of East Lothian'. The lands appear to have passed to the Hay family in 1468. When the house was erected is unknown but it is likely around

A rare image of Belton House near Dunbar, taken around 1883

this time. Originally a tower house with 6-foot-thick walls, around which the later structure was built, additions were made in 1739 and 1865. The original house measured around 16 metres by 8 metres. There were two carved, wooden, tinctured coats of arms, displayed in the house before its demolition – one for Lady Yester, the other for Lord Hay. These both bore the date 1553 and the mottoes '*Lux venit ab alto* (Light comes from above)' and '*Spair quhan thow hes nocht* (Ask if you are in need)' the former the motto of Lothian (in Latin), the latter of Yester (in Scots).

In 1824 a huge refurbishment and upgrade was undertaken with new pavements, windows, locks and doors. The total cost of the work was almost £500. Five years later the rooms were painted and papered. On the main

staircase, for example, it was suggested that the ceilings and soffits be painted a light shade of stone colour, the cornice and walls an imitation of light, warm-toned stone, the woodwork an imitation of wainscot, and the balusters an imitation of bronze. In 1849 a 28-page inventory of the house reveals much about the interior. The main rooms were all named after colours, and were likely decorated in these – white, grey, buff, blue, green and pink. There were also two 'Gothic' rooms. In 1913 it had 40 rooms.

Upon the death of the penultimate owner the house passed to a relative in England who seemed to take little interest in the building. The roof was removed to avoid paying taxes and it was gutted in 1956. The final moments of Belton House hardly befit its illustrious history. In July 1967 the 432 City of Edinburgh Engineer Regiment of the Territorial Army detonated 200 charges of plastic explosives and the building was soon levelled.

HALLIS WALLIS,
INVERESK

The recent rediscovery of the Musselburgh Burgh Minutes, dating from the mid sixteenth to the early twentieth centuries, is a great boon to researchers of the town's history. These were the minutes that James Paterson, Musselburgh businessman and sometime historian, pored over in the middle of the nineteenth century whilst researching his book, *History of the Regality of Musselburgh*. In this book he details a number of obscure local houses. One of these, at the south end of Newbigging, was called Hallis Wallis (also known as Halleswalls). Mention of the croft of land of this name is made as early as 1478 when it passed from Henry Froge to Simon Preston. Whether a house existed on the land at this time is unclear, but by 1663 it was listed as a 'croft of land . . . with mansion-house, yeard, and dove-cott'. In 1668 it was disponed to the Magistrates and Council of Musselburgh by Sir William Sharpe. No further information appears, but certainly the house no longer exists.

BOTHWELL CASTLE,
HADDINGTON

Despite its grand name, Bothwell Castle (also called Bothwell's Kitchen) was actually only a large house. Indeed, its true name was Sandybed House. The latter name emanated from an event in the sixteenth century when James

Bothwell Castle, known as Sandybed House until the Earl of Bothwell hid there from those who sought to murder him (© East Lothian Local History Centre)

Hepburn, 4th Earl of Bothwell, ran into the house whilst being chased by the Earls of Arran and Moray. Here he changed into the clothes of a female servant and remained for several days, escaping the clutches of his would-be captors. In gratitude Bothwell granted Sandybed House four bolls of grain annually (this would continue for 200 years) and the etymology of the house name was changed forever. From around 1762 it housed a girls' school run by Jenny Halyburton.

Situated next to the River Tyne in Haddington's Hardgate, it was described by MacGibbon and Ross, in 1892, as 'one of the best specimens of old Scottish domestic architecture left in Haddington' which, they added, 'if kept in proper order, would preserve a most picturesque feature of the town'. There must have been a rapid deterioration, as in 1913 the Bute List noted that the house was believed to be condemned and called for it to be brought under the care of the Ancient Monuments Board for Scotland (AMBS) adding that it was 'in a shocking state, even for a ruin . . . derelict and covered with posters advertising local events [and] falling into a greater and greater state of ruination'.

Also in 1913 RCAHMS detailed both the exterior and interior of the building:

> On plan the structure consisted of a main block running north and south parallel to the street and two wings, which extended eastwards to the river and enclosed a small courtyard. At the south-west angle of the frontage there projects a circular tower, in which was placed the main entrance. Above this is a weather worn armorial panel within the usual moulded border. The entrance in the tower has long been built up and superseded by a doorway more conveniently placed in the centre of the main block. This main block contained a sunk floor, two upper floors and an attic. The area is reached from the street level by a staircase within the tower, and it is probable that this stair originally continued upwards and gave access to the upper floors before the erection of a wide scale and platt staircase built out on the courtyard between the wings. The wings were three storeys high and were also served by this later staircase. At the eastern end of the south wing there was a rectangular dovecot, not detached by forming part of the main structure. The walls are built of rubble with ashlar dressings. The window and door jambs are moulded in some instances, splayed in others. The interior of the building was finished with care and taste.

Certainly, the owner at this time, one of the Todrick family, intended to demolish, but this plan did not come to fruition. In April 1928 it was put up for sale at public roup with an upset price of £100. It was purchased by local builder Richard Baillie for £205. His initial intention was to re-roof and restore the building and use it to provide rent-free accommodation to the town's spinsters, whilst utilising a section of it as a museum. Again, neither came to fruition.

In 1934 the AMBS recommended it be scheduled, meaning that it would be considered a building of national importance. In the following ten years it seems to have deteriorated with Gray and Jamieson describing it as 'an utter ruin'. By 1949 it was in a terrible condition, causing one councillor to argue that they had better demolish it before it falls down. Such concerns did not lead to decisive action. It was still standing in March 1960 when AMBS withdrew their earlier recommendation, noting that 'the present remains were no longer worthy of scheduling'. It is unclear exactly when the building was demolished but it was certainly still standing in February 1961. As such it was one of the last of the old houses in the northern section of Hardgate.

STONEYHILL,
INVERESK

The earliest mention of Stoneyhill, south-west of the Old Bridge, comes in the latter half of the sixteenth century when it is owned by Jacobi Hammiltoun. In the following century it changed hands many times, passing from Joanis Fairlie to the Dobie family to Sir William Sharpe, also the one-time owner of Hallis Wallis, who had it in 1681. By 1728 it had passed to the notorious Colonel Charteris. He died in the house and his funeral possession through Musselburgh was 'bespattered . . . with filth and garbage'. The mansion house, according to David Macbeth Moir, was taken down in 1838. He notes that at the time of writing only the offices of the original building remained and it was these that are described as Stoneyhill. Moir's description suggests that its end was long overdue; 'the material exhibited every mark of a hoar antiquity. The wood work in the walls was literally reduced to must.'

PRESTON HOUSE,
PRESTONPANS

Preston House is one of the least well known of the houses mentioned in this book that are said to have played some role in the Battle of Prestonpans. It is, however, the most historically significant. Although three images of it are known to exist, these show little more than an ivy-covered wall. Indeed, at a recent archaeological dig of the area Dr Tony Pollard noted that 'it seems Preston House was erased from the face of the earth'. The lack of a substantial photograph meant that the full scale and impressive nature of the house can only be appreciated by looking at contemporary plans, which highlight its imposing nature and magnificent gardens, allowing it to be compared to the impressive Bankton House.

The house is believed to have been built in the late sixteenth or early seventeenth century for Thomas Oswald, son of Edinburgh's Lord Provost. In 1650 it was burned after the Battle of Dunbar, although the extent of the damage is unclear. After the Oswalds came Lord Grange who laid out the extensive gardens filled with walks and mazes that required two hours to walk around. Grange, a Jacobite, was so paranoid about his political allegiances being betrayed that he banished his own wife, Rachel Chiesley, Lady Grange, to St Kilda to protect himself as he felt she would reveal his secrets. Given his support for the Jacobite rising it is perhaps fitting that the building was to play

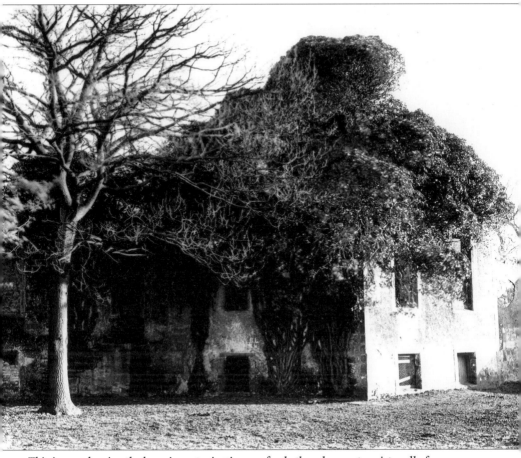

This image showing the house's west wing is one of only three known to exist – all of which show the building in ruin (© East Lothian Local History Centre)

a central part in the Battle of Prestonpans. It is likely that clandestine Jacobite meetings were held there prior to the battle, and once the conflict began General Cope used the 10-foot-high walls to protect his army's right flank. Trapped there, his soldiers were cut down by their Jacobite opponents.

In 1781 Dr James Schaw bequeathed it to the town of Prestonpans, 'to be fitted up for the maintenance and education of boys of poor but respectable parents' with preference of entry being given to those with the surnames Schaw, McNeil, Cunningham and Stewart, in that order. Schaw's Hospital, as it was named, was opened in the building. It was, however, a school rather than a hospital and produced a number of boys who went on to successful careers. It is believed, for example, that one student, William Jelly, ended up as chief medical adviser to the Emperor of Austria. In 1832 it closed as a school

when new premises were built. The last teacher planted the ivy which would, a century later, virtually obscure its remains. At this time the house was falling into disrepair, but was still utilised as a private dwelling for the remainder of the nineteenth century.

McNeill's description of the house, from 1902, clearly outlines its impressive stature:

> The house, though in ruins now, was a two-storied building, constructed in the old Scotch baronial style. The whole building, from east to west, measures 142 feet. The main or front door is closed up, but quite a number of the finely rounded steps leading up to it are intact. There are a pair of beautiful circular pillars, one on each side of the door, with very fine fluted stonework behind them. Schaw's, or some other coat of arms, is said to be emblazoned over the door, but heavy rods of ivy hold the mastery here, and whose they are remains a mystery. From the main door passages run east and west the whole length of the building, and there is a continuous passage from wing to wing in the lower flat of the building. A few of the lower windows are, or have been, iron-stanchioned, while several of the upper windows have been treated in a similar manner. The old kitchen is situated on the ground floor in the west wing, and a curious little place it is. It has four diminutive windows, two to the front and two to the back. The ceiling is low but strongly arched with stone. The floor has been laid with pavement, and that business has been meant with the fire is evident from the fact that the fireplace covers a space of nine feet, while a couple of iron hooks still retain a place in the ceiling, capable each of bearing aloft the dead weight of either boar or bullock. There is a fine room, 18 by 15, over this, but the ivy is creeping in everywhere. At the extreme east end of the building is a very spacious and lightsome room. It contains a very small fireplace, four very large windows, and a monster of a door at the east end, fully three and a half feet wide by eleven feet in height. This is known as Dr Schaw's Library. A very large recess in the wall shows where his bookshelves had been, but not a single volume of old forgotten lore is to be found there now. Along the back or south of the house runs what is called the avenue. It is simply a continuation of what had evidently been a direct route eastward through the village of Preston in days that are no more. Opposite what remains of the south side of the ruins there remained until recently a large stone-paved court. It

was bounded by the parapet wall still overlooking the garden south-wards. Along this parapet wall still runs the original wood railing, with its great iron spikes which formerly went to embellish it. This wood railing was set up when the house was constructed, and it has now become so frail that but for the fruit trees Mr Wright planted against it many years ago it would hold its place no longer.

Almost in a line with the old house runs a very high and time-worn wall. That this wall had been built many years antecedent to Preston House is evident, and from the door and window marks shown therein it is also evident that Preston village extended very much farther east at one time than many people now imagine; and it was only, we doubt not, when Preston House was built that this main highway through Preston village was unceremoniously stopped. The proprietor of Preston House had cut out over his door the following inscription, 'No plague shal. near thy dwelling come. No ill shall thee befall.' Possibly the plague of 1797 was here referred to. If the above inscription was over the south door it is gone for ever, because that side of the house was erased long ago; but if it were over the north door, there it remains snugly ensconced behind a heavy coat of firmly intertwined ivy, never more to be read till the woodman with his glittering hatchet makes a clearance.

By the early twentieth century it was in serious disrepair – Charles E. Green called it 'an utter ruin'. In 1920 the remains were surveyed by RCAHMS. Only the north front portion remained with walls extending from the centre to a two-storey wing at either end. The eastern wing had had a modern roof added, being slated and ogival in design. It was being used as a store. It is believed to have been demolished around 1930, although the *Third Statistical Account*, written in 1953, noted it was 'derelict' and a 1965 guidebook stated that only a 'fragment survives'. A further survey by RCAHMS in 1972 revealed no trace of the house.

In 2008 Baron Gordon Prestoungrange, as part of his attempts to promote the Battle of Prestonpans to a wider audience, commissioned the building of a model showing the battlefield. The result was a particularly impressive scale model which includes both Bankton and Preston houses. Not since the early twentieth century had anyone had a chance to see Preston House in such intricate detail. It now resides in the Prestoungrange Gothenburg Public House and is also used as an educational tool to teach schoolchildren about the battle. The following year the Battle of Prestonpans Heritage Trust commis-

sioned an archaeological survey to 'properly interpret and protect the battle site'. Residents in nearby Schaw Road and Polwarth Terrace, some of whom had already uncovered artefacts from the battle, were asked if they would allow their gardens to be dug up in an effort to uncover information. The dig found evidence that the stones used to build the eastern wall were taken for use in surrounding buildings. Indeed, two sculptured white cockades, the emblem of the Jacobites, are still evident in a nearby wall.

'OLD' NEWTON HALL,
YESTER

Newton Hall, or 'Old' Newton Hall as it came to be known after the erection of a newer building of the same name, was built in the late sixteenth century. Sitting two miles south-west of Gifford it measured 51 feet by 22 feet and consisted of two storeys plus an attic. Little is known of the building as, for reasons unknown, it is not listed in the Valuation Rolls. On the 1853 OS map it is denoted as a ruin. In 1920 RCAHMS stated that the house was in ruin and the walls covered in 'ivy and other vegetation'. Above the northern doorway was an heraldic panel displaying two shields. The upper one bore a lion passant and the initials PN, the lower three cinquefoils the initials MH, whilst the lintel bears the inscription '1668. IHN. 30'. It is likely that these are the initials of members of the Hay, Newton and Hay Newton family.

In 1970 the building, at this time an 'overgrown ruin', was re-examined by RCAHMS due to a 'serious masonry fall'. This had made the adjacent parts of the structure unsafe. During this examination some ivy was removed. This revealed some details that had not been uncovered 50 years earlier, such as a doorway that led to a previously unknown wing. It is likely that it was as a result of this deterioration and subsequent examination that the building was demolished in 1971.

PENCAITLAND HOUSE,
PENCAITLAND

Little is known of the early history of Pencaitland House, also known as Penkaet House. It is said to have mainly dated from the seventeenth century, although some parts were built as early as the fourteenth century. Sitting at the eastern end of the sixteenth-century bridge which links Easter and Wester

Pencaitland, the three-storey house met its end in a fire in 1876. Sixteen years after the house was burned Martine described it as 'an old fashioned pile of buildings, of little architectural beauty, but no doubt in olden times well suited for the convenience and comfort of families who lived in the old style'. At the time of the fire the house was tenanted by James Hay. He discovered the blaze around midnight on the second floor and alerted the tenants of the house's two wings and they proceeded to empty the house of as many documents and furniture as time would allow. After the last of the furniture was saved the ceiling caved in and the fire rapidly took hold. Haddington Fire Brigade arrived at 3 a.m. but, hampered by a lack of water, it was still alight three hours later. The following afternoon a large portion of the back wall of the house collapsed and this in turn pulled down a part of the front wall. In the aftermath it was conjectured that the fire started during the day when a bedroom fire set alight some beams and these smouldered until exposed to air whereafter they burst into flame.

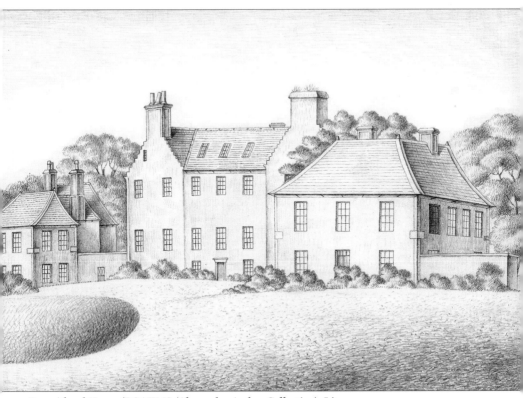

Pencaitland House (RCAHMS (Alexander Archer Collection). Licensor www.rcahms.gov.uk)

BANKTON HOUSE,
PRESTONPANS

Bankton House, more commonly known as Colonel Gardiner's House, sitting to the south of Prestonpans, was originally called Holy Stop, being a stopping place for monks making their way from Preston to Newbattle. Over time the name evolved into Olivestob and remained so until the mid eighteenth century. Having been erected as early as the twelfth century it changed hands many times over the years. The first known owner was Mark Ker, Earl of Lothian. In 1632 it was purchased by Sir Alexander Morison of Prestongrange. His estates were sequestrated and sold 13 years later and it was around this time that the lands passed to the Seton family. It then passed to the Hamiltons through marriage. In 1733 James Hamilton sold the estate to James Gardiner, a colonel in the British Army. Gardiner was mortally wounded at the Battle of Prestonpans and soon after this his effects were sold and the property was

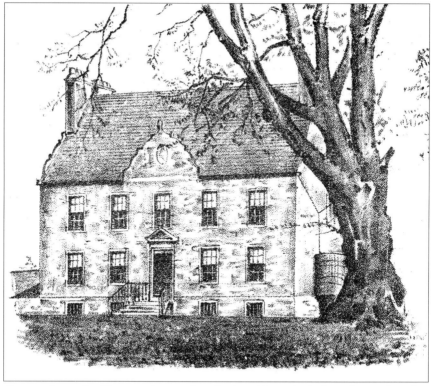

Above and opposite. These two images show Bankton House in the late nineteenth and early twentieth centuries. They are, however, probably representations of how the house would have looked in its heyday (© East Lothian Local History Centre)

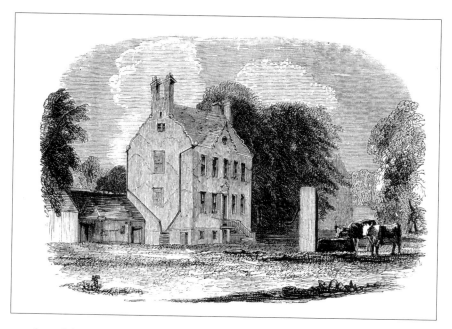

purchased by Andrew McDouall, an advocate. It was he who changed the name of the house to Bankton in the mid eighteenth century, although it was still being referred to by both names a century later. After his promotion to the bench he took the title Lord Bankton.

It is said that in the early nineteenth century an old woman prophesised that the house would succumb to fire three times and that the third time it would 'tumble to the ground'. Around this time Eaton notes that the interior walls were 'richly panelled in oak' although these were lost in the first fire which completely destroyed the building in 1852. The fire was believed to have started when a beam was ignited by heat emanating from a kitchen vent. Within half an hour the roof had caved in and soon the whole building was on fire. Such was the ferocity of the blaze that even the swift attendance of the Musselburgh Fire Brigade could not ensure its survival. In 1886 a guide describes 'the remains of Bankton' implying that it had not been fully restored in the intervening 34 years. It must have been upgraded relatively soon afterwards as images show it looking eminently habitable.

In September 1893, when it was being used as a farmhouse, a signalman at Prestonpans Railway Station noticed a glare on the stackyard. Investigation showed it to be a fire at Bankton House, described as 'one of the largest and most destructive farmyard fires that have taken place in the district'. The damage was estimated at between £1,600 and £1,700. At the turn of the century the house was three storeys with an additional two garret storeys in the roof,

as it is today. Both gables house an extensive chimney. The lower storey is partly below ground level. The main door is on the middle storey and is reached by a set of stairs. The level of the ground has lowered, perhaps since rebuilding, resulting in the lower storey windows being fully visible from in front of the house. Walls run from the east and west of the house, each leading to its own pavilion.

Evidence of just how far this once-mighty house had fallen came in 1966 when it went on fire for a third time. At this time it was serving as a bothy for a squad of Irish farm labourers. Indeed, so insignificant is it deemed that it is only referred to as 'a Prestonpans farmhouse' in a short *Courier* article. The house was badly damaged and when the flames had subsided it was a shell with no roof. By November 1967 it was believed to be well on its way to being levelled with a newspaper article noting that 'only the final arrangements for its demolition now remain'. Frank Tindall, the County Planning Officer, although gloomy in his assessment of the situation, said that he felt there was 'a faint glimmer of hope' if funding could be found. Neither the funds nor demolition came in the short-term. Frank Tindall, however, continued to seek a positive solution and he finally achieved this after being appointed director of the Lothian Building Preservation Trust in 1983. The owners, the British Coal Board, were persuaded to gift the house and surrounding land to the trust. £760,000 was raised to pay for the restoration work. Between 1988 and 1995, with grants coming from bodies as diverse as East Lothian Council, Historic Scotland and the European Regional Development Fund, the building was restored to its former glory by the Lothian Building Preservation Trust and Nicholas Groves-Raines Architects. The interior is split into a series of flats. Despite being rebuilt at least twice the architecture has changed little.

LOCHEND HOUSE, DUNBAR

The Baillie family owned the lands of Lochend as early as 1614. The first mention of an actual house comes from the writings of a John Taylor, who noted that around 1630 he visited 'Master James Baylies House'. The lands and barony of Lochend were disponed to George Warrender in 1708. In later years a second house was erected. Some remains of the original building still exist. These include a Renaissance gateway, once part of a wall, bearing the date 1684 which now graces Leithen Lodge in Peebles after being removed in 1992. The Dunbar and District History Society attempted to retrieve it but were unsuc-

cessful. A heraldic panel bearing the inscription 'Sedes Dent Fata Quietas', 'May the Fates Give a Quiet Seat', once formed part of another gateway. The initials 'IB' on a stone denote that this building may have been erected by James Baillie, father of Gideon Baillie. In 1915 RCAHMS described it as the remains of 'a two-storeyed 17th century mansion'.

In 1826 a descendent, also George, hired the architect William Burn to design a new house. Nine years later it was described, in the *New Statistical Account*, as 'an elegant mansion in the Anglo-Gothic style, much admired for the chasteness of the building and the commodious arrangements within'. In 1846 a fire broke out in the house when it was full of guests but was soon under control. Perhaps the fates had their eyes set on Lochend, for on 11 March 1859, a day on which a gale was blowing, a shepherd walking past the house noticed flames coming from the roof. The fire was stirred by the strong winds and the house was destroyed in less than two hours. All the occupants survived. George Warrender was away on business and his visiting sister, Sister Julian, a nun, is said to have led the family to safety and returned to save jewellery (protecting it from looters in the process).

Only the billiard room survived, although this was finally demolished in 1909. There was great sadness felt at the demise of the building. In 1861 the *Courier* noted that workmen were demolishing the part of the house with fire damage, but hoped that it would be replaced. Catherine Miller Mitchell, in a poem titled *Lochend*, laments the house's passing:

> The fires destroying rage an awful war did wage,
> Till in ruins lay the mansion late so fair.

Despite the desire for the house to be replaced, it never was. Today some ruins still remain, and their continued existence should be ensured due to their being A-listed by Historic Scotland.

'OLD' GOSFORD HOUSE, GLADSMUIR

'Old' Gosford House (previously known simply as Gosford House until the erection of a newer structure of the same name) was, it has been argued, built around 1659. This can be ascertained by the discovery of a lintel, during demolition, bearing the initials of Peter Wedderburn and Agnes Dickson. Wedderburn had purchased the Gosford estate in 1659. Known as 'The Red

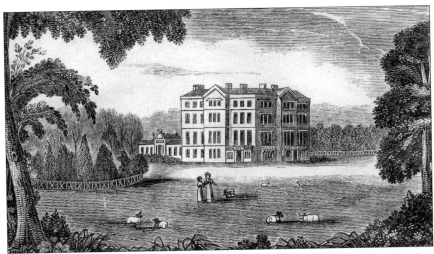

Adam Neill's engraving from 1848 showing 'Old' Gosford House (© East Lothian Local History Centre)

House' due to its distinctive stone, it was purchased by Francis Wemyss Charteris, 7th Earl of Wemyss, in 1781 in order that he could be closer to a rough golf course at Gosford. Soon after, the earl commissioned Robert Adam to build a new house to the west. This house, the present Gosford House, was completed in 1800. The new earl preferred the old house and Amisfield House at Haddington, resulting in the new structure remaining empty. In the 1830s the old house was enlarged by William Burn. In 1853 the 9th Earl considered demolishing the new house but was dissuaded by his son, the future earl.

In 1890 the family moved into the new house and the old building fell into ruin. After this the history of the old house is sparse. By 1904 it was still occupied by a caretaker, at which time it stood on the edge of a wood, 'its ragged, ruddy stone clasped with ivy, its detached moundlets of ruin skilfully trimmed'. In 1926 John Pringle Reid described it as 'a picturesque ruin'. The site was visited by members of East Lothian Antiquarian and Field Naturalists' Society on 20 May 1939 and it had been pulled down three weeks previously.

WALLYFORD HOUSE, INVERESK

Around the area where the houses to the east of Wallyford in Wemyss Gardens and Inchview now stand, was once Wallyford House. Its demolition came as a result of the need for land on which to build these houses. A plain building, it

measured 82 feet by 56 feet, was built of freestone rubble and sandstone (once covered in harling), and its two storeys were topped by crow-stepped gables. The house was originally L-shaped but the addition of an extra wing added symmetry with the east and west both protruding to the front. The most important rooms had a southern exposure. The house was on three floors. On the ground were the kitchen and a number of apartments. Above this was the dining room, and on the second floor were several bedrooms. Above one door, which lay between the two protruding sections, was a plaque with embossed date reading 1672, suggesting that it may have been built around this time. The date was flanked and topped by three *fleurs-de-lis*. William Binning is listed as owner by 1681 and the family still owned it in 1731.

Little is known of the building for the next century. By the middle of the nineteenth century it was being used as a store by the Aitchison family. By 1876 it was housing up to 27 mining families. In October 1884, at which time it was unfurnished and described as being in 'a ruinous condition', it was burned down. A section of the building at this time was being used as a school. The best efforts of the Musselburgh Fire Brigade were to no avail as there was no water source near the building. It was completely gutted. A local source recalls that the ruin was still standing in the mid 1980s and was finally demolished after being set on fire by vandals. The last remnants of the building were 'two fireplaces with moulded jambs and lintels on the first floor of the east wing'.

ORMISTON HALL,
ORMISTON

In the very year Bonnie Prince Charlie's army was defeating the government forces at Prestonpans, a new mansion was being built four miles south, in Ormiston. Commissioned by the Cockburn family, it was built by John Baxter Snr to replace an older castle, the last hiding place of the Protestant reformer George Wishart in 1545, the remains of which stood 200 yards to the west. By 1747 the family was deeply in debt and the sale of the Ormiston lands provided a financial fillip. The Hope family took over the erection of Ormiston Hall, which was completed the following year. Sir Thomas Dick Lauder once described the house as being in the 'tea-canister style of architecture' – presumably due to its being square. Three more 'canisters' were added at later

Overleaf. Wallyford House (RCAHMS. Licensor www.rcahms.gov.uk)

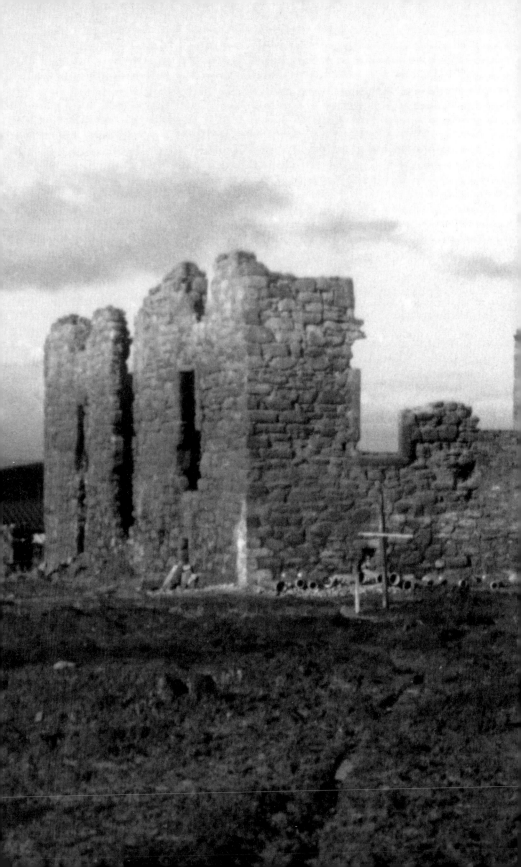

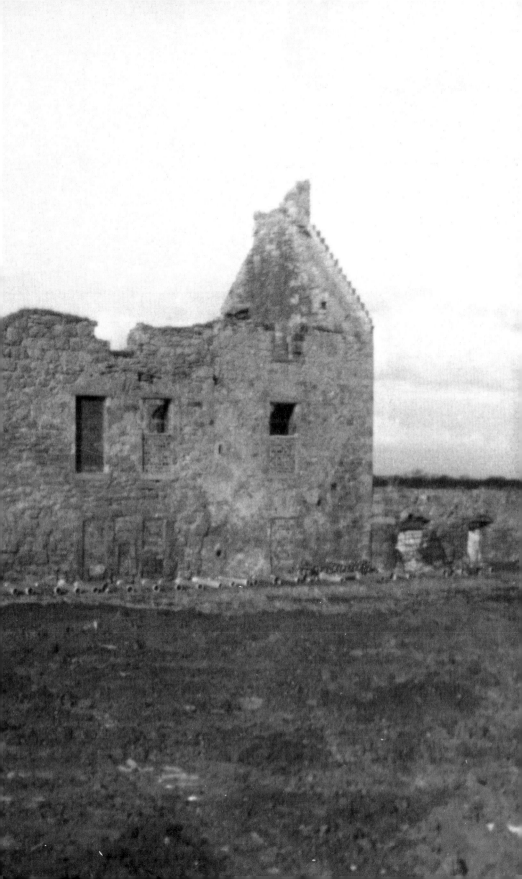

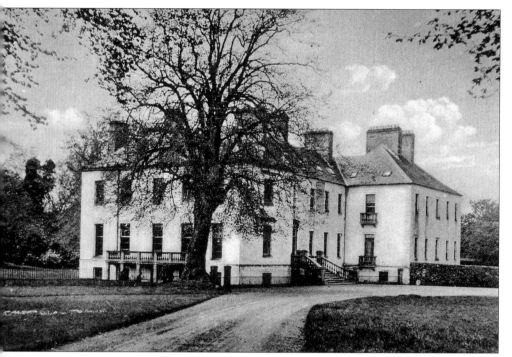

Ormiston Hall in the early twentieth century (© East Lothian Local History Centre)

dates, one at an irregular angle, thus corrupting the square nature of the structure – these additions likely came in 1772 (designed by Alexander Steven), 1827 (by Thomas Brown) and 1851 (by David Bryce). Its plain nature did not seem to bring negative reviews; in 1885 Groome's *Gazetteer* noted that 'as it has no external pretension, it gives no offence'.

Over the years it was inhabited by an array of tenants until its final one in 1911. In 1912 the contents of the Hall came up for sale; from objects as impressive as a Steinway grand piano, oil paintings and an oak billiard table to the basic necessities of house and garden – a mangle and lawnmower. It would remain empty until the Second World War when, like many large buildings, it was used to house troops – in this case Polish ones. On 23 April 1944, when soldiers were still stationed at the house, the National Fire Service was called to the Hall. So serious was the blaze that five pumps, a turntable ladder and a hose-laying lorry attended but still the fire destroyed the house. By 1970 this 'great, ungainly, empty, white building' had no roof. In January 1972 councillors agreed to allow its demolition, although the foundations and some of the walls were to be retained to evidence the size of the building.

NEWHALL,
YESTER

Little is known of Newhall. Sitting between the farms of Marvingston and Bankrugg, it was designed by William Adam before 1723. Throughout its existence it seems to have been owned by the Hay Mackenzie family. From 1893 it was reduced to housing farm workers and nine years later it was listed as ruinous with its annual rental price being as little as £4. Most sources note that it was demolished in 1909 but there is evidence in the Valuation Rolls that point towards its demise coming in 1932 or 1933.

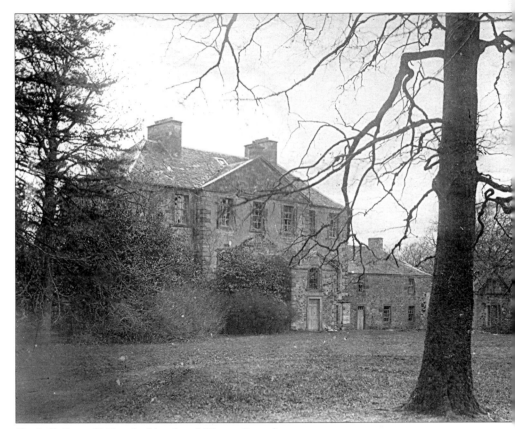

Newhall, Yester (© East Lothian Local History Centre)

THURSTON HOUSE,
INNERWICK

In 1745 the estate of Thurston, five miles south of Dunbar, was purchased by the Hunter family, having been previously owned by the Cants. After the death of Robert Hunter, his wife Agnes determined to pass the red sandstone house to one of three nephews. Calling each to the estate she chose the one, Robert, who arrived on foot (the others came by coach and on horseback) as she felt he was the least pretentious. It was he who added the house's wings.

In January 1882 it was purchased by Sir William Miller for £170,000. By 1895 it was owned by a Richard Hunter and it was he who commissioned a refurbishment and reconstruction in the early 1890s. This was undertaken by the architect John Kinross, assisted by Hamilton More Nisbett.

In 1907 the house was burgled and this led to an alarm system being installed. This caution was rewarded when, in 1909, raiders again targeted the building. The alarm highlighted that a French window had been breached and this led to a protracted game of cat-and-mouse with servants and police. Evading capture at the house, the thieves made their way to bicycles and headed eastwards. One was soon captured and the remaining two were caught

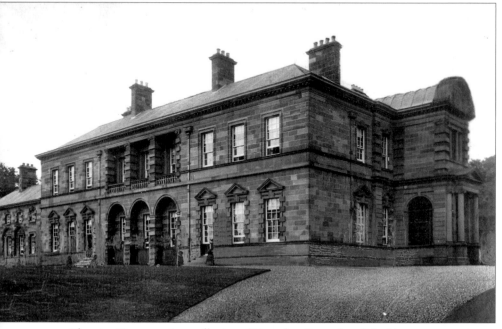

Thurston House was in excellent condition when it was demolished in 1952 (© East Lothian Local History Centre)

on the road to Cockburnspath with the aid of a motor car – perhaps the first time such a vehicle had been used to capture criminals in East Lothian.

In October 1948 Thurston estate came up for sale at the Roxburghe Marine Hotel in Dunbar. It was described as 'an imposing residence of noble design' and 'a finely proportioned residence, beautifully decorated and in first-class order'. The sale catalogue detailed the interior. A pillared porch led to oak doors and glass-panelled inner doors. These opened to reveal an entrance hall of 18 feet by 11 feet. Next came a front hall of 51 feet by 18 feet. This room was fitted with an Italian fireplace with ornamental surround and fluted wall pillars. The roof was a circular dome. Other rooms included the dining room with its French windows opening onto the south lawn. There was also a billiard room, library, drawing room, smoking room and others. Despite enquiries from some organisations the house went unsold and as a result was demolished in 1952. It is frequently cited as one of the best examples of a house that was demolished when in almost perfect order. Stone from the house was used in the foundations of Nunraw Abbey whose foundation stone was laid in 1954. When an extension was being added to St Rule's House in Marine Road, Dunbar, the interior doors were brought from Thurston.

SEACLIFF, WHITEKIRK AND TYNINGHAME

Although the mansion of Seacliff, situated less than a mile south-east of Tantallon Castle, still stands, it has lain ruined for over 100 years. It is believed to have been built in the latter half of the eighteenth century for Robert Colt but it was not until an extensive rebuild, commissioned by the then owner George Sligo, was undertaken in 1843, that we can begin to build a picture of how the house looked. The architect, David Bryce, was a primary advocate of the Scots baronial style and this is immediately apparent in the house; Sonia Baker noted it had 'crow-stepped gables, turrets and bartizans aplenty'. As well as this architectural extravagance there was also a long conservatory built on the west of the house. The house was built on three floors. Within its walls were a range of rooms that any wealthy landowner would expect – a drawing room, dining room, library, billiard room and conservatory, as well as the standard bedrooms, dressing rooms and bathrooms. At the east of the house was a service wing housing rooms such as a laundry, dairy and coal house.

Whether Sligo was upgrading simply to enhance the value and enable a quick sale is unknown, but certainly the house had been purchased within

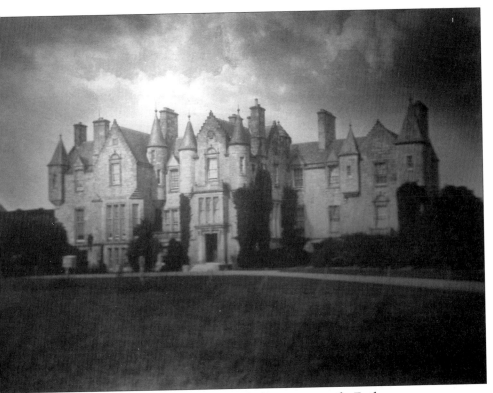

Seacliff, victim of a major fire in 1907, looking out across the Forth

three years by John Watson Laidlay. Despite Sligo's extensive upgrade Laidlay obviously felt that further change was needed and in 1863 he hired Francis Farquharson to make extensive enlargements, most notably a complete rebuild of the north wing. After Laidlay's death in 1885 his eldest son Andrew took over the estate and moved his family into Seacliff. Andrew's one indulgence during his tenure was the installation of plumbing and drainage, including flushing toilets. He failed to install electricity and, ironically, it may have been this decision that cost him his life.

At around 2 a.m. on 28 July 1907 a fire began spreading east from the library, aided by a westerly wind. Members of the household were alerted by Effie Hamilton, the housemaid, and Mrs Laidlay and her daughter escaped from their top-storey bedroom by tying sheets together, affixing them to the window and lowering themselves to the balcony below from where they climbed to safety with the aid of a ladder. The housemaid then made attempts to reach the house's owner, Andrew Laidlay, but the smoke and heat were too intense. By the time North Berwick Fire Brigade arrived the blaze had already

taken hold and the roof was collapsing. Their efforts were hampered by a lack of water. They eventually attempted to draw some from the sea, but rocks and receding waters impeded its success. The lack of water, however, had little bearing on the house's demise. The cause of the fire is unknown, but the *Courier* reported that a likely cause was that Mr Laidlay was reading by the light of a paraffin lamp, fell asleep and the silk and lace lampshade caught fire. The mansion was almost completely destroyed, with rough estimates of the damage at between £25,000 and £30,000. Mr Laidlay's remains were discovered in the ruins.

His wife sold the estate in 1919 and it was purchased by John R. Dale who was already tenant farmer at two farms within its boundaries. The Dale family own the estate today, but the mansion still sits in ruins, a sad reminder of the glory days of one of the finest of East Lothian's country houses.

CLERKINGTON HOUSE, HADDINGTON

Prior to the building of the Clerkington House that is most well known amongst Haddington's older residents, another structure existed. It was owned by the Cockburn family until they sold it, somewhat fortuitously, less than ten years before the devastating flood of 1775 swept away a whole wing.

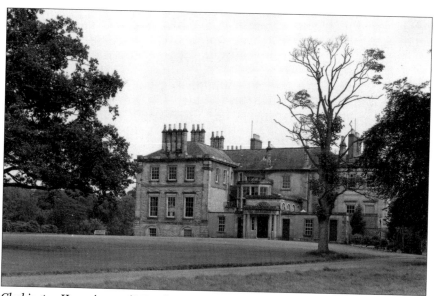

Clerkington House in 1951 (© DTZ)

Clerkington House – showing the interior around the 1920s

In 1920 local historian J.G. Wallace-James would note that 'a few walls and foundations mark the site' of the parts of the original house after the flood. In 1785 Dr Barclay noted 'the mansion house of Clerkington [was] immediately swept away' suggesting the whole house was removed, although a contemporary account argued that it was only one wing.

Twenty years later, in 1795, the estate was purchased by Alexander Houstoun, the beginning of a 125-year family relationship with the house.

In 1920 the house was purchased from the Houstouns by James Johnston Ford who had tenanted the building for some years. Two months after purchasing the house Ford died suddenly at his other home in North Berwick. In later years it was his son Ludovic, a racing driver most famous for finishing sixth at Le Mans, who lived there. Like many country houses it was requisitioned by the military during the Second World War and from 1939–41 it played host to the 405 Searchlight Company (later Battery), 4th/5th Battalion, Royal Scots. Thereafter Ford sold the house in 1951 to a Julius Felsenstein. It is probable that he was the 'man from Sheffield', alluded to years later by a former housekeeper, who intended to turn the house into flats. By November 1966 it was in poor condition, with many smashed windows, but the building remained standing until the mid 1970s when, under the ownership of Captain Anthony R.G. Stevenson, it was finally demolished. A local man remembers exploring the house just prior to its demolition. One room was painted white with a huge red mural on one wall depicting a woman in a top hat followed by a band.

'NEW' NEWTON HALL, YESTER

It is unclear whether 'New' Newton Hall, built 100 yards to the north of 'Old' Newton Hall, was erected as a replacement for its older neighbour, or if it existed in tandem with it. Certainly, 'New' Newton Hall was shown on the 1852 OS map when its older namesake was depicted as a ruin.

In April 1921 the house was purchased from the Hay Newtons by Mary Ann Mackenzie, formerly of Alderston House. By 1940 it seems to have been in a habitable state, as J.D. Brunton commissioned architects Dick Peddie & Mackay to make alterations to it. During the Second World War, however, it was occupied by troops and, as was the case in other mansion houses, they failed to show it respect when staying there. Some years before it was demolished its roof was removed to avoid the roof tax. By the time of its demolition

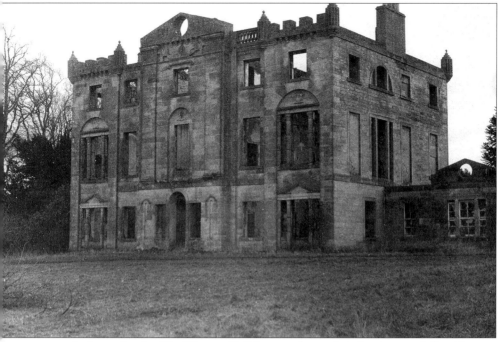

An image showing 'New' Newton Hall from north-west in 1963, two years before its demolition (© East Lothian Local History Centre)

its only value, according to the *Courier*, was in the stones with which it was built. In May 1965, despite being a Supplementary Listed Building, it was blown up by the Royal Engineers. It was visited again, five years after demolition, and was described as a ruin. The stones were later cleared and since then two houses have been built on the site.

GLASCLUNE HOUSE, NORTH BERWICK

From the nineteenth century the golf links and beach made North Berwick a highly desirable town to live in. The monied made their way to there and erected house after house to accommodate themselves, either permanently or when holidaying. Glasclune House was erected between 1889 and 1892 on Greenheads Road. Commissioned by John Blair Balfour, Liberal MP for Clackmannan and Kinross and former Lord Advocate for Scotland, it was designed by George Washington Browne, working for Kinnear & Peddie, in the symmetrical Queen Anne style with four pedimented dormer windows and

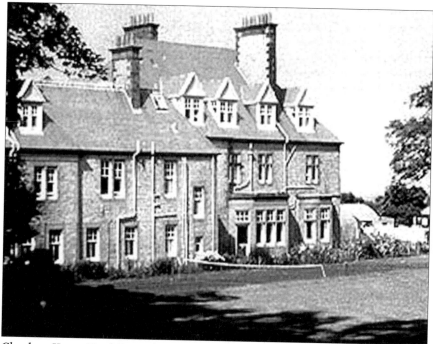

Glasclune House, North Berwick – erected around 1890 and demolished in 1981 after a major fire gutted the building (© www.northberwick.org.uk)

built by Peter Whitecross & Sons of North Berwick. The interiors were completed by Scott Morton & Co. and included a Jacobean timber stair at the top of which was an arcaded gallery. The ceilings were adorned with grapes downstairs and roses upstairs. Balfour, known as 1st Baron Kinross from 1902, died in January 1905 and his wife, Marianne Eliza Moncreiff, Lady Kinross, took over the house. It was during her ownership that the house seems to have first been linked with Dr Barnardo's, a children's charity. In 1912, a year before her death, a bazaar and exhibition was held in the grounds with the proceeds going to the organisation.

Before her death it was sold to the Cross family. Marjory Cross, later known as Lady Hawke after a remarriage in 1916, lived there until her death in 1936. It remained in her family's hands until 1938 when her husband, Lord Hawke, former Yorkshire County Cricket Club captain and president, died. It was then purchased by the Viscountess Garnock (also known as Countess Lindsay). During the Second World War the Viscountess let it to the War Office to house troops. By late 1944 the army had departed for operations in Europe, and in March 1945, and then again a year later, the house came up for sale. At this time it was described as containing, amongst other things, an

entrance hall, lounge, billiard room, morning room, dining room, drawing room, 16 principal bedrooms, five bathrooms, gardens, glasshouses, tennis court and garages as well as two dwelling houses suitable for servants. It was advertised as being suitable for use as a private hotel, nursing home or school.

It was purchased in the late 1940s by Dr Barnardo's for use as a home for girls (boys would later be housed there also). At its peak around 40 children lived there. It remained a children's home for the next 22 years after which time it became a home for children with 'severe emotional and behavioural difficulties'. It was run by superintendents – Eric and Dorothy Falconer. In 1979, a fire broke out on the ground floor and was quickly brought under control by local firemen. Three hours later a fireman, Deputy Superintendent William Craig, led 17 children to safety as a second fire raged through the building causing an estimated £300,000 worth of damage. So serious was the fire that at one point 60 firemen from East Lothian and Edinburgh tackled the blaze. A 15-year-old was later charged with starting the fire deliberately. After the fire Eric Falconer said, 'Glasclune was a fine house with extensive grounds and it has been a wonderful setting for children for over thirty years.' In later years the former cook, Sophia Brumby, wrote, 'Glasclune was a lovely home, very comfortable for the children.' The building was damaged to such an extent that it was demolished in 1981. On the land stands Glasclune Gardens and Glasclune Court.

STAIR PARK,
TRANENT

In 1890 the coalmaster John Durie built a house called Stair Park, north of the road to the west of Tranent. It was a wise choice, with the house commanding impressive views of the Prestonpans battlefield and the Firth of Forth. Francis Cooper & Son, Musselburgh builders, were hired to erect the 30-apartment house in red freestone at a cost of £7,000. A long driveway led up to a doorway and porch that was arched and pillared. The floor directly above opened out onto a balcony. The façades on either side were topped with different designs of ogee arches. It was, according to the *Courier*, 'striking in its architectural treatment'. Durie, however, was unable to take much advantage of the house as he died in 1894. His wife removed to Edinburgh and the house was let to a number of tenants over the next few years. By 1913 it was empty, awaiting a new tenant. It was advertised for sale or let, with two acres of gardens, three public rooms, seven bedrooms, a kitchen, a servant's bedroom, a pantry, a

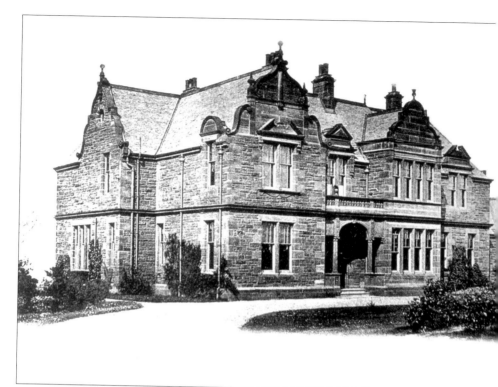

The short-lived Stair Park at Tranent. Built in 1890 it is said to have been burned down by suffragists in 1913 (© East Lothian Local History Centre)

laundry and two bathrooms, and 'every modern convenience'.

Police were inspecting the property twice a day. On 10 June 1913 a passing trader saw smoke and flames rising from the roof. The local fire brigade (soon to be joined by the one from Haddington) was no match for the blaze which was fanned by the high situation of the house and high winds. When the flames subsided only the walls remained.

Conspiracy theories began to circulate almost immediately. The *Courier* noted that 'the facts seem to point unmistakably to incendiarism'; the police had checked the building shortly before it went on fire and a window at the rear was half open and had been treated with black soap and covered in paper to muffle the sound of breaking glass. It was believed that oil was poured onto the pitch pine floor and set alight. The general feeling amongst local people was that suffragists were to blame, and according to the *Courier* they were 'exceedingly wroth that so fine a building should have been sacrificed to petty political spite'. Given that in the previous month attempts had been made to blow up St Mary's Episcopal Church in nearby Dalkeith and the Blackford Hill

Observatory we can perhaps forgive such paranoia and ire. No evidence was ever found to implicate the female suffrage movement.

In 1923 the Catholic Church bought the land, or came close to doing so, with the intention of building a new place of worship there. This, however, never came to fruition. The house was back in the hands of Durie's trustees the following year. In 1928 the trustees sold the house to a farmer called James Fullarton. The house stood, known locally as 'The Burnt Hoose' until it was finally demolished in the early 1960s. What remains unclear is that after the fire tenants, including the Tranent Co-operative Society, are frequently listed, suggesting that the house had some function, although it could have been for some such means as storage.

CHAPTER 3

VILLAGES, STREETS AND HOUSES

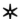

VILLAGES

In the eighteenth and early nineteenth centuries agricultural improvers in Scotland were constantly seeking ways to increase profits derived from their farms. As well as improving farming techniques and inventing and introducing more efficient tools, there was a drive to free up fertile land that was being used for other purposes. In some cases, however, settlements already existed on this land. The answer to this problem was to evict the tenants and level the buildings. In most East Lothian cases there was a concerted attempt to create new villages – or planned villages – to house those who had lost their homes as these would be the same people who would work the new land; thus the new improved housing was borne out of financial motives rather than any philanthropic gesture. There are examples, however, of mass evictions with no evidence that the evictees were re-housed.

Some villages disappeared through other means. Eldbottle, recently uncovered during the creation of a golf course at Archerfield, was probably abandoned due to wind-blown sand covering land and buildings and making farming unviable. Blackshiels was simply subsumed into the village of Fala in 1890 when changes in the county boundaries saw it moving from East Lothian to Midlothian. By the time of its demise it was merely a conglomeration of four buildings.

BOTHANS, YESTER

Bothans was home to the workforce of the Hays of Yester. Their houses would have been, most likely, ramshackle, wooden affairs. It is commonly argued that

63

the village of Gifford was the direct descendant of the village of Bothans – the residents simply and conveniently moved en masse to the former. This is unlikely, as it has been noted that the first mention of Gifford in the Old Parish Registers is in 1662, whilst Bothans residents are still listed in 1684. The population of the Gifford area began to grow at a gradual rate, rather than in a single flurry – nine residents in the 1670s rising to 65 in the late 1690s. Bothans, on the other hand, was a 'dying village' by the latter half of the seventeenth century, evidenced by the fact that it is only mentioned in the registers five times between 1656 and 1677. Today all that remains are the remnants of the church.

WHITTINGEHAME

The removal of the old village of Whittingehame, known as Whittingham and Whittinghame before 1897, happened after the main glut of planned villages in the mid eighteenth century. It was in 1817 that James Balfour of Balbirnie purchased the Whittingehame estate from Robert Hay of Drumelzier. In later years it was noted that the old cottages sat on the road from Gifford to Dunbar, stretched out in a semi-circle for around half a mile. They were 'decrepit . . . roughly-built . . . thatch-roofed, with free spaces between them, each with its own allotment of ground'. It is unknown when Balfour actually cleared the old village and indeed it may have been achieved over a few years. Certainly the public house was still in business in the old village as many as 12 years after Balfour purchased the lands.

Lang adds that 'houses of a more modern type' formed the foundations of the new village, about half a mile north of the old. Many of the old tenants, he argued, were simply moved from old to new. Of the land where the old village stood, Martine is complimentary of the changes, noting that Balfour 'spent a great sum of money in beautifying and improving it, in building, planting, draining, and making new roads'.

LONGNIDDRY, GLADSMUIR

Longniddry, around the 1770s, has been described as:

a long straggling conglomeration of rubble-walled, thatched or pantiled cot-houses, farm houses, barns and steadings, stretching

from the Orchard area of Glassel Park to Kitchener Crescent, and south over the Longniddry Farm area. The layout of the land around the village was a hangover from the days of the medieval 'runrig' method of farming. The great open fields were devoid of walls, hedges or fences, and divided into 'rigs' or strips.

It was this village that, in 1779, John Glassel, recently returned from America, bought at auction after the bankruptcy of the previous owners, the York Buildings Company. The village was situated a mile east of Port Seton and set just back from the sea, on top of the most fertile land in the area. It was this that would lead to its ultimate demise. Glassel was aware of the financial benefits to be had by farming this land and so set about demolishing over 70 houses and evicting the tenants. By the time he had finished he had reduced it to 'the proportions of a hamlet'. The Longniddry demolition differs from most of the other examples detailed in this section in two ways. First, the village was not completely levelled – a remnant remained and formed the foundation of the village that exists today. Second, a replacement village was not erected to house those who had lost their homes. Whilst other landlords seem to have acted on some compunction caused by their deeds by erecting a new 'planned' village for the evicted, Glassel did not. What became of the evictees is unclear, although the common course for evicted tenants in the late eighteenth century was to move to an area where the kelp industry thrived, or to emigrate.

SETON, TRANENT

The village of Seton stood just west of Seton Castle. In 1791 the population was 86, mostly weavers, tailors and shoemakers. This may explain why an Incorporation of Tailors was based in the village. The estate was owned by the York Buildings Company, who had purchased it from the Earl of Winton. When the company went into administration in 1779 it was purchased by Alexander Mackenzie. He set about demanding that the householders produce title deeds to their properties to prove ownership. Most no longer had these and were swiftly evicted. Others sent their documents to Edinburgh and were thereafter deemed to no longer have their deeds. Only one villager retained his house – John Proffit's daughter worked for a Writer to the Signet who proved her father's ownership of the house. The evicted villagers moved to nearby Meadowmill which around this time was recorded in Sasines as 'Meadowmill, now known as Relief', perhaps as a result of giving relief to the evictees.

CUTHILL,
PRESTONPANS

The village of Cuthill, pronounced 'Kittle', lay at the western end of Prestonpans and had existed since it was created a burgh of barony by the Abbey of Newbattle. By the mid nineteenth century it comprised a series of houses and buildings close to the shore of the Firth of Forth. Around 50 years later, McNeill described these dilapidated structures:

> some of these look as if they had been built to overhang the rocks . . . there were holes in the floors through which the water came up; openings in the walls through which the waters rushed in; there were windows stuffed with rags, and roofs without tiles

Lucky Vint's Tavern, for example, which once stood 20 yards east of Bankfoot House was, by 1902, little more than foundations. The ingress of the sea is evident from the fact that these could only be seen at low tide.

One of the uniform terraced streets at Cuthill. This one was called Summerlee, after the coal company that purchased the local mine in 1895 (© East Lothian Local History Centre)

From 1876 Prestongrange Coal and Iron Company Ltd began to build streets of brick terraced houses at Cuthill for their workforce. Front and Middle Streets were the first erected. Water was accessed via a tap at the bottom of the stairs. These were described by Martine as 'a long row of excellent miners' and workmen's houses'. In 1895 the Summerlee and Mossend Iron and Coal Company Ltd took over at Prestongrange Colliery and immediately started to provide additional housing for their ever-growing Prestongrange Colliery workforce (it rose from 1,700 to 4,100 between 1895 and 1910). The first 44 red-brick terraced houses were built on two storeys, the upper level being reached by an outside stair. There was a communal toilet for every eight houses and ash disposal facilities were provided nearby. This new street was called Summerlee Street and it was extended by a further 29 houses in 1905. McNeill, soon after the first were built, noted that they were 'very respectable new buildings' housing 'a highly respectable class of workmen'. The *Scotsman* described the houses as 'dismal and factory-like'. By the time this street was finished, in mid 1914, it would comprise 160 houses. The last 32 were an extension of Summerlee Street. They were known locally as Back Street and Bath Street, due to the houses having a private bath and sink, but in actuality there was no such street name (although it pervades virtually every history written about the area).

The extent of the housing expanded in tandem with the growth of the surrounding mine workings. Those built in 1905 were erected only a year before the sinking of a new shaft at Prestongrange. In the 40 years from 1881 the population of Prestonpans doubled. But a village of such size (by 1925 there were around 250 houses) requires a distinct infrastructure. Much of this is detailed elsewhere in this book, but a quick overview provides evidence that this was a thriving community: there was a picture house (built *c.*1912), a co-operative store (1925), a mission hall (*c.*1911), a miners' welfare institute (1925) and a number of public houses.

The inadequacy of the Cuthill housing is perhaps best outlined by the fact that some lasted less than 50 years. In 1934 the council oversaw the demolition of 63 houses in Middle Street, replacing them with 50 new houses. They were, according to Frank Tindall, demolished in order to widen Prestonpans High Street, but also because 'they had been neglected and had fallen below tolerable standards'. Those houses that remained after the initial demolitions were wholly unfit for human habitation – they had obsolete boilers and so lacked hot water, and had poor-quality roofs and plasterwork. The remaining streets and the accompanying infrastructure had been pulled down around 1960 and partly replaced by a new housing estate known locally as Ponderosa,

named after the ranch on the popular television programme *Bonanza*, due to the use of wooden fencing. The house building between Prestonpans and Cuthill saw the latter subsumed into the former.

<center>SMEATON VILLAGE,
INVERESK</center>

The company of A.G. Moore & Co. Ltd erected 90 houses around 1908 to provide accommodation for their workers at Smeaton Colliery. Smeaton Village, situated next to Smeaton Colliery, was not so much a village as a row of houses, with its own mission hall, co-operative store (p. 128) and welfare institute (p. 181). The houses, a mundane terrace of brick-built abodes on two levels, were very similar in style to those at Cuthill. Twenty-four of the houses were torn down in the early 1930s. In 1947, as a result of nationalisation, the remaining houses were taken over by the National Coal Board who ran them until the 1950s when they were demolished.

STREETS AND HOUSES

In the nineteenth and early twentieth centuries there was a realisation that the terrible living conditions so prevalent in Scotland's towns could not continue. Slums facilitated the rise and spread of tuberculosis and cholera. Thus attempts were made, albeit fragmented, to improve the housing stock of towns and villages throughout the county. Councils were fully aware that many dwellings, although picturesque, were ramshackle, decrepit and unfit for human habitation. They were dirty, damp, cramped and lacking sanitation and drainage. One resident at Cuthill was subjected to a stench that emanated into her house from the neighbouring stable when she lit a fire.

The populations of mining towns exploded in the last years of the nineteenth century and first years of the twentieth century. From 1881 to 1921 the population of Prestonpans doubled from 2,573 to 5,154, whilst Tranent's rose from 5,198 to 9,653. Scattered miners' houses were replaced by purpose-built coal company housing, generally near the large collieries that were gradually replacing the small pits prevalent throughout the county. Those built in later years had far greater advantages than those built earlier. This was due in great part to a 1917 report by the Housing Commission. It noted that new houses should have a minimum standard of accommodation, with a 'living

<center>68</center>

room, two bedrooms, a scullery, with sink, tub, washing boiler, a food larder, a coal cellar, and, where there are water pipes, a water-closet, and with power to Local Authorities to require the provision of a bath, with domestic hot-water supply'. Several mining communities emerged in East Lothian – for example, at Cuthill (1876–c.1916), Smeaton (c.1908), Ormiston (1914), Preston (mid 1920s) and Tranent (mid 1920s). Some of these houses still exist whilst others lasted less than 50 years.

In the immediate post-war era there were serious attempts to address the issue of overcrowding. In the five years after the end of the Second World War, 235 pre-fabricated houses were erected in the landward areas in the county. With the arrival of Frank Tindall as the County Planning Officer in 1950, there were concerted attempts to end the stagnation of house-building in the county town of Haddington. He oversaw participation in the Glasgow Overspill scheme that saw Glasgow families re-housed in the county. By 1965 there had been built 265 'overspill' houses. This contributed greatly to the growth of the town's population from 4,500 to 6,500 in the 20 years after 1950. Tindall also oversaw Sir Robert Matthew's creation of the Inchview scheme at the western end of Prestonpans, which became known as Ponderosa. The late 1960s saw a rapid rise in private house-building at the expense of houses being built from public funds. In 1980, for example, the ratio of private to public houses built was 266 to 18. As houses were being built the councils were able gradually to rid the county of its more decrepit housing stock. Large swathes of inadequate houses were removed from towns such as Prestonpans, Haddington and Musselburgh.

HARDGATE, HADDINGTON

Many of the buildings in the northern section of Hardgate are now gone, demolished in the 1950s in an effort to upgrade and modernise the area. A number of these are mentioned in this book, including Bothwell Castle (p. 33), the various incarnations of the slaughterhouse (p. 121) and the town's three picture houses (p. 178). In 1957 the building of 27 new houses was underway.

The residents of the street doubtless witnessed many memorable events on their doorsteps through the centuries; the baker Wull Cochrane killing two French soldiers who tried to steal bread from him during the Siege of Haddington, the Earl of Bothwell escaping from would-be assailants, and the return of the depleted 42nd Regiment from the Battle of Waterloo. A more

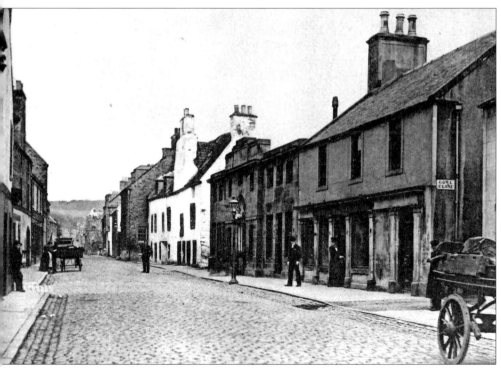

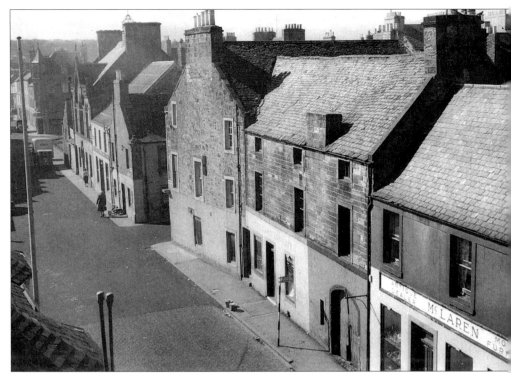

In 1956 George Angus climbed onto the roof of the New County Cinema in Haddington's Hardgate and took these two photographs (opposite top and above) of the western side of the street just prior to its demolition. The image (above) looks down towards Sidegate and the one (opposite) looks towards Dunbar Road. The other image (opposite bottom) shows the eastern side of the street. The building second from the right stands almost exactly where the present-day garage stands – directly behind it stood the town's slaughterhouse. (Opposite top and above © George Angus; opposite bottom © East Lothian Local History Centre)

recent incident happened on an evening in March 1941. The nearby picture house was packed when a German bomb fell on the building formerly occupied by Pringle's cabinetmaker's and upholstery shop (p. 126), destroying it completely.

Some of the northern part of Hardgate did survive the carnage of the 1950s, most notably the bank building, Bothwell Bank and Tenterfield. One artefact, however, will soon be making a re-appearance. Just north of Bothwell Castle once stood a house, the lintel of which was engraved with candles and the date 1599. This lintel survives and is to be displayed in the soon-to-be-opened John Gray Centre in Lodge Street.

JOHN KNOX'S BIRTHPLACE,
GIFFORDGATE, HADDINGTON

For many years there has been much speculation as to where John Knox was born. In the nineteenth century this focused on either the town of Gifford or the Haddington suburb of Giffordgate. The Giffordgate argument won out – so much so that in 1881 the writer Thomas Carlyle commissioned an oak tree to be planted at Giffordgate in the garden where his parents had lived and near where it is thought John Knox was born. Despite attempts in the twentieth century to argue that Morham may have been the true birthplace, it is now widely accepted that Giffordgate, on the east of the Tyne just south of Nungate, was indeed Knox's birthplace. It is unclear exactly when the house was demolished but it seems likely that it was between 1832 and 1853. A map drawn up at the former date shows the house, whilst a map from the latter date shows an 'X' marking the 'Supposed Birth place of John Knox'. This, therefore, throws doubt on the claim of numerous postcards to show Knox's true birthplace.

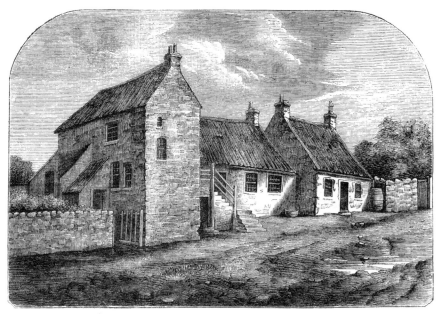

A representation of the house at Giffordgate that was commonly, and probably erroneously, claimed to be the birthplace of John Knox (© Scottish Reformation Society)

DAVIE DOBSON'S HOUSE,
TRANENT

This disjointed, ragged building was situated in Fowler's Lane (later known as Fowler Street) and, it has been said, dated from the twelfth or thirteenth centuries. In the latter half of the sixteenth century it was said to be grand enough to house Mary, Queen of Scots and her entourage. Mary and the Earl of Bothwell had played a game of archery at Seton Castle and the forfeit was dinner at the 'principal hostelry in Tranent'. In later years the Historiographer Royal, John Hill Burton, disparagingly scoffed at the town's ability to host such an occasion: 'What means the place [Tranent] possessed for entertaining royalty in the sixteenth century it were hard to say; it is now smoky, cindery, rife with whiskey shops.' A century on from Burton's assertion the historian Alison Weir argued that the town did not actually play host to the Queen as she had actually been unwell on the day of the archery contest. The upper floor was said to have been a grand hall, stretching from one end of the building to the other. It also had a doocot that housed 200 pairs of pigeons.

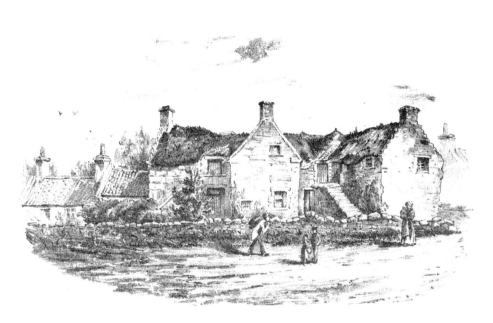

Davie Dobson's House, Tranent (© East Lothian Local History Centre)

David Dobson owned the house, and adjoining properties, in the latter half of the nineteenth century, by which time he was an old man. The house was split into four separate dwellings and passed through a number of hands before it was purchased by the Porteous family at the turn of the century. It remained until the mid 1930s but at this time it was swept away, being replaced by two new houses.

FARMER'S HOUSE,
NUNGATE, HADDINGTON

In 1912 the writer Francis Watt lamented the fact that the Nungate was 'swept and garnished. If I lived in it I should be delighted, but I would that some millionaire of antiquarian taste had bought all fifty years since, and carefully dusted and preserved it under glass as a unique specimen of what is now gone and cannot return.' Reminiscing, he described it as 'once a jewel of rare excellence. Miry and malodorous, dirty and disreputable, it was yet the very image of the old Scots town of centuries ago. It was crammed with every feature of old Scots architecture. Roundles, pends, closes, wynds, outside stairs, every-

The decrepit Farmer's House in the Nungate (© East Lothian Local History Centre)

74

thing. Nobody built, nobody pulled down. It culminated in *Farmer's House.'*

James Farmer lived in his house at East Gate Side in the Nungate for many years. His parents moved there around the 1840s and he spent much of his life there. As a result of his long association with the house it was known locally as 'Farmer's House'. It stood in large gardens where apple trees grew. This was attested to in 1896 when a labourer stole 9 lbs of apples from the garden. The same year saw part of the fence stolen. The house was believed to date from between the thirteenth and fifteenth centuries. That it was pre-Reformation is certainly a possibility; in the late nineteenth century its wainscoted rooms were visited by the archaeologist Sir James Simpson and colleagues who were, according to John Martine, 'highly pleased and delighted'. Martine concluded, due to its finely painted rooms and mouldings of scriptural scenes, that it had housed dignitaries of the Roman Catholic church. By 1897 it looked like the remnant of a past age and a local official described it as 'ancient and picturesque' but in a 'very dangerous condition'. Certainly the slates on the roof looked as if a hard rain would wash them off and send them clattering to the ground. Councillors agreed to serve notice that it be demolished. This occurred around the turn of the century, almost certainly before Farmer died, aged 64 years, on 18 May 1900. At this time he was living at Giffordgate, Nungate.

PIGEON SQUARE,
TRANENT

In the years just prior to its demolition Pigeon Square, situated in Church Street, was a rather sad-looking conglomeration of one- and two-storey buildings, with a roof partly grey-slated and partly thatched and the walls layered with clay or mud. It went through many names before the one it is most commonly known by. In the early seventeenth century, when it was owned by Dr Forest, it was known as Forest's Bounds. A century later it was Lee's Bounds, after its owner Lawrence Lee. By the end of that century it was housing many of those who were involved in the Tranent Massacre (an event that saw a number of local people murdered by soldiers of the East Lothian Volunteer Yeomanry for daring to proclaim that they opposed enforced recruitment into the military).

For many years the square in front of the houses played an important part in the Carters' Play, which was one of the many festivals organised by the trade incorporations and friendly societies. Numerous booths and shows used the

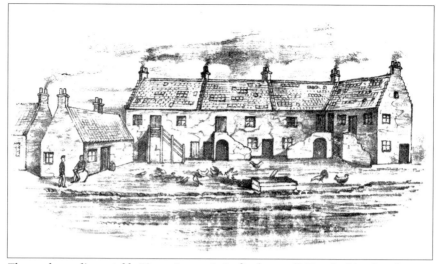

The rundown, disreputable Pigeon Square in its final years (© East Lothian Local History Centre)

area to set out their stalls and revellers descended upon the square. On one occasion in the nineteenth century the Prestonpans town drummer, Puddock Wull, was called in to entertain at the shows. From Tranent he passed through Cockenzie and Prestonpans before returning to his starting point. All the way he proclaimed:

Shows at Pigeon Square, Tranent,
Come a'! Come a'! Come a' and see!
A horse's heid where its tail should be.

In addition to this he also made a number of other outrageous claims of what could be viewed at the event. None were true, in the strictest sense of the word. The horse claim was a trick – it was trained to walk backwards up a stair. Wull returned home with more bruises than he had arrived with.

For a time, probably in the early nineteenth century, it was known as Texal Square. This name was derived from a lady called Nannie Muirhead who lived in the south-west-corner house. Described as 'anything but a virtuous woman', much of her time was spent on the warship *Texal* in the Firth of Forth. Her conduct became so bad that she was tarred and feathered by the sailors and put ashore at Cockenzie. Her behaviour seemingly improved little when she settled in what became known as Pigeon Square. The name Pigeon Square came into being soon after Muirhead's death. There are two stories regarding

how this name came about, but Peter McNeill notes that the one given most credence locally was that a family called Dow acquired a house in the square in 1830. Their name was pronounced 'Doo' (Scots for 'pigeon').

He also details that it was not the most reputable of dwellings, calling it a 'howf for the most degraded characters'. Indeed, the surrounding area must have been equally notorious. When plans were made to build the new public school on the land where Pigeon Square had once stood, a letter-writer to the *Courier* called Veritas railed against its placement arguing that the area was 'a nucleus of disease, dirt and degradation'. The houses were purchased by the Tranent School Board for £560 and demolished in September 1875 (at which time it was 'a mass of ruins . . . an eyesore and a nuisance').

THE INKBOTTLE,
COCKENZIE AND PORT SETON

Standing on the corner of Gosford Road and Cope Lane, The Inkbottle, so named due to its square shape, the shallow slope of its red-tiled roof and its distinctive central chimney, was one of several names by which this house was

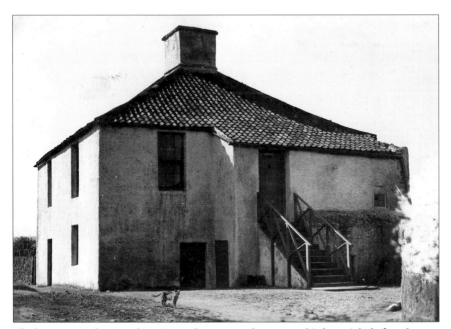

The house at Cockenzie where General Cope may have spent his last night before the Battle of Prestonpans. It was also known as The Backet, The Pavilion and Cope's House (© East Lothian Local History Centre)

known. Visitors to the town called it The Backet and it was also known as Cope's House. In 1899 a Cockenzie resident took exception to the interventions of 'saut-water folk' and proclaimed that locals knew it as The Pavilion. The same resident claimed its place in history – General Cope was said to have slept there the night before the Battle of Prestonpans – was in fact apocryphal. Cope, he claimed, actually slept on the battlefield and that the legend arose from the house being marked 'Cope's House' on a map. He further claimed that the house was built by a foreigner called Swedaire, probably the Dr Schwediaur who is mentioned as a salt manufacturer in the *Old Statistical Account*. It may have started life as a glassworks in 1729 when it was owned by the York Buildings Company.

By the twentieth century the house was owned by the Earl of Wemyss and let out to a painter called Joseph Millar. In 1919 it was sold to a fisherman called Alexander Lyall who transformed it into three houses and let it out. In 1922 it was sold to Alexander McClelland and swiftly thereafter to Isabel Henry Johnston. In 1925 it was upgraded, after fears it would be demolished. At this time it is described as having all the fireplaces in the centre of the rooms, allowing the building to be centrally heated (although not as we would know it today). The upper part of the building was made up of large square rooms that were 'beautifully and artistically furnished'. Despite this upgrade, the property continued to deteriorate. Its last tenant, in the early 1930s, was James Kennedy, a stonemason. By 1935 the house had been condemned, and it had been demolished by 1937.

EDEN COTTAGE, MUSSELBURGH

The massive house-rebuilding programme of the late 1940s and early 1950s made sure all had a house when their previous occupancy was pulled down. However, one resident was made homeless. A ghost named the 'Green Lady' had, it was said, lived in the 250-year-old Eden Cottage in Market Street, Musselburgh for many years. She had taken up occupancy after a duel between two suitors. Her preferred love was killed and, overcome with grief, she hanged herself from an apple tree in front of her house. Those who lived there handed down stories of sightings. One family saw her twice – a grey apparition that disappeared 'in a shaft of light'.

In 1921 it was up for sale and was noted as having two sitting rooms, four bedrooms, a kitchen and garden. Described by the *Musselburgh News* as 'once

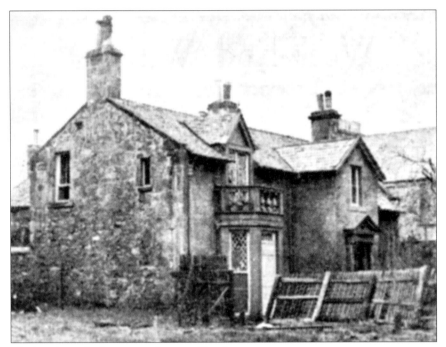

The last days of Eden Cottage in Musselburgh

an attractive villa, lattice-windowed . . . secluded by a high boundary wall', it was, in 1949, 'deserted and tumble-down' and its owner, Margaret Telfer, was issued with a compulsory purchase order by the council (for which she received compensation). When its last resident departed at the end of 1949 the house became a target for vandalism and the theft of its lead piping. It was demolished soon after.

CUTHILL HOUSE, PRESTONPANS

Cuthill is another house in Prestonpans said to have acted as a resting place for one of the major protagonists of the events of 1745 – this time Bonnie Prince Charlie. In August 1980 the building was described as a 'death trap'. The last owner had left the building at the end of 1979 and since then it had become a haven for glue-sniffers and vandals. This led local residents to draw up a petition calling for its demolition. The council, however, were on the ball and the building was already the subject of a compulsory purchase order. Soon after it was demolished.

ALT HAMER/ALDHAMMER HOUSE
(168 HIGH STREET), PRESTONPANS

It is said that the name Aldhammer emerged in East Lothian when, in the eleventh century, a Norse pirate of that name was shipwrecked in the area that is now Prestonpans. Being unable to repair his vessel he built a small settlement. While the town would take the name Priests' Town which evolved into Salt Preston and finally Prestonpans the name Aldhammer has remained in use as the name of at least two buildings. It is currently the name of an office belonging to East Lothian Council sitting on the north side of the town's High Street. On the spot where this building stands was once a house of the same name. It was built in the eighteenth century, certainly being in place by 1763. Its walls were 3 feet thick.

In the nineteenth century it was owned successively by salt merchants – Mr Alexander and A.A. Meek. By the 1920s it had been converted from a family home to a nursing home, run by the district nurse Agnes Campbell, although still owned by the Meek family.

By 1939 much of the house, which was split into five dwellings, was

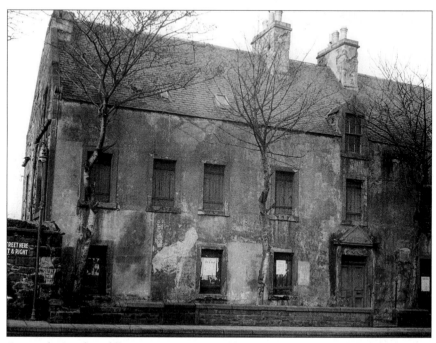

Any aesthetic value Aldhammer House once added to Prestonpans High Street is clearly gone forever in this image which shows the house boarded up and awaiting demolition (© East Lothian Local History Centre)

condemned. The rest of the building soon followed. It was demolished in June 1962 as part of the scheme to widen Prestonpans High Street. Embedded in the walls were a cannonball and a whisky measure. A few days after its demolition the stump of a tree next to the building was removed, revealing a well.

LAND O' CAKES, PRESTONPANS

The evocatively named Land o' Cakes was a two-storied block that stood at the centre of Prestonpans, on the north side of the High Street. At one time it served as a licensed premises under a man called Forbes. His wife Barbara was a well-known baker of oatmeal cakes and Forbes named the premises based on this. Forbes would frequently partake of his own wares. If his wife served up a poor breakfast he would tell her, 'Babbie, that's a puir breakfast this mornin', ye had better gie's a bit glass, I think, to help it.' If the breakfast was a good one he would compliment her, 'Ay, Babbie that's a grand breakfast, I think it deserves a bit glass to keep it company.' It is unknown when it was demolished, but after its demise it was immortalised in the Davy Steele song 'Here's a Health tae the Sauters'.

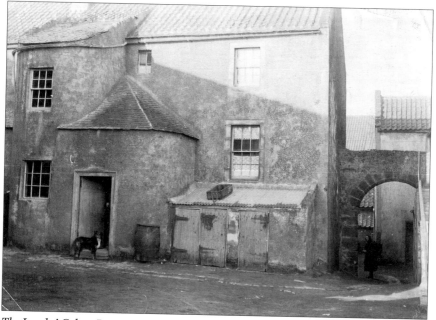

The Land o' Cakes, Prestonpans (© East Lothian Local History Centre)

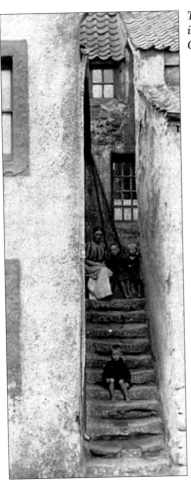

The narrow stairway leading to Castle o' Clouts in Prestonpans (© East Lothian Local History Centre)

CASTLE O' CLOUTS,
PRESTONPANS

On Prestonpans High Street, near the Queen's Hotel, once stood a two-storey building called Castle o' Clouts, a building name evident in a number of towns in Scotland. Although the name historically has been attached to buildings that are somewhat rickety, this was not the case in Prestonpans where it was a 'sturdy-looking block'. The building once was home to a tailor called Tam Rodger. Above his door he hung a sign that read 'Claes ta Clout' (clothes to mend) and this prompted one passing wit to ask if this was the 'Castle o' Clouts'. By 1879 it was owned by a retired grocer called John Broadfoot Davie. In July 1910 the whole building was demolished and replaced, the new frontage being in line with that of the King's Arms Hotel.

BANKFOOT HOUSE,
PRESTONPANS

Little is known of the early history of Bankfoot House. By 1855 the seven-bedroomed house at Cuthill, facing onto the Firth of Forth, was owned by Sir George Grant-Suttie.

In late 1943 part of the building was purchased by Robert Reid and in 1955 he sold the western side to Prestongrange Bowling Club. In the mid 1960s the bowling club lost its licence to sell alcohol. Present-day members recall that Reid had taken pictures of members leaving the club after hours.

As a result of this the club moved into the nearby Welfare Institute for around a year. They bought a house for Reid elsewhere in Prestonpans and, around 1974, purchased the whole of the now-vacant Bankfoot House.

The upper floor of the house was derelict by 1984, but the lower floor was used until the last week of 1999 when Prestongrange Bowling Club moved into their present building (behind Bankfoot House). During its ownership by the bowling club the house had served as a meeting place for groups as diverse as the local freemasons and the Salvation Army.

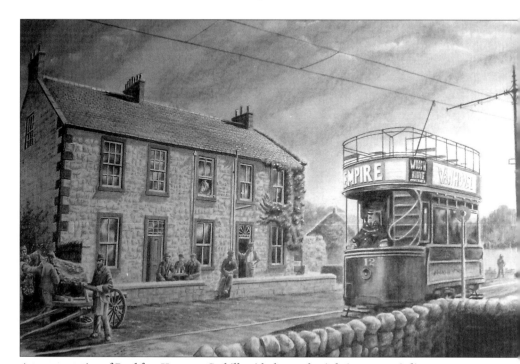

A representation of Bankfoot House at Cuthill, with the emphasis being on poetic licence (© Prestongrange Bowling and Social Club)

CHAPTER 4

HEALTH
AND WELFARE

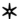

The need for hospital provision has existed, in one form or another, since time immemorial. Methods of treatment have necessarily changed over time, but the underlying reason for their existence – caring for and curing the needy – has remained constant. In the neighbouring Scottish Borders are the remains of the twelfth-century hospital at Soutra, originally run by Augustinian monks. An early example in East Lothian is the fifteenth-century hospital at St Germains.

A leper hospital existed to the west of Haddington as early as the sixteenth century, but it was not until the nineteenth century that hospital provision started to become more widespread, driven as much by a desire to protect the uninfected as to aid the afflicted. In the case of infectious diseases such as smallpox, cholera, leprosy and tuberculosis (TB), the buildings were generally, and necessarily, built in isolation from inhabited areas; this can be seen with the Smallpox Hospital at Haddington, the Fever Hospital at Dunbar and the sanatorium at East Fortune. As cures were found, or diseases became less prevalent, most of these buildings were demolished or used for alternative purposes. Musselburgh's Fever Hospital was somewhat anomalous as it sat within the burgh.

From the nineteenth century a number of organisations, such as the Grassmarket Mission, the British Red Cross and St Dunstan's, began to buy property along the East Lothian coast to send the needy there to rest and recuperate. Many of these houses, including The Poplars in Aberlady and Whatton Lodge at Gullane, still exist, but others, such as Tantallon Hall, have been demolished.

ST LAWRENCE LEPER HOSPITAL,
NEAR HADDINGTON

'Bewast the toun of Haddington' for at St Lawrence (also known as St Laurence) once stood a leper hospital. It was endowed by James V in the early sixteenth century and founded by Richard Guthrie, abbot of St Thomas the Martyr's monastery at Arbroath. Its distance from the county town is explained by the fact that leper colonies had to be sited at least a mile beyond the town walls.

In March 1906 the *Courier* intimated that the hospital had been purchased by local builder Richard Baillie who intended to demolish it and raise two houses. Excavations of the site uncovered a burial ground revealing the skeletons of thousands of lepers. Little is known of the structure of the building, but Gray and Jamieson give some insight, noting that at the time of its demolition:

> The beams of the roof were found to be held together with hand-made nails. Through the west gable wall, four feet thick, ran a wide chimney from a fireplace in the basement. From built-up windows and doors it was evident that the structure had been much altered. A row of stones projected from the south wall.

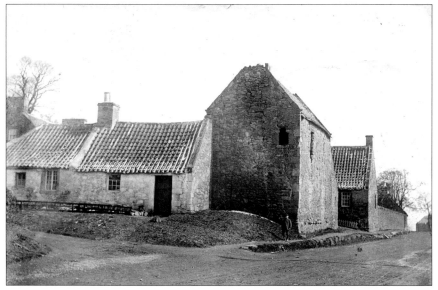

The Leper Hospital at St Lawrence just prior to its demolition early in the twentieth century (© East Lothian Local History Centre)

YORKE LODGE (COTTAGE HOSPITAL), DUNBAR

Yorke Lodge was situated at the east end of Dunbar on Queen's Road, near the East Links. It is believed to have been built in 1884 for John Hutchison Bowe, a potato merchant, and was originally called Tennis Lodge. In September 1891 a severe storm affected the east coast and the result was a high tide at Dunbar which damaged the building's gable end. Part of said gable gave way and a section of the floor in one of the rooms fell into the sea. The area was filled with bags of cement and gravel and this was successful in stopping further breaches.

It was being called Yorke Lodge by 1893, but some records still refer to it as Tennis Lodge in 1901. Bowe died in 1900 and the house came up for public sale the following year – at this time it had three public rooms, six bedrooms, a kitchen, a servants' room and a stable – at an upset price of £1,750. In 1903 it was owned by a George Denholm and it was from this family that it was purchased, in 1926, for £3,000. In May of that year it was formally opened as a Cottage Hospital by the Countess of Haddington, replacing the Battery Hospital. Mr James M. Grahame was appointed as honorary surgeon and Miss Balloch as matron. The monies for the building and equipment came largely from fundraising at a two-day fete in Broxmouth Park.

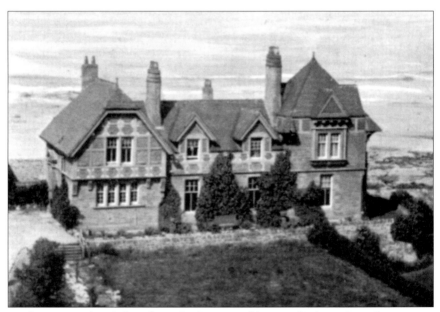

Dunbar's cottage hospital, Yorke Lodge (© East Lothian Local History Centre)

In August 1930 the Princess Royal, who was staying with General Sir Reginald Wingate and his wife, accompanied her hosts on a trip to the hospital. The group was met by local dignitaries and they toured the facility. As she was leaving a nurse presented her with a bouquet of carnations and she reciprocated with a gift of £20 towards hospital funds. In 1937 the hospital consisted of two public wards, two private wards, an operating theatre and staff accommodation. The annual budget, around 1937, was about £1,400 with the monies being raised from voluntary subscriptions, entertainments and an annual sale. In July 1948 the hospital was transferred to the control of the National Health Service and it was at this time that it became known as Dunbar Cottage Hospital. In March 1973 hospital services in Dunbar were moved to Belhaven Hospital and the former Yorke Lodge was closed.

In 1982 it was purchased by the Civil Service Benevolent Fund and they were given planning permission to build a residential home, sheltered housing and staff accommodation around the existing building. They soon came to the conclusion that this was not financially feasible and two years later applied to demolish the house. The council's planning department asked that the decision be held over until a later meeting to allow the Scottish Development Department to decide whether the building should be listed. Some months later the planning department intimated that they would support the demolition if plans were provided. The planning committee concurred and the days of Yorke Lodge were numbered. Permission to demolish the building was finally given in November 1984. In May 1985 the foundation stone of the building that now stands in its place, Lammermuir House, was laid.

SMALLPOX HOSPITAL, HADDINGTON

In 1863 it became compulsory to vaccinate children against smallpox. As a result, by the twentieth century the disease had been virtually eradicated. It did, however, linger – in great part due to the lack of compulsion for adults to be vaccinated, and the lack of isolated treatment facilities. The impetus for an isolated smallpox facility in East Lothian came in 1903 when a serious outbreak of the disease occurred around Haddington. Advice as to the structural requirements of any hospital came from the Local Government Board who proposed well-ventilated wooden buildings, arguing that masonry and bricks harboured germs. Plans for a Combination Smallpox Hospital (Combination as it was to be used by both East and Midlothian) were submitted in 1906 by the

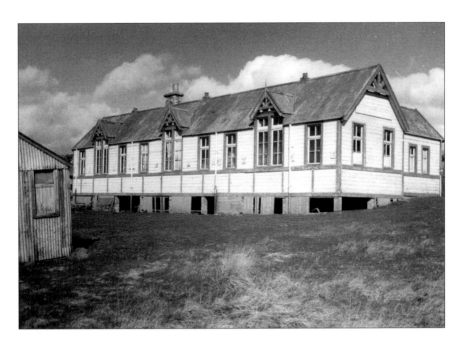

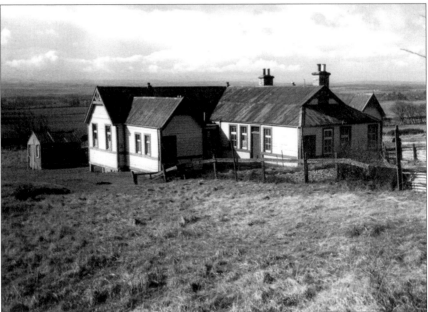

Two view of the Smallpox Hospital near Haddington, looking from the south-east and the north just prior to its demolition in 1977 (© East Lothian Local History Centre)

architect Robert Orr, the lands purchased in December of that year and building work completed in mid 1907 at a total cost of around £1,500.

The new hospital replaced an earlier temporary structure at Garleton, although a report in *The Scotsman* details the death of a smallpox sufferer at the Garleton Hospital as late as 1912.

The buildings were erected on a sloping area and this required that the front section was raised on brick supports. The exterior walls were made up of closely fitted weather boarding behind which was a layer of felt and, in an effort to reduce the fire risk, asbestos cement sheeting. The outer layer of the roof was corrugated iron.

The main building was erected in the shape of a capital T. The top bar of the T comprised three wards, each measuring 25 feet by 16 feet and capable of holding two beds. Each of these wards had a main window with a smaller one on either side. A fireplace was fitted with a boiler which in turn heated water and fed it into hot water pipes. The lower bar of the T included a nurses' room, a kitchen, a scullery and a bathroom.

The interior walls were coated with white Ripolin enamel giving the effect that each wall was a single porcelain sheet. This enamel prevailed through virtually the whole building, and grooves and mouldings were conspicuous by their absence in an effort to afford germs no place to breed. The windows were fitted with red blinds as it was believed red light destroyed the smallpox germ. In addition to this exercise in hygiene an incinerator was located to the west of the building in order that material from the wards could be burned on site. On the east end of the building, perhaps a warning as much as a declaration, was a sign reading 'Smallpox Hospital'.

Smallpox as a disease was, however, in its death throes; East Lothian had its smallpox hospital, but the need for it had all but disappeared. The lack of use led to its being rented, from the time of the First World War, by the County Tuberculosis Committee. Its use a TB sanatorium lasted until April 1925 when a purpose-built unit was erected at East Fortune. Other than being resurrected for a single smallpox case during the Second World War the buildings were redundant. After the war they were declared surplus to the requirements of the newly formed National Health Service and were passed into the control of the county council. Thereafter it was used as a storage unit and to house the occasional council employee. The wooden buildings gradually deteriorated and by the time of a survey in 1977, just prior to its demolition, many were in a poor condition.

HOPETOUN UNIT,
HADDINGTON

In the days before those with physical and learning difficulties were integrated into the community, they resided in units that in many ways resembled hospitals. The residents were cared for by nurses and lived in dormitory-style rooms.

In early August 1983 a Lothian Health Board-funded, £2 million, 72-bed unit, built to house those with learning difficulties, was opened in the grounds of Herdmanflat Hospital in Haddington. Named the Hopetoun Unit it consisted of three wards (named Tyne, Esk and Forth), each housing 24 beds (later reduced to 21 beds per ward). Residents, many of whom were long-term, had access to a gymnasium which had space for music therapy, occupational therapy, speech therapy and physiotherapy. Although it would be considered anathema in this age where care in the community is considered the way forward, it had, according to the *Edinburgh Evening News*, a 'homely atmosphere'.

From August 1992 the unit was taken over by the East Lothian Care and Accommodation Project (ELCAP) whose task it was to transfer residents into

ELCAP is a charitable organisation. In order to raise funds for the ELCAP Trust it would frequently hold fairs such as this one in the mid 1990s (© ELCAP)

their own private accommodation in the community. Concerted efforts saw this being achieved by January 1998 with the result that the unit was closed. Linda Headland, director of the company, proclaimed that she took great pride from 'closing places that people shouldn't have been living in'. The following years saw attempts to utilise the unit but it was never again used and lay empty until it was finally demolished in the early twenty-first century.

BARO GRAVEYARD, GARVALD

The vast majority of East Lothian's graveyards are in a fair-to-excellent condition. This can be attributed in great part to an unsung army of volunteers who have, over the years, tended carefully to their local burial grounds. They, along with the various incarnations of East Lothian's council, have ensured that the grass is cut, weeds pulled and lichen removed. These volunteers, as part of an ongoing project, are transcribing the text engraved on the stones and publishing it to aid family historians. Despite these efforts it has not always been possible to save these important historic records. In some cases a

The remnants of gravestones at the Bara Graveyard (© Islay Donaldson)

graveyard has not had the aid of any local volunteers – in conjunction with the rigours of time and the elements, this has led to severe deterioration. Baro (also known as Bara) Church, lying within the farm of Linplum, was never rebuilt after its roof collapsed. The ploughing of part of the lands around the church and planting of the area with trees and shrubs further led to the material decline of the graveyard. By the nineteenth century a few gravestones still existed and were readable, but today it is merely a conglomeration of toppled, overgrown stones.

CASTLE GORDON, MUSSELBURGH

Castle Gordon, or Gordon Castle as it was known until the late nineteenth century, was situated on Market Street (later 6 Campie Road). It is unclear when the building was erected but it is certainly visible on Hay's map of 1824. In 1855 it was owned by George Campbell and by 1880 it had become a 'private lunatic asylum' under the control of Miss Mackenzie. An advertisement from 1913 noted that it was 'for the care and treatment of ladies suffering from mental and nervous disorders'. In the late 1930s the house was purchased by the Miller family. The building was demolished in the early 1950s.

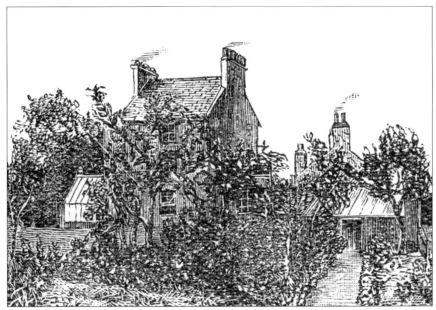

Castle Gordon in Musselburgh was a home that looked after women with 'mental and nervous disorders' (© East Lothian Local History Centre)

INDUSTRY, AGRICULTURE AND TRADE

INDUSTRY

Written evidence of East Lothian's industrial past does not emerge until the twelfth century. From this time onwards we can trace a growth through the Industrial Revolution and into the twentieth century. While larger industries, such as the New Mills Cloth Manufactory, had existed prior to the Industrial Revolution many people worked in small-scale industries. The manufacturing sector was controlled to a great extent by the trade incorporations – bodies of skilled tradesmen who banded together to protect their trading rights through the creation of a local monopoly. This chapter will focus, to a great extent, on those industries which emerged around or after the time of the Industrial Revolution. The range of industries found across the county in the immediate post-Industrial Revolution period was diverse, and primarily focused on larger towns such as Musselburgh, Prestonpans, Haddington and Dunbar. For example, in 1853 Musselburgh housed a dye works as well as sail cloth, hair cloth, and oil manufactories. In the same year, a map of Haddington shows a tannery, brewery, distillery, flesh market, and corn and flour mill.

Although coal mining did not play as large a part in the history of East Lothian as it did in neighbouring Midlothian it still had a significant effect, both on the people in the west of the county and on the landscape. As we move east into East Lothian from Midlothian an invisible line running south-east from Prestonpans to Pencaitland and then south-west to Peaston marks the end, for all intents and purposes, of the coal seam. As a result a number of mines, both small and large, could, until recently, be found throughout the western end of the county. Extraction of 'black stanes' by the monks of Newbattle in the twelfth century is generally cited as the earliest evidence of coal mining in the area. These mine workings would have been simple affairs

such as 'in-gaun-ee' workings or bell pits. By the late nineteenth and early twentieth centuries the advance of technology, especially the introduction of steam power, alongside increased urbanisation, meant that it was possible to extract coal on an industrial level and as a result larger mines such as those at Tranet (Fleets) and Prestonpans (Prestongrange and Prestonlinks) were sunk.

In 1923 there were six coal companies at work in East Lothian. The largest of these, by some considerable distance, was the Edinburgh Collieries Co. Ltd with six collieries and a total of 3,335 employees working close to 20,000 acres of coal – both inland and underneath the Forth. The largest single colliery was Prestongrange, run from 1895 by the Summerlee Iron Co. Ltd with 988 employees; the smallest was run by A. White & Co. Ltd (Tyneside No.2) with 78 employees. During the Second World War, however, it became clear that the privately run coal industry was burdened by a wealth of problems, including low productivity, poor working conditions, poor living conditions and poor relations between employers and employees. After the war the government took stock and passed the Coal Industry Nationalisation Act. The private owners were bought out and the mining industry came under the control of the National Coal Board.

By the 1980s many on the political right felt that the trade unions were too strong and the constant friction with government was having a detrimental effect on the country as a whole. Thus, in 1984, the Conservative government attempted to reduce their power. This led to a protracted strike which sounded the death knell of the industry. Any negative impact on East Lothian was limited as the last of the major mines in the county was closed in the 1960s. As with the history of mining throughout Scotland, what was once a proud East Lothian industry that impacted in some way on most people living at the western end of East Lothian has now been all but eradicated. The only substantial remnants are to be found at the Prestongrange Colliery at the western end of Prestonpans, which is now run as an industrial heritage museum.

Other industries prevailed from an early date. One of the largest and best known of these was the production of pottery. Arnold Fleming, writing in 1923, noted that 'in the opinion of many potters of a past generation Prestonpans was considered the birthplace of fine pottery making in Scotland'. Many years later, in 1989, Patrick McVeigh concurred, noting that Prestonpans had 'witnessed the birth of factory-based potting'. William Forrest's 1799 map shows three potteries at, from west to east, Morrison's Haven, Bankfoot and the Auld Kirk. Over the years a number of others had emerged and disappeared, including Newhalls, Cuttle, Rombach and Cubie. By 1854 only two potteries existed, both

in the west of the town – Rennie's and Mitchell & Belfield. By 1892 only Belfield was left and this was to disappear around 1939.

NEW MILLS CLOTH MANUFACTORY, HADDINGTON

Around 100 years before the Industrial Revolution irrevocably changed Scotland's landscape beyond recognition, there emerged in Haddington a cloth manufactory of great size and scope. The genesis of the works came in 1681 after a visit to Scotland by the Duke of York (later King James II). The lack of commodities created that were worthy of export, he argued, meant that Scotland lacked the means to import goods from England. Thus a number of promoters, headed by Robert Blackwood and Colonel James Stanfield, laid plans to create a works in Scotland and the New Mills Company was founded. Its geographic situation was likely in great part due to Stanfield, who had lands at Newmills (now the lands known as Amisfield) on the eastern side of Haddington. Stanfield leased the company his walk mills (where cloth was worked) and office houses. Little is known of the buildings other than they must have been extensive as by 1683 there were 27 looms. Despite protestations from England that such a venture could not compete financially or qualitatively the company was soon looking to expand and Stanfield was spoken to regarding attaining ground upon which to build a warehouse. It is unclear whether additional buildings were actually erected. Stanfield was murdered in 1687 and the estate and buildings were sold to the company. The effects of the company – land, buildings and plant – were sold in February 1713 to Colonel Francis Charteris who subsequently changed the name of the lands to Amisfield. It is likely the buildings were torn down soon after.

BRUNTON'S WIRE WORKS, MUSSELBURGH

In the late 1870s a number of buildings, which were to become Brunton's Wire Works, were erected at Mall Avenue, on the south of the River Esk next to the train station. In 1875, when the land was feued to Robert Boyle Watson, no buildings were in place. The following year, when the land was passed to the glass manufacturers Watson and Holmes, it was noted as housing 'buildings thereon'. Part of the land was owned by a company called Ward & Fraser, and

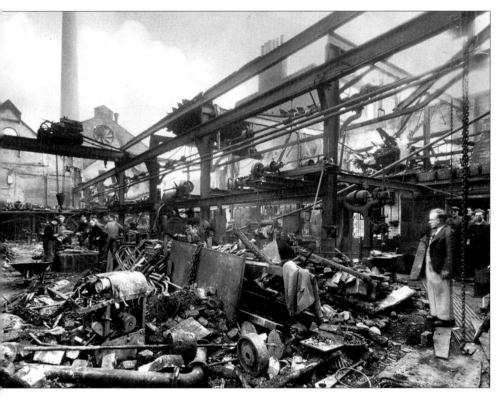

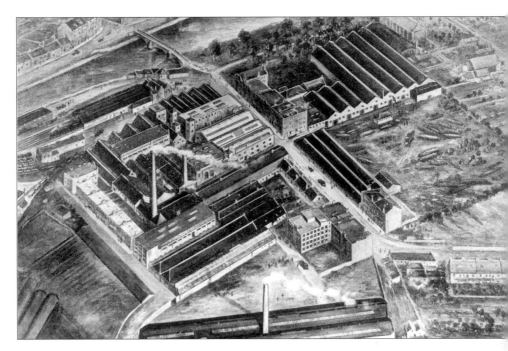

Four images showing Brunton's Wire Mill from around 1926–90. The aerial view above shows the extent of the works around 1926 – three parts of the works are visible. The long buildings at the bottom are the Ashkirk Works and Laboratory. The section at the left (with the two chimneys) was the Station Road Works, whilst at the top right of the aerial view is the Mall Park Works. The image opposite, bottom, is of the Station Road Works around 1926. The image opposite, top, shows the works after the extensive fire of the 1950s. This resulted in some buildings being replaced and the image above, bottom, shows the new buildings just a few years prior to their demolition
(© East Lothian Local History Centre)

when this was taken over by the Musselburgh Wiremills Co. Ltd in 1878 it is recorded as having 'wiremills thereon'. At this time the site comprised three rectangular buildings. The Musselburgh Wiremills Company went into liquidation and was wound up in 1884, but continued as a family partnership until John Brunton, whose father had been involved in the company, bought over the partners in the early 1920s and in October 1930 founded the private company Bruntons Incorporated.

The growth of the company was slow but it had begun to expand by the beginning of the twentieth century when new buildings were purchased. Sea Mill, the building that would eventually become the aerodynamics department, was purchased in 1901. Ashkirk was erected, the final three storeys being added in 1904.

In 1916, at the height of the First World War, the company experienced a major fire. It broke out in the engineering department. The heat was so intense that it twisted the floor-bearing iron girders, and it took only 45 minutes for the roof also to succumb. Fortunately there was little wind, allowing the fire crews present to limit the damage to between £3,000 and £4,000. Its cause aroused much debate. One theory was that a spark from an arc lamp landed on an oily wooden floor. Another surmised that sabotage was involved, this being given some credence when a member of the workforce – a 'spy' – was arrested when leaving the end of a shift. The army helped in the clearing up operation which took around a year. One positive to come from the blaze was the construction of Brunton's Research Laboratory, above the door of which was the motto '*Rerum Cognoscere Causus* (Understand the Cause of Things)'. A second fire, in 1950, resulted in extensive damage with the Musselburgh Fire Chief noting that 'it was the biggest fire in my time'. The fire spread from the maintenance department and ended up in the administration block, resulting in the company's records being destroyed. At this time the mill was extensive, employing around 2,500 workers.

In 1988 the company was taken over by Carclo Engineering Group for £5.5 million, although there was a feeling that rather than being an attempt to save the company it had fallen victim to asset-stripping. On 28 February 1992 the factory closed its gates for the last time. Today the land on the River Esk where the main factory had stood for so many years is derelict and awaiting possible development. The achievements of the company are too many to list. However, suffice to say that the first direct Atlantic aeroplane flight was achieved by a plane fitted with Brunton's wire, whilst many of the wires used to build the Forth Road Bridge were produced by the firm.

CUSTOMS HOUSE,
DUNBAR

Dunbar's Customs House was built in 1710 at the foot of Victoria Street with the aim of discouraging smugglers by encouraging payment of duties. It was a relatively plain affair with eight windows on its frontage and stairs leading to the door, which was situated on the first floor. Its jurisdiction covered the area from Berwickshire to Scoughall, although by the early nineteenth century this had extended to Gullane Point. Around 1821, when the Excise Service moved to Leith, the building was occupied by the coastguard, their jurisdiction extending from Whitekirk to Thorntonloch. By the 1890s the building was owned by Alexander Brodie, sub-divided, and occupied mainly by fishermen. The condition of the building was poor and families living there began to be re-housed from the 1920s. It was demolished in the mid 1950s; Frank Tindall described its demise as a 'great loss' and added that it was 'a finely wrought classical building in its last stages of decay'.

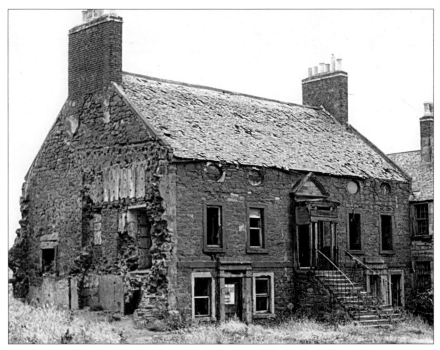

The Customs House at Dunbar just prior to its demolition in the mid 1950s
(© East Lothian Local History Centre)

BELTONFORD PAPER MILL AND
THE MALTINGS, WEST BARNS

In 1862 Alexander Annandale, a paper manufacturer at Lasswade in Mid-lothian, began to purchase land and buildings at West Barns. Conjecture had been rife as to how he would utilise his investment, with suggestions being a distillery, a pottery or a gutta percha manufactory. The *Courier*'s belief that it would be a paper mill was proven correct. Annandale purchased red and white bricks from the Seafield Brick and Tile Works at Belhaven (p. 107) and began to erect a new mill. Its dominant features were two chimneys, both over 100 feet in height. When one was completed in 1864, Union flags were flown from it and local youths (of both sexes) were given the opportunity to be hoisted to the top of each using a block and tackle. The following year the plant was installed. Despite early estimates that the mill could produce 50 tons of paper weekly, by 1866 it was producing only 20 tons. In 1886 the mills were made into a public company. This created a flow of cash that saw an upgrade to the mill increasing the output to 70 tons per week. Further new machinery and buildings meant that by 1892 production had risen once again, to 80 tons per week.

The expenditure was, however, ultimately to prove pointless, as at 3 a.m. on 2 April of the same year fire tore through the building. The speed of its spread was immense, taking over half of the main building in 15 minutes. According to the *Courier* 'the streets of Dunbar and the fields for miles around were strewn with the ash'. Wagons of coal and paper, some several hundred

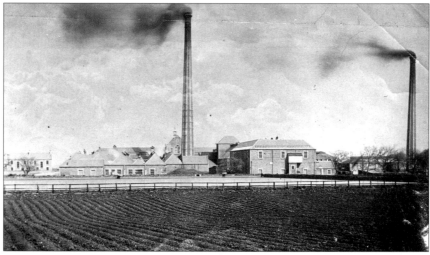

Beltonford Paper Mill with its impressive chimneys
(© East Lothian Local History Centre)

yards away from the main fire, caught alight and were 'burnt to a cinder'. The fire was so intense that the nearby town of West Barns was under threat, but was saved by the hard work of the local fire brigade and the mill's night shift, alongside the good fortune that there was no westerly wind. About half of the buildings were rescued and initial reactions as to the future of the mill were positive, expecting work to recommence in 9–12 months. Such optimism was to prove misplaced; the ill health of Alexander Annandale Jnr meant that the mill never re-opened. In 1894 the remaining buildings were sold to Alexander Hunter, a brewer at Belhaven, and the buildings became a maltings. The Annandale family retained some of the buildings, such as a flour mill, bakehouse and stable, but these were demolished the following year. Around 1910 Robert and William MacAdam's company British Malt Products (BMP) took over the running of the concern.

In the mid 1940s there was a major fire at the works. Fire crews from Dunbar, East Linton and Haddington attended what turned out to be a substantial blaze that was estimated to have cost six figures' worth of damage. Despite this the business survived until 1970 when BMP eventually sold out to Associated British Maltsters. They in turn sold the works to East Lothian Council in 1974 which demolished the buildings after a fire that caused up to £100,000 of damage. Until 1992 it lay 'derelict and overgrown'. At this time any remaining traces, including 8,000 tonnes of rubble, were removed as part of a concerted effort to bring the land back into industrial use through the Dunbar Initiative.

MELLIS'S SOAP WORKS, PRESTONPANS

Shortly after the Battle of Prestonpans a new industry was undertaken in Prestonpans – the creation of soap. It is unclear who began the concern, which was based on the High Street and extended south to Kirk Street, but for many of its formative years it was run by William and Thomas Paterson, and produced around 90,000 lbs of hard soap annually. The Paterson's co-partnership was dissolved in April 1834 and Thomas continued on in a sole capacity. James Mellis, a relative of the Patersons, witnessed the dissolution. He owned the concern by 1852 and benefited hugely the following year when excise duty on soap was removed.

Nothing is known of the interior of the works, but the few pictures of the exterior show distinctive brickwork.

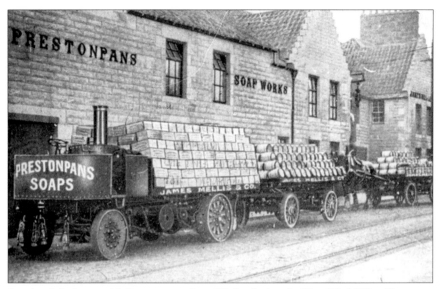

Lorries sit laden outside Prestonpans Soap Works during the First World War. The soap they are carrying is headed for the front (© East Lothian Local History Centre)

In 1913 a fire at the works gutted the boiler house and caused £1,000 of damage. The two wars were a productive time for the soap works as glycerine, a by-product of soap, was needed to make explosives. Indeed, at the turn of the century the firm had created a glycerine recovery plant, probably in response to the need for explosives due to the Boer War. It was the emergence of detergents that led to the end of the industry in Prestonpans. The business was closed in 1955 due to 'extreme difficult and unprofitable trading conditions'. It was probably demolished soon after.

SALT WORKS, PRESTONPANS

Salt manufacturing at Prestonpans was introduced at roughly the same time as coal mining, with salt being extracted from the waters of the Forth around Prestonpans, then called Aldhammer, as early as 1198, when the monks of Newbattle were granted lands in the area. The industry flourished in the area and indeed the etymology of the town's name owes some debt to the existence of salt pans in the area. Ten salt works existed by the fourteenth century and there were still six in 1796. But the industry was not restricted to Prestonpans. There was a salt pan at Torness in 1682 and a pan opened at Woodbush near

Dunbar in 1889. The industry grew until the 1820s when the repeal of salt duties was to prove the first nail in the coffin for the industry in the town. The opening of mines in England and Europe meant that by 1900 only one works, with two salt pans, remained.

The salt works that is most well known was based at 164 High Street, behind the site that is now Aldhammer House. It is unclear when this building was erected. It was run for many years in the late nineteenth and twentieth centuries by the Alexander family, and later the Meek family trading as the Scottish Salt Company. It continued to produce salt until 1959, and after this was used to pack salt.

The works was disused by 1974, although the following year Alex Hamilton attempted to get the council to revive the industry on a small scale, supplemented by analogous industries and an industrial museum.

In December 1977 there was uproar amongst councillors and community council members when the Scottish Salt Company began to demolish the building, including, it was believed, the last salt pan in Scotland. It soon turned out, however, that the company was merely following guidelines laid down by the East Lothian Planning Department and that the salt pan had already been demolished around 15 years previously. The final demolition took place in 1978, although some of the structure remained. When the site eventually came up for development in 1986 the council was at pains to retain as much character as possible. Some of the remaining building, such as a turreted salt girnel (store), was saved and it was proposed to incorporate this into any new design. On the site were eventually built Aldhammer House (a council office), 17 houses and a shop.

MORRISON'S HAVEN POTTERY AND BANKFOOT POTTERY, PRESTONPANS

A pottery had existed at Morrison's Haven since around 1700. By 1730 it consisted of two beehive-shaped kilns. Around 1750 it was leased by Anthony Hilcote. In 1772 the lease was taken over by Rowland Bagnall (who died the following year) and George Gordon under whose guidance it made its name as a producer of quality domestic white earthenware, using clay brought in from the Upper Birslie Plantation. Gordon continued to expand, taking over the nearby Bankfoot Pottery in 1795 and adding a brick and tile works to the pottery at Morrison's Haven. After George Gordon's death in 1809 things started to go awry; George's son Robert took over and his role as a founder of

the East Lothian Bank did not serve him well, as when that institution collapsed in 1822 he suffered serious financial loss. It seems that his pottery at Morrison's Haven never recovered. Additional problems piled up when Sir James Grant-Suttie, the owner of Prestongrange, accused Robert Gordon of neglecting buildings, claiming land that was not his, amongst other things, although evidence has emerged that Grant-Suttie was creating issues in order to attack Gordon and reclaim and consolidate his lands. This ultimately led to Gordon's removal from Morrison's Haven around 1836 or 1837. It is unclear what happened to the buildings but it is likely that they were demolished as they were, as has been noted, in a poor condition. Further to this the Grant-Suttie family had no interest in the pottery industry.

KIRK STREET POTTERY AND
WATSON'S POTTERY, PRESTONPANS

In 1750 William Cadell erected a building to house a pottery works. It was situated in Kirk Street 'on the shores of the Firth . . . a little to the west of the church' and known as Kirk Street Pottery. Soon after it passed to William's son John and attained a reasonable size; with three kilns it was larger than Gordon's Pottery. Its output was primarily white earthenware, with a speciality of figure-making.

By the late eighteenth century the business was struggling to keep pace with Cadell's other interests. In 1795 it was taken over by Thomson & Co. and was run by this company for around 20 years. Soon after it was taken over by a potter called Hamilton Watson and assumed the name Watson's Pottery, although it was also known as the Pott Works. Watson too lasted around 20 years, until 1838, when he was sequestrated. It is unclear when the building was demolished.

BELFIELD'S POTTERY,
PRESTONPANS

Belfield's Pottery was based at Cuthill, the site being called Seacliff. The building was used as an industrial works producing salt and magnesium prior to becoming a pottery, and a section of it was also used as a house at the same time as it was functioning as a pottery. McNeill has argued that some of the property dates from around 1700. He describes it as:

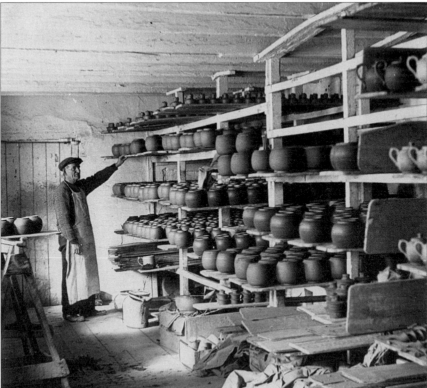

One view showing the yard at Belfield's Pottery at Prestonpans, the other taken inside the drying shed showing teapots lining the walls (© East Lothian Local History Centre)

a quaint and interesting factory, delightfully situated on the rocky shores of the Forth. In winter a high and stormy tide sometimes penetrates into the kilnyard.

In the 1830s the potteries at Morrison's Haven, Bankfoot and Kirk Street were in financial difficulty, leaving a gap in the market. Charles Belfield, son of a Prestonpans potter and formerly a worker at Thomson's and then Gordon's, opened it as a pottery around 1838, purchasing bankrupt stock from Watson's the following year. Charles and James Belfield, in association with a potter called Andrew Mitchell, bought the property outright in 1847. The following years saw the works run by a succession of Belfields and Mitchells, with the Belfields eventually buying Mitchell's share of the business from his widow.

The works became famed for its sanitary ware, such as toilets and sinks, whose quality was regarded as excellent. In later years they began to produce teapots and drainpipes.

The exact date of closure is unclear but it is likely to have been 1939 as the Valuation Roll for 1940 lists the works as 'silent'. After its closure it housed a tyre re-treading works and a garage. It was demolished in 1989 and the replacement houses were named The Pottery. On its demolition Patrick McVeigh noted that 'this was the most important remaining record of the pottery industry in Scotland'.

NEWBIGGING POTTERY, MUSSELBURGH

William Reid trained as a potter at West Pans and set up his own pottery at Newbigging in Musselburgh around 1801, having purchased the site four years previously. Six years later he extended the works, purchasing two adjoining houses, a garden, a park, a courtyard and offices. By 1824 it was a substantial concern with long rectangular buildings running north to south. The number of kilns is debated – Hay's 1824 town plan and the 1853 OS map both show three kilns, but an image, dated 1839, depicts a fourth, smaller kiln. Reid ran the works until his death in 1835 at which time it was employing up to 80 men. It was taken over by his wife and sons and soon ran into financial difficulties. Unable to sell up, his wife, Marion, ran it until 1866. A number of people ran the pottery on her behalf, including Mr Howden, William Logan and Andrew and Joseph Winkle. In 1860 the works was rented by William Miller who moved a starch and pithina manufactory into the premises. In 1866, after 31

years of attempting to sell, Marion Reid finally succeeded. The new owner is listed in the Valuation Rolls as the Third Provident Investment Company, although they were simply providing a mortgage for the actual purchaser James Turner. Turner had little experience of the industry and within two years was declared bankrupt. The following 60 years saw a small number of owners – the earliest being William and Alexander Gray trading as Midlothian Stone Ware Potteries, the last being Marjory Richardson. By 1930 the works was empty and in 1932 was sold to R. Banks & Son, a building company, for £420. It is unclear exactly when the site was demolished but it is still evident on a map dated 1944.

BRICK WORKS,
WALLYFORD

Wallyford has housed two brick works. The first was opened in the mid nineteenth century. As with the first brickworks (and most others in Scotland) the second was built close to a colliery. It was opened in 1924 by Edinburgh Collieries Company Ltd. Red clay, also known as blaes, was brought in from various coal mines and deposited at the brick works by rail. This was crushed into small pieces (about 3 inches in size) and then ground into dust, which was mixed with water. This mixture was then pressed into brick shapes and slowly fired to a temperature of 1,000 degrees. From start to finish the process took around 11 days. The works was capable of firing 35,000–40,000 bricks at one time. The nationalisation of the coal mining industry, in 1947, saw the works pass to the National Coal Board. In 1969 the leasehold was acquired by the Scottish Brick Corporation and the works closed three years later, by which time it was employing around 30 people. It was demolished after 1972.

SEAFIELD BRICK AND TILE WORKS,
BELHAVEN, DUNBAR

In the nineteenth century there was a gradual move from stone-built buildings to brick-built ones. As a result we see brick works springing up throughout Scotland. East Lothian was no different and a number appeared.

Early in the nineteenth century David France reclaimed a large area of Belhaven Sands back from the sea in an area called Seafield, halfway between West Barns and Belhaven. To hold back the waters of the Forth he erected an

A photograph taken from Bielside House looking towards what is believed to be the Seafield Brick and Tile Works at West Barns (© East Lothian Local History Centre)

'extensive sea dyke wall', a feat that led James Miller to note that France had 'beat Canute'. Before this the waters of the Forth would occasionally reach the road. Many years later a mason called Thomas Porteous recalled building the wall with stones from the Winterfield and Belhaven foreshore. It was on this reclaimed land that France erected Seafield Brick and Tile Works. The works was slightly unusual in that most brick works were erected near to, or even connected to, coal mines – Seafield fulfilled neither of these criteria. In 1850 it was taken over by William Brodie – 'a man of great intelligence, scientific attainments, indomitable perseverance and public spirit'. He swiftly turned it into one of the largest of its kind in Scotland – large enough to supply the bricks for the Tay Bridge in 1877. In 1859 Miller noted that 'it is now considered, on account of the superior class of machinery used, and the immense quantity of drainage pipes made, one of the most extensive and best manufactories of the kind in Scotland'. At this time Brodie rebuilt the works and erected a new workshop for engineering purposes.

In 1877 Brodie died and the works passed to his daughter. Brodie's death seems to have been the catalyst for the demise of the works. The following year the building and machinery were sold. Around 1890 the works was closed. In August 1892 the premises was being advertised for let. In 1894 John Martine noted that it was 'now silent'. Some time after this the sea smashed the retaining wall built during France's reclamation exercise and took back what was rightly hers. Remnants of the wall were still in place in 1917 but it was gradually being eroded.

SEA-FISH HATCHERY,
DUNBAR

In the late ninenteenth century, as a result of over-fishing, there was a growing scarcity of some types of fish. In an effort to combat the decline, countries such as Norway, Canada and the United States began to erect sea-fish hatcheries – undertakings that would facilitate the breeding of fish to enable the partial replenishment of stocks.

In 1894 a hatchery was opened at Dunbar, sitting on the rocks beside Dunbar Castle, but also utilising it – the door of the tidal pond was built into the castle wall and led to a natural cavern. Norwegian fisheries expert Harald Christian Dannevig was employed to oversee the operation and it was soon a great success; two years after it opened it had hatched 80 million plaice, although it also dealt with turbot, sole and lemon sole.

The hatchery comprised a number of buildings and structures built of a mix of concrete, wood and iron – a hatching house, spawning pond, chamber, pump and boiler house and tidal pond. The process began at the spawning pond. Built from plans drawn up by Strain, Robertson & Thomson, it had a

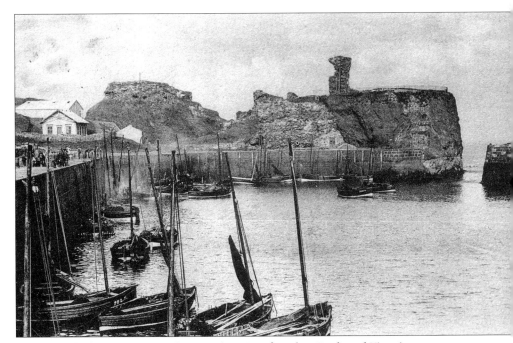

At the far left of this view, sitting between the ruins of Dunbar Castle and Victoria Harbour, are some of the buildings housing the sea-fish hatchery (© East Lothian Local History Centre)

capacity of 62,000 gallons. It measured over 40 feet in length, with its breadth widening from 18 feet to over 26 feet. The spawn was transferred, via the spawn collecting and filtering chamber, to the hatching house. This was a substantial wooden building measuring 35 feet by 24 feet, with a height of 20 feet. It sat three feet off its foundation to allow space for pipe work and the circulation of air.

When the venture was initially undertaken it had been hoped that the numerous sea-creeks in the area would be utilised as an enclosed tidal pond, building upon a temporary affair which was housed in the dungeon of the castle. It was around 40 feet long and capable of holding 47,000 gallons of water, but extension of the system to include all the desired sea-creeks would raise this to half a million gallons.

The magistrates and council of Dunbar initially granted the endeavour a creek at the opening to the harbour to facilitate this, but it was found that this could be a danger to fishing boats. Consent for the scheme was withdrawn and it was decided that an alternative site should be used. As a result the hatchery was dismantled during the summer of 1898 and moved to the Bay of Nigg.

CARBERRY COLLIERY,
INVERESK

On the southern side of Salters Road (the A6094) between Dalkeith and Musselburgh once lay Carberry Colliery. Sinking of the first shaft began in 1866 and the first two shafts were 229 metres and 241 metres deep. In 1900 the owners Deans & Moore were taken over by the Edinburgh Collieries Company Ltd. Over the next two years a third shaft was sunk in and this resulted in No.1 shaft being closed. Further shafts were sunk in 1912. The largest workforce was 966 in 1914, producing 250,000 tons of coal. By the 1950s it had levelled out to between 500 and 600 workers and remained so almost until its closure in April 1960.

Opposite. The headframe at Carberry Colliery near Musselburgh
(© East Lothian Local History Centre)

FLEETS COLLIERY, TRANENT

Prior to the nationalisation of the coal industry, Fleets Colliery was owned by the Edinburgh Collieries Company. Sinking of the pit had taken place in 1866 and a further shaft was sunk in the 1880s. A Cornish beam engine, built at Perran in 1847, was transferred from Dolphinston in 1885.

In 1937, with monies provided by the Central Miners' Welfare Committee using resources from the Miners' Welfare Fund, colliery baths were built.

The pit was one of the largest in East Lothian. By 1948 its 816 employees were producing 766 tons of coal per day. At the time of the closing of the colliery in January 1959 a protest meeting was held at the Town Hall in Tranent. Anger was expressed at the impending closure whilst others argued that although the pit had been uneconomical a new stretch of coal had been discovered. It was further noted that a two-year stay of execution would allow the workers to move from Fleets to the new super-pit at Monktonhall. All arguments fell on deaf ears and the pit closed.

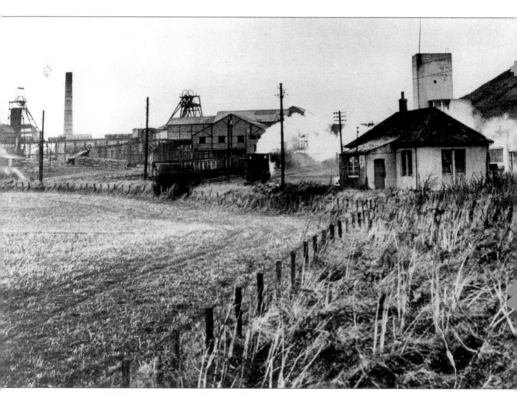

Fleets Colliery, Tranent (© East Lothian Local History Centre)

WOODHALL COLLIERY,
PENCAITLAND

Conditions were no better in Pencaitland than in other coal mines – Andrew Grey, a hewer, giving evidence to the Children's Employment Commission of 1842, noted, 'colliers in this part of the country are subject to many oppressions: first the black spittle, which attacks the men as soon as they get the length of 30 years; next rheumatic pains, from working in low seams, where water oozes out, or rises and severe ruptures occasioned by lifting coal. Many are ruptured on both sides: I am, and suffer severely, and a vast number of men here are also.'

Sinking of the Woodhall Colliery at Pencaitland, owned by James Reid's Woodhall Coal Company Ltd, began in 1903. The official opening took place on 21 January the following year. The first turf was cut by Mr Burt, who was lessee of the minerals at the colliery. At the opening ceremony he noted that the mine had the potential for seven seams, although only one was to be opened in the first years. When asked what he would call the pit, Burt noted that he would name it after his wife; her maiden name was Ramsay, so he called it 'The Ramsay Pit'.

In 1906 the owners expressed concern at the amount of dross being extracted; in one month it was 52 per cent. Photographs taken in the 1930s reveal a ramshackle array of wooden and corrugated iron buildings and the colliery was closed around 1942.

HOUSE O' MUIR COLLIERY,
HUMBIE

Whilst many of the collieries detailed so far are of a reasonable size, employing sizeable workforces, there were a number of small collieries employing little more than a handful of miners. House o' Muir, owned by the Marquis of Linlithgow and tenanted by Andrew White, was one of these. Lying south of Ormiston, its workers, as low as 19 in number in 1843, were cut off from the outside world – in 1912 they continued to work, unaware of the vast strike action unfolding around them that saw every coal mine in the Lothians closed. Likewise they were unaware of, and unaffected by, the Leith Dockers' Strike in 1913. In the same year some old workings were discovered at House o' Muir. These included a spiral staircase which would once have provided access to the depths from above ground. On being exposed to the air it collapsed. For the following 14 years the coal was worked by employees until 1928 when it was listed in the Valuation Rolls as 'unworked'.

COFFIN HOUSE,
HADDINGTON

Around 1950 a young lad from Edinburgh, recently invalided out of the Royal Navy with stomach ulcers, won a scholarship on a British Legion scheme, the aim of which was to teach a trade to disabled ex-servicemen. After qualifying, around 1950, he was taken on by Stark's, a Haddington firm of joiners and undertakers based at St Martin's Gate in the town's Nungate, as a trainee French polisher. And so Sean Connery (or Tam as he was known then) made his way to East Lothian's county town. Stories abound about Connery's short time with the firm, most notably of his sleeping inside a coffin.

In the 1950s the house was sold to Haddington Town Council who, using £800 from the Common Good Fund, installed sanitation and generally upgraded the building. In 1956 Ranco Motors (originally known as Haddington Light Industries) moved into the premises and utilised it as a training unit. They moved to new premises soon after and the building at St Martin's Gate was demolished.

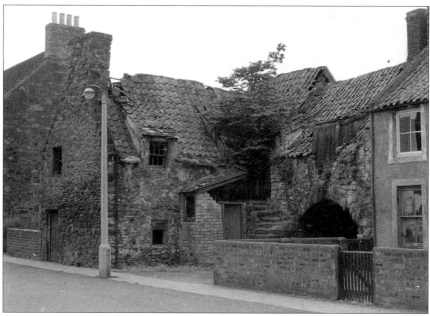

Coffin House in the Nungate where Sean Connery served his apprenticeship and, according to local legend, occasionally slept in a coffin when he missed his last bus home to Edinburgh (© East Lothian Local History Centre)

AGRICULTURE

To drive through East Lothian is to slice through some of the finest farmland in Scotland. The monks of Newbattle realised this as early as the twelfth century and, along with coal and salt, began to exploit the natural resources around the area now known as Prestonpans by grazing sheep and oxen.

East Lothian's place at the forefront of agriculture was aided to a great degree by local inventors and improvers. By the mid eighteenth century men such as Andrew Meikle from East Linton introduced new implements and inventions, such as the large scythe, the reaping machine and Small's Plough, that fully utilised the richness of the land. Meikle himself invented the threshing machine. Improvers such as Lord Belhaven, Cockburn of Ormiston and Fletcher of Saltoun built on recent changes such as the introduction of enclosures, espousing agricultural improvement and overseeing its intro- duction. New crops such as turnips and potatoes were being planted and crop rotation, including fallowing, implemented.

Farmhouses are evident throughout the East Lothian countryside. Some have been lost, due in great part to the modernisation of the farming industry after the Second World War. Stone-built buildings were replaced by steel, concrete and timber sheds. Many of those that still survive can thank the efforts of the County Planning Officer, Frank Tindall, who set out to find alternate uses for them.

EAST MAINS FARM CHIMNEY
AND CATTLE COURT, SALTOUN

By the 1960s agriculture had changed to such an extent that Frank Tindall, concerned at the changing use of agricultural buildings, was prompted to undertake a survey. Some farms had been consolidated in an effort to facilitate the intensive production of barley, wheat, potatoes, vegetables and the breeding of cattle. The worry was that many farm buildings were no longer required and as such would succumb to demolition. In June 1968 the enigmatic, decorative brick chimney and cattle courts at East Mains Farm, much to the chagrin of Tindall, were demolished. Some of the outbuildings did survive. In his autobiography he noted the bittersweet victory of it being 'the last to suffer this fate in my time'. Spurred on by the demolition, Tindall began his survey of the agricultural architecture of East Lothian. Robert Dunnet, a student from the department of architecture at the University of Edinburgh, was charged

Two views of East Mains Farm at Saltoun. One shows the decorative chimney, the other the cattle courts shortly before their demolition in 1968 (© East Lothian Local History Centre)

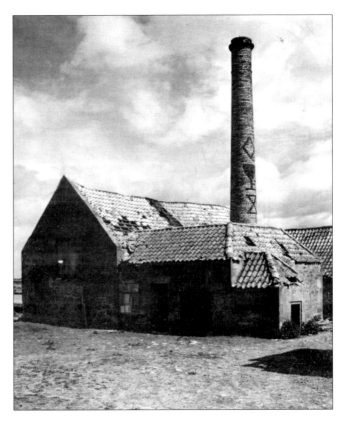

with surveying 130 farms. The final report, called 'East Lothian Farm Buildings', was published in August of the same year. It guided East Lothian's planning committee in deciding how to approach the dilemma of what to do with these rural structures. In some cases the decision was a positive one, such as the restoration of a horse mill at Newhouse, Dunbar. It also noted that some farmhouses were utilised as storage units – this saving at least two, at Doon Farm and Hallhill, from demolition.

MILLKNOWE FARMHOUSE, STENTON

Sitting under the waters of Whiteadder Reservoir are much of Millknowe Farm and the remains of its farmhouse and steading, just east of the equally submerged Kingside School (p. 189). Owned in the mid nineteenth century by William Hay of Hopes it is unclear when the farmhouse and steading were erected but they were certainly there in 1841. The decision to erect a major reservoir in the were spelled the end for the buildings. In May 1968 the Whiteadder Reservoir covered over the buildings.

Millknowe Farmhouse prior to its being submerged beneath the water of the Whiteadder Reservoir

TRADE

Since land was farmed and primary industry emerged there has been a need to trade. This early trade included not only local markets, but with England, Europe and places beyond the reach of horse and cart, evidenced by the existence of a harbour at Morrison's Haven as early as 1526. Indeed, harbours began to spring up along the coast, from Musselburgh to Dunbar, and a hardy breed of local men began hunting cod, plaice, haddock and herring, alongside oysters and whales. The industry grew to a great size – even the relatively small port of Aberlady once had a fleet of 90 boats. This trade required regulation and a Customs House was founded at Dunbar in 1710. Its aims were to collect duties and stem the smuggling of goods.

Similar regulation was necessary in the main trading towns. Market crosses were erected after trading rights were given by the Crown and this would commonly be allied to a machine or building where goods were weighed. Trade incorporations began to emerge in East Lothian and controlled the basic industries for many years – as well as ensuring minimum standards they guarded against outsiders selling goods within the burgh, essentially creating a trading monopoly.

From the nineteenth century shops began to emerge in far greater numbers and these were soon joined by co-operative stores.

Today East Lothian still retains a solid trading base. Whilst the trading harbours have all but disappeared, the trade incorporations have not been witnessed on the streets for over a century, and market crosses are simply historic landmarks, locally owned shops are still highly prevalent on the high streets of most towns and villages.

MORRISON'S HAVEN HARBOUR, PRESTONPANS

Morrison's Haven, originally called Newhaven, was a harbour based at the western end of Prestonpans founded in 1526 by the monks of Newbattle Abbey. A harbour may have already been in existence prior to this date. In 1541 Alexander Acheson, a servitor of the abbey, was granted the tenancy of the harbour by James V, and the name changed to Acheson's Haven. Ownership of the harbour passed to Mark Ker in 1587 and the Acheson family's link with the harbour seems to have ended by 1602. In 1609 the estates of Prestongrange, including the harbour, were purchased by John Morison and it took on the

Morrison's Haven Harbour at Prestonpans before the pleasure boat Topaz *became beached there and all traffic was stopped from entering (© East Lothian Local History Centre)*

name by which it is now most commonly known (although it seems to have been called Milnhaven for a short time in the eighteenth or early nineteenth century).

Morrison's Haven was a port of substantial standing – by the 1680s it hosted a Customs House (covering the area from Fisherrow to Aberlady), it was being used, on average, by 58 boats annually, and the trade was international with exports heading for London and across Europe. A vast array of goods were passing through the port around the late seventeenth and early eighteenth centuries, including pottery, coal, salt, soap, oysters, tobacco, brandy, claret, Delft china, chocolate, candles, apples and onions, making their way as far afield as the Balkans. This heavy usage, mainly by foreign boats, is likely the reason that William Morrison undertook building work on the harbour. Suffering from duties and taxes imposed by Scotland's new post-1707 government in Westminster, the foreign trade at Morrison's Haven tailed off for around a century, until it was buoyed by the growing industrial prominence of Prestonpans.

The greatest potential for Morrison's Haven came from Prestongrange Colliery. Having been susceptible to flooding it was not deemed financially viable until Sir James Grant-Suttie took control in 1818. He let the mine to Matthias Dunn and the following years saw various ad hoc methods being used to keep the flooding to a minimum. In 1850 the lease on the mine was taken on by the Prestongrange Coal and Iron Company. That Prestongrange

Colliery was considered a serious ongoing concern is clear. First, they invested money in a new Cornish beam engine to eradicate the flooding problem and second, built the row of houses at Cuthill. Local coal was now available in abundance. To cope with the added export demands the harbour was improved in the mid 1870s at a cost of £10,000, from plans put forward by John Buchanan. The resulting deepened harbour complemented the newly opened brick and tile works and newly laid railway tracks – one set of which led to Prestongrange Colliery pithead, the other to the Firebrick Works on the colliery site. In 1913–14 the harbour covered an area of 1.974 acres, measuring 720 feet by 160 feet whilst the entrance was 70 feet wide.

By the 1930s the port was no longer used by trading boats as silt was filling up the harbour basin. Even its place as a port for pleasure boats soon ended when a boat called *Topaz* entered the harbour and was unable to get out. Here it was to remain, serving as a diving board for children who were drawn to the makeshift swimming pool warmed by the water pumped out of Prestongrange Colliery. Concerns for the swimmers heralded the end of the harbour. According to John McNeill, a labourer who helped fill in the harbour in 1957, 'the wooden pier and supports were all rotting away and it was an accident just waiting to happen'. The harbour was filled with thousands of tons of refuse, creating an area of reclaimed land. Scotland's oldest harbour was no more. The last boat, the *Topaz*, lies beneath the infill.

MERCAT CROSSES, HADDINGTON

Mercat crosses, or maket crosses, traditionally served as a focal point for a town's merchants. They would meet to trade and make deals. East Lothian is blessed with a plethora of mercat crosses. Indeed, a visit westwards to Midlothian provides ample evidence of just how lucky East Lothian is; in Midlothian not a single mercat cross survives. Whilst most mercat crosses in the county are extant some have disappeared. In North Berwick a circular series of setts once marked the spot where the cross stood. Haddington's cross has, since it was first erected around the reign of David I (1124–53), gone through a number of incarnations. Little is known of its early history and it may have been built and replaced on a number of occasions.

This cross, and later ones, were used frequently as a place to celebrate important events, such as coronations and the monarch's birthday. Although drinking to the monarch's health was abolished in 1832 it was briefly resur-

A rare photograph showing a man leaning on what might be be John Marine's 'worn fir stick' in the late nineteenth century (© East Lothian Local History Centre)

rected in 1840 for Queen Victoria's marriage. It was also the place where one would find out the latest important news and would have been plastered with royal proclamations and legal documents.

In 1693 John Jack, a stonemason, erected one at a cost of 'fourtie pund Scots', in the High Street opposite Fishmarket Close. It had a square base with four steps, the 12-foot-tall shaft was as 'thick as a man's waist' and topped by a stone unicorn. It finally met its end around 1811 when two local youths bet an English artisan that he could not scale the structure. They lost their bet and Haddington lost its cross when it collapsed. It was replaced by a new cross that Martine described as a 'worn fir stick'. It was burned before May 1880 and replaced by the current one, also known as 'the goat'.

TRON,
HADDINGTON

Haddington's Tron sat outside what is now Main's hardware shop, the site still marked by a circle of cobbles. It had sat there since before 1579, at which time the town council ordered that its weights be of brass and stamped with the burgh stamp. Its purpose was to weigh any manner of things, from food to material. Martine called it 'a large ugly wooden erection'. Its situation close to the George Inn, a hotel where the post coach would stop, meant that it got in the way of carriages drawing up. What happened to it is not known for certain, but Martine suggests that it may well have had its pillars sawn through and collapsed as a result. When this event took place is unknown but the tron was certainly in place in 1773 but not by 1819. Martine suggests around 1803.

SLAUGHTERHOUSES, HADDINGTON

Little is known of the first of Haddington's three slaughterhouses, or flesh markets, but it closed its doors in Newton Port in 1806. The building was gone by 1819 and the site later housed the malthouse of Messrs Bernard.

Its replacement was an extensive building sited on Hardgate where the derelict Gulf Garage stands today. It was designed by the Haddington architect James Burn and cost £1,500. A procession of magistrates, freemasons and the band of the Haddington Volunteers marched from the Masonic Hall in Lodge Street to the site, where Francis, Lord Elcho laid the foundation stone.

By the end of the century discussion was underway regarding replacing the building with a new one. In 1898 the building was described as unsanitary and inadequate by Dr R. Howden, the burgh medical officer. He added that 'the question of providing a new slaughterhouse for the burgh must be shortly faced'. This proposal met with a great deal of opposition with scenes of a 'disgraceful nature' taking place between councillors at a council meeting. One of the main points of contention was that the slaughterhouse was only being removed because it sat on an area of six feet that was needed in order to erect the soon-to-be-built Victoria Bridge. This was denied. It is unclear when the new slaughterhouse, situated on the eastern side of Giffordgate, was opened. It was certainly in place by February 1903 when it was visited by Dr Howden who considered it a vast improvement on the old premises, although he had reservations about the means used to clean the floor and walls. Councillors were also concerned by the filthy state of the building. At the time of Howden's visit the old slaughterhouse was still functioning. It is unclear when the slaughterhouse at Hardgate was closed or when it was demolished.

By 1965 there was a serious attempt to close the 'new' slaughterhouse, but this did not come to fruition as it was felt this would have a negative impact on local butchers and the auction mart. The requirement to 'bring it up-to-date and into line with public health regulations' would have cost the council around £10,000. As such it was finally closed in June 1967. The decision was criticised by the county sanitary inspector, James S. Gibson, who argued that it left East Lothian in a situation where it had no control over the quality of the meat in the county. When it was demolished is unclear but it was still standing in 1977.

GIMMERS MILL BRIDGE, HADDINGTON

It is believed that the Gimmers Mill Bridge was erected around 1850. This 'useful rather than . . . artistic structure' was built to facilitate easy access for works traffic heading to and from the Gimmers Mill. Privately owned, the public was permitted to use it to pass between Haddington and the Nungate.

By January 1871 the bridge was under some strain. As a consequence of the damage caused by traffic the bridge was closed to all but those using it for business purposes. A gate was installed that opened and closed when appropriate, although this had been removed by the 1890s.

By November 1895 there was certainly thought being given to a new bridge. Alexander Hogarth, owner of Gimmers Mill, proposed to replace the bridge with a steel structure affixed to the existing stone piers. This apparent philanthropy was not, however, all it seemed. Hogarth outlined that he was willing to pay, but if forced to do so would only allow mill traffic to cross it. If funds were found from the public purse then the bridge would be a public one.

In January 1898 a horse-drawn cart carrying a load of flour was crossing the bridge when its wheels failed to connect with the rails that would have ensured it travelled in a straight route across the bridge. As a result it collided with the side of the bridge, 33 feet of which collapsed, and the horse and cart fell into the water below. The horse later died. Ironically, detail of this accident was published in the *Courier* on the same day that plans were printed of a new bridge, Victoria Bridge, to be erected. A new bridge was long overdue as both the Gimmers Mill Bridge, by this time a rickety affair, and the decidedly narrow Nungate Bridge, were growing increasingly unsuitable for carrying ever-growing traffic. The last pier was demolished in August 1901.

Health and safety does not seem to have played a great part in the decision to let this group of children stand on the decidedly rickety Gimmers Mill Bridge around 1895. It would be another six years before it was finally pulled down (© East Lothian Local History Centre)

AUCTION MART,
HADDINGTON

An auction mart was opened at Hope Park (referred to at the time as Mr McNiven's large park), at the western end of Haddington, in April 1879. It was built by the sales firm of Clapperton, Brand & McNiven. The site was built around an octagonal building where sales took place, described by the *Courier* as 'circular in outline, and snugly roofed and slated, the pavilion rises to a considerable altitude, tapering off into a kind of pagoda-like apex, the Eastern idea being still further increased by the crowning figure of a large gilded bullock'. It was erected by Mr Gullan, joiner. The cement sale ring was 30 feet in diameter, surrounded by tiered galleries capable of holding upwards of 300 traders. Outside the sale ring were 70–80 stalls and a similar number of pens, access from these to the sale ring being provided by spacious avenues. Whilst the sale of animals was the primary function of the auction mart this was augmented by roups of goods. The site was opened on 21 April with a well-attended lunch. Traders used the occasion to fill every stall and pen, with 270 cattle, cows and calves, 1,150 sheep and 30 pigs on display.

Exactly when the auction mart was removed is unclear. Certainly it was there in 1974 when it was photographed by local historian and photographer George Angus (who knew it as the Cattle Market). By this time, however, the sale building had lost its 'pagoda-like apex'. The building was gone by June 1975.

Local historian George Angus took this photograph of the Auction Mart (which he knew as the Cattle Market) from the West Church tower in 1974. By this time the 'pagoda-like apex' had been removed and the concern was in its final days (© George Angus)

HAYWEIGHTS,
MUSSELBURGH

Musselburgh's customs box and weighing machine were situated on the town's High Street, near the junction with Bridge Street. Sometime between 1853 and 1893 these were replaced by a custom brick-built octagonal building. This was initially known as the Custom House, but later as the Hayweights. Its initial function was as a weigh-house to weigh hay, sand and gravel, but in later years it was simply a prominent landmark. It was so prominent, in fact, that anyone passing through the town could barely miss it. In its early years it had a plain roof that tapered upwards to a point and was topped by a street light. In 1909 the original roof was removed and replaced by an extravagant ogee-shaped one topped with a four-faced clock which itself had a rounded turret roof. This addition was paid for by Dr A.D.M. Black. Due to illness, Black was unable to

The Musselburgh Hayweights was removed from its prominent position on the High Street, next to the Brunton Hall, after a car crashed into it in 1970 (© East Lothian Local History Centre)

make the formal handover of the gift, so his son Colin attended in his stead. Black's philanthropy came about after a town council meeting where it was suggested that it would be desirous to have a clock in this area of the town.

In 1970 the building was struck by a car and as a result was considered dangerous. On 14 July of that year the clock was removed. For some years it was stored in a builder's yard in Millhill and, later, at the Macmerry council depot. The uncertainty over the clock's future prompted Dora Hill, taking on the persona of the clock, to write, in 1982:

> I hope the powers that be
> Will make decisions now at last,
> And find a spot where I'll be seen,
> No more a thing of the past.
> I'm sure I still could set my feet
> In my old accustomed place,
> Where the townsfolk still will love and see,
> My auld and weel-kent face.

It was another 16 years before the clock's future was secured, although in 1990 the mechanism was incorporated in the clock tower at Eskmills. In 1998 Tesco, who were opening a new store in Mall Avenue, offered East Lothian Council £20,000 to be contributed towards a community scheme. It was spent on restoring the Hayweights roof and clock to public view west of the car park on Mall Avenue. Although the feeling was generally welcoming the chairman of the Community Council, George Montgomery, urged caution, noting that he was worried it would be an attraction for drug users. It currently sits on pillars, providing a relaxing seating area for anyone walking along the southern bank of the River Esk.

PRINGLE'S, HADDINGTON

With the building of the Victoria Bridge a swathe of houses leading from Market Street through to the River Tyne were demolished to create a thoroughfare to the river crossing. On the corner between Hardgate and the newly built Victoria Terrace was built a prominent shop. In 1904, two years after it was erected, it was purchased by James Pringle, cabinetmaker and upholsterer. The Pringle family would own the premises for around the next 36

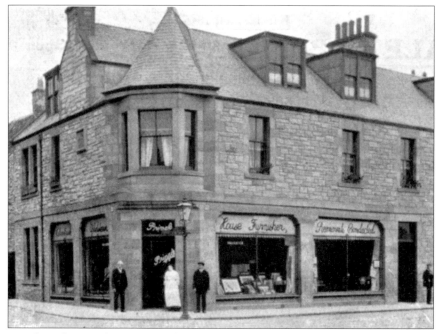

Pringle's cabinet making and upholstery shop in Haddington, prior to its being flattened by a German bomb during the Second World War (© East Lothian Local History Centre)

years until it was sold to the East Lothian Co-operative Society (ELCO). Within two years, disaster struck. On 3 March 1941 a German bomber offloaded a stick of bombs. The first explosion destroyed the building and two people were killed.

PRESTONPANS CO-OPERATIVE SOCIETY, CUTHILL BRANCH, PRESTONPANS

The Prestonpans Co-operative Society was founded in 1869. It was supported by the local mining community and continued to grow as a result. The expansion of housing in Cuthill, due to the growing importance of the coal mine at Prestongrange led to premises being opened there in November 1925, replacing a temporary building. Designed by Peter Whitecross, with the help of the society's general manager Peter Marr, it was opened by Charles McLeod, the president of the society, to the strains of Prestongrange Silver Band. Like much of the infrastructure in Cuthill it survived until the demolition of the area around 1960.

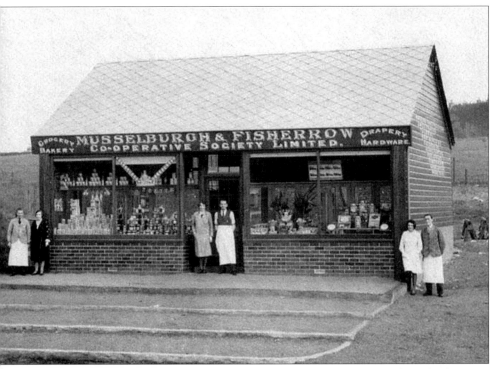

The co-operative store at Smeaton was not up to the same architectural standard as others erected by the Musselburgh & Fisherrow Co-operative Society (© Musselburgh Museum Committee)

MUSSELBURGH AND FISHERROW
CO-OPERATIVE SOCIETY, SMEATON BRANCH

The Musselburgh and Fisherrow Co-operative Society (M&F) was founded by net mill workers in 1862. Although the early years were ones of growth, there were disputes, not least when miners within the organisation broke away and formed their own society. This split continued until the smaller of the two groups was taken over in 1896. Prior to this the M&F had begun building new stores in and around the town. After this the building of new stores continued apace. Many of these buildings were of a substantial red-brick type and as a result still exist. The Wallyford branch, opened in early 1904, is one of the few to have been demolished, lasting until the first decade of the twenty-first century. Later branch buildings erected by the society, such as those at Whitecraig, Danderhall and Smeaton moved away from the style of the earlier builds. Whitecraig, for example, was built in an art deco style. Of all the M&F

shops, Smeaton was the least substantial and may even have been a temporary structure erected in a relatively flimsy style in the knowledge that the local colliery was in its final years.

There is little extant information about the Smeaton branch. Even the short history of the M&F makes no reference to it. It was built in the first two years of the 1930s, primarily to serve the houses of Smeaton Village. These were owned by A.G. Moore & Co. and the vast majority were occupied by mineworkers, all working at the Smeaton Colliery until its closure in 1948. The store closed within a couple of years of the colliery's closure.

OAK TREE CAFÉ, HADDINGTON

The building, in 1932, of the A1 past Haddington, precipitated the erection of a small café and filling station at the far western entry into the town, on Bye Pass Road, to catch those making their way between Edinburgh and the south. Originally called the Letham Filling Station its first owners were the Haddington Motor Engineering Company. Owned by the Shearsmith family the company was known for building an early motor car called the Dalgleish-Gullane. Of the 14 made only one survives. Around 1949 the business was sold to George Sprigg and it is likely at this time that its name was changed to the more user-friendly Oak Tree Café. Around 1960 it was purchased by Scottish Oils & Shellmax, and was owned by national companies from this time until it was finally demolished.

The café closed in 1994 as the owners, Texaco, considered that the re-routing of the A1 would result in a serious decrease in trade. By 2000 fears were being raised as to the safety of the site and the Haddington and District Amenity Society and the Community Council were calling for it to be cleaned up at Texaco's expense. Councillor Charles Ingle called the site 'an absolute disgrace to the town'. Three years later and little had changed, other than boulders having been placed around the site to deter travelling people from siting their caravans there. Jan Wilson, chair of the Community Council, noted 'it is a dreadful eyesore and it is a blight on one of the main entrances into Haddington' adding that the group would like to see the site developed into a café, market garden or filling station. Perhaps the onslaught from local groups had some effect as Texaco put the site up for sale in December of that year. The building was finally demolished in April 2008 by the owners Premier Property Group.

GOLDEN SIGNS,
HADDINGTON

One of the greatest achievements of County Planning Officer Frank Tindall is still visible today – his regeneration of Haddington town centre. With support from senior figures in the council, he set out to upgrade the existing shabby shop fronts and houses. Dreary façades were painted in an array of earth colours, doors in bright colours, windows were painted white and replaced where needed, litter bins and lampposts were upgraded and attempts were made to persuade shopkeepers to mount golden signs above their doors. All of the buildings that benefited from the town centre regeneration still exist. Whilst many of the golden signs have now disappeared, a handful do survive, dotted above shop fronts in the High Street. Many of the original brackets are put to use displaying modern signs.

Three of the golden signs erected in Haddington at the time of the regeneration of the town centre. The small changes such as the addition of these signs or the lights attached to buildings were as important as the major changes in creating an overall impressive effect (© East Lothian Local History Centre)

CHAPTER 6

TOURISM

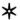

Until the middle of the nineteenth century, the Great North Road had been the primary thoroughfare for travellers coming from the east of England to Edinburgh. Their coaches would pass the ancient burghs of Dunbar, East Linton and Haddington before heading on to Edinburgh. It was the arrival of the railway in the 1840s, however, that laid a solid foundation for East Lothian's tourist trade, although the area was certainly attracting visitors prior to this – the *New Statistical Account* for North Berwick, written by Rev. Robert Balfour Graham in 1839, noted that each summer and autumn there was a 'crowded influx of strangers for the enjoyment of sea-bathing and perambulation among the beautiful scenery'.

The main line route was similar to that of the existing road passing through Dunbar, East Linton and Longniddry and on to Scotland's capital city. It became clear, even before the first sod of earth had been removed to lay the main line, that branch lines were required. One was soon in place for Haddington after heated debate regarding why the county town was not on the main line. The branch line from Edinburgh to North Berwick, later known as the Biarritz of the North, or the Scotch Brighton, was opened four years later in 1850, an attempt by the North British Railway Company to secure a regular, year-round, passenger base amongst Edinburgh-employed professionals. This plan failed miserably, but the summer traffic grew beyond expectations and this, alongside the penchant of the great and the good for visiting the town, laid the foundation for the town's growth. In 1903, on the West Links, were 'four MPs, the Speaker of the House of Commons, two bishops and the Prime Minister. Later they were joined by Lord Kitchener. HMS *Dreadnought*, on passage to Rosyth, fired a ten-gun salute over the course.' Tourism was beginning to take hold as day-trippers and those on longer holidays were attracted to the golden beaches on the southern lip of the Forth. In 1925 it was

reported that around 94,000 visitors descended on North Berwick Station. To facilitate this influx the resident population more than doubled from 1,164 in 1861 to 2,376 in 1891. In Easter 1895 around 3,000 visitors descended on the town. In July 1873 there were complaints that each weekend North Berwick was 'converted into a miniature Donybrook fair'. In 1862 the *Haddingtonshire Courier* began to publish lists of notable visitors to the county, and this was continued, more comprehensively, by the *North Berwick Advertiser and East Lothian Visiter* [sic.], first published around 1878. Even the less-fashionable town of Prestonpans was attracting masses of swimmers in 1879.

Why was East Lothian such a popular destination? Certainly its natural setting – sited on the coast, with wonderful scenery – had a bearing. Joseph Robertson, in a travel guide written in 1814, described the county as 'the richest and most beautiful . . . in Scotland'. In an article in *Harper's Magazine* in 1889, W.G. Blaikie is fully aware of the pulling power of the county's natural beauties, but also notes that golf is a factor: 'The glory of North Berwick is its beach, and its links, and its islands, and its sea view, and its Law, and its incomparable fresh air.'

The insatiable demand of golfers had to be met and courses sprang up along the coastline in the second half of the nineteenth century. Such was the power of the golfer that in 1903 a railway platform was built for the exclusive use of Luffness Golf Club members.

In the early years of the railway the lack of beds meant that many potential visitors passed through to stay in Edinburgh. In order to attract this lost trade a number of hotels were built. In North Berwick alone the figures are astounding – a 1907 town guide lists six hotels (a seventh, the Tantallon, would open the following year), six guest houses and a boarding house. In addition to these existed a growing number of smaller private lets and bed and breakfasts.

Whilst North Berwick was the town of choice in East Lothian, other towns were quick to realise the potential of the tourist trade. Dunbar, like North Berwick, had the geographic benefits conferred on it by the foresight of the town's founders. Alongside this, argued John McDonald in 1893, were 'excellent facilities for the enjoyment of fishing, boating, and shooting – not to mention the more staid amusements of golfing, bowling, and tennis'. All in all, he said, Dunbar is 'one of the best sea-side resorts on the east coast'. Although such bluster can perhaps be attributed to the over-exuberance of a local businessman who saw the financial benefits of a positive press, the simple fact is that Dunbar did indeed have impressive facilities.

It is clear that the railway was the lifeblood of East Lothian's coastal towns. The population of Gullane, whose tourist potential was as good as, if

not better than, North Berwick, stagnated before its arrival. After the creation of a branch line it exploded, rising from 243 in 1891 to 830 in 1911, only 13 years after the arrival of the railway. Even after the demise of the railway, tourists continued to make for Gullane. One day in 1935 saw 858 cars parked at Gullane Sands.

When the tourist trade began to diminish the county was left with a wealth of buildings and facilities that were, in many cases (but not all), surplus to requirements. Unwilling to remove the hotels, they stayed in place until the burghs were forced to deal with them – notably due to a lack of upgrading or when, in many cases, fire simplified the job of the town planners. In some cases structures were replaced – railways with an upgraded version and a better road system and outdoor swimming pools with indoor heated affairs. Most of the county's golf courses survive almost intact and still provide the foundation for the modern tourist influx into the county – those that did disappear usually did so at the behest of the landowner rather than dwindling membership figures.

Tourism continues to play a prominent part in East Lothian Council's strategy, with golf attracting visitors from both home and abroad. From the 1960s a Tourist Information Office, run by J. Cairns Boston, was set up in Dunbar. In the 1980s it became part of the East Lothian Tourist Board.

ROYAL HOTEL, NORTH BERWICK

With the rise in tourist numbers into North Berwick it was soon clear that there was a distinct lack of accommodation available to visitors. In an attempt to address this issue some local men ploughed funds into building a new hotel on Station Road. John Henderson was hired to draw up plans. The Royal Hotel, so named due to a visit to the town by the Prince of Wales in 1859, was the first of the large hotels to be built in North Berwick. The *Courier* outlined that whilst the exterior of the building may not have placed great emphasis on aesthetics, the interior was elegant and spacious. Its 14 private bedrooms were described as 'models of chaste finish and furnishing', helping to elevate it to 'one of the most charming sea-side residences in Scotland'. Around 40 were in attendance at the July 1861 opening and ranged from local worthies to a member of the House of Lords. The chair was taken by Sir Hew Dalymple, Bt, who received a large cheer when he toasted 'Prosperity to the Royal Hotel of North Berwick'. With magnificent views over the Forth and situated adjoining

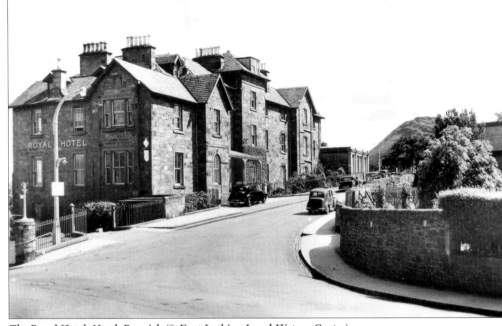

The Royal Hotel, North Berwick (© East Lothian Local History Centre)

the railway station, it addressed the tourists' needs perfectly.

Before it was finished some argued that it would never cover its costs. However, by early 1862 it was being reported that the hotel, rather than being a failing concern, was so profitable that another wing of at least 20 bedrooms was being added to the building. The work was finished by February the following year and by September the owners were advertising for contractors to undertake a further addition. This extension would see an additional 25 rooms added. It was at this time being touted as the finest hotel in Scotland.

The first to run the hotel was Nicholas Lambre, a host renowned for his culinary skills. An Edinburgh hotel of his features in the recently rediscovered Jules Verne autobiographical novel *Voyage à Reculons en Angleterre et en Écosse*. After Lambre the hotel went through a number of managers including Alexander McGregor, Charles Johnstone and William Fleck. It was during McGregor's tenure, in 1872, that another extension was added and run as a separate hotel by Charles Johnstone who later combined both establishments. In 1894 Arthur G. Holloway took over as proprietor. Within a year plans were passed by the Dean of Guild Court for the erection of a new bar, bathroom, lavatories and the alteration of the entrance hall. Around 1903 further alterations were made when John Colin Campbell took over the tenancy. An advert

from the time notes the hotel had been 'entirely re-modelled, re-decorated and refurnished', adding that it also had a nine-hole putting green in the grounds. In 1908 the licence was transferred to Campbell's wife Emily, prompting the chief constable to say 'it would be well if licence-holders were men'.

In 1923 the hotel was sold to the existing tenant, William Gladstone Walker, for £8,500. In 1936 Walker's heirs sold the hotel to Eglinton Hotels. The architectural firm of Neil & Hurd was brought in to make changes to the building. Eglinton retained the building for around 30 years before selling to Grand Metropolitan Hotels in the mid 1960s. They ran it as a three-star AA and RAC hotel. By 1974 they had changed its name to the Royal Hunting Lodge Hotel.

By the 1990s it was clear that plans were afoot to demolish the building. Over the next decade plans were mooted to build a supermarket on the site (1992) and 57 flats and houses (1994) until, in March 1999, permission was granted by East Lothian Council to demolish the building and erect sheltered flats in its stead (despite a petition of over 1,000 signatures protesting its demolition).

BELHAVEN SPA, DUNBAR

The veneration of water has taken place since time immemorial. Gods such as Poseidon and Neptune were worshipped in its honour and rivers such as the Ganges and the Jordan hold spiritual significance for many. When, in days past, water was found that bore unusual qualities, it was celebrated and promoted to be a great health aid to those who partook of it. Whether there is any benefit to be had from drinking such waters is still under debate, but what is certain is that towns which discovered such waters on their doorsteps utilised it as a promotional tool to draw visitors from throughout the country.

It is little surprise then, that the people of Belhaven attempted to capitalise on the discovery of a well near the village. The spa on Belhaven Beach is not well known outside local circles today. It never acquired the fame of St Ronan's Well at Innerleithen (the title of a Sir Walter Scott novel) or St Margaret's Well beneath the shadow of Arthur's Seat in Edinburgh. That it has not descended into absolute obscurity is due in great part to the engraving shown here and a handful of newspaper articles. The well was discovered between 1829 and 1833 by an exciseman named George Grant who thereafter highlighted its existence to a Dr White. The water was compared to that at the

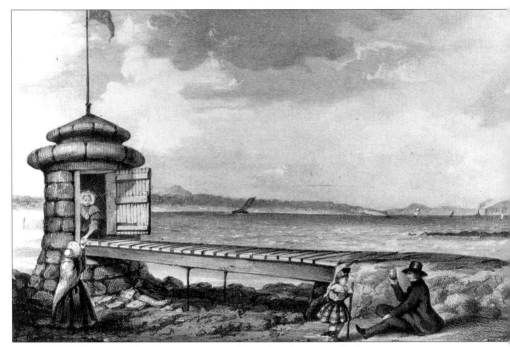

The healing waters on Belhaven Beach were held in place by a stone-built structure which eventually succumbed to a violent storm in the early 1850s (© East Lothian Local History Centre)

much-heralded Harrogate Spa and people were soon travelling great distances to partake of its healing powers, which were said to be beneficial to biliousness and skin diseases. The beehive-shaped structure was soon built to contain the waters, and the well was opened, 'with great ceremony', around 1833. So beneficial were its properties believed to be that it was transported to buyers outside the county. Local residents also viewed it as a potential attraction to the area; in 1847 a house advertised for sale mentioned the nearby spa, obviously considering it a selling point.

Its benefits were short-lived as, by the early 1850s, a storm had destroyed the building and the stones were removed to build a wall. In the mid 1860s, in an effort to benefit from the burgeoning tourist trade in the county, attempts were made to resurrect the spa by Bailie Hume. This attempt seems to have disappeared with little flourish. Soon after a further attempt was made by a local man, James M.B. White, who vowed to once again open it to the public, 'whether nobles or commons . . . this much neglected and really efficacious mineral water'. Obviously a man of vision, he hoped to see 'hundreds of valetudinarians and other sojourners taking a sip of the virtuous water'. White was

driven in his desire to see the well opened once more, denouncing all those who stood in his way and laughing aside the fact that the land may be private. White's attentions prompted the landowner, Mr Rennie, along with White and some others, to visit the site in late 1869. The result of this visit was that White was given permission to dig a trench above the high-water mark in an attempt to find the spring. White wrote of the search:

> Shrill on the hillocks is the briny Frith's scent
> Where the lord of the springs is running over the bent.

The scene was soon drawing locals as testing saw the excavators cutting through red sandstone and limestone before striking the source. It was then filtered and tested by Mr Milne of the West Port Dispensary and found to contain sodium, potassium, magnesium and carbonate of lime. The following year the water was tested by Dr Stevenson Macadam, a professor of chemistry at the University of Edinburgh, who found it similar to the sulphur waters at Harrogate, thus disproving the rumours that it was formed from 'decayed seaweed and the sap off dead men's bones'. In December 1870 it was noted that the spring would be covered by a temporary structure before a hotel was built to reap the tourism benefits. Nothing further is heard of this venture.

Around 30 years later attempts were once more made to resurrect this potential tourist attraction. The new tenant at Winterfield Mains, potato merchant Ernest Pordage, was investigating ways in which the spa could be utilised. At first he tried to bore a hole nearby and tap the spring. This failed and he attempted to re-open the old source. His plans, which were received positively by local people, were soon in disarray. In 1901, less than two years after his venture began he stood in Haddington Sheriff Court and was declared bankrupt.

The foundations of the stone spa remain extant, still visible at low tide.

MARINE HOTEL, NORTH BERWICK

In September 1874 a prospectus was printed in the *Haddingtonshire Courier* offering 2,400 shares for sale, at £5 each, in a new hotel called the Marine at the West Links. A number of attractions are noted with great emphasis being placed on the hot and cold salt and freshwater baths (the only ones between Edinburgh and Scarborough), the bowling and croquet greens. The calculated

cost of the building, designed by William Beattie, was estimated not to exceed £12,000. Within three weeks it was noted that the full quota of shares was now almost sold. Work began around March 1875 with local firm J. & R. Whitecross having won the contract. By late November, with the building almost complete, a further 2,000 shares, at £5 apiece, were now being offered. The final cost was upwards of £21,000. At this time it was described in glowing terms as 'a lofty and massive pile of building, almost palatial in its style and proportions, which dwarfs into comparative insignificance the numerous handsome villas . . . in near proximity'. Built in the popular Scots baronial style a detailed description is given:

> The exigencies of the situation – the principal entrance being from the south, or land side, and the most important feature of the edifice consisting in its north, or sea prospect – has caused equal attention to be paid to the architectural working out of the elevations, both in front and rear, so that the building may be said to have two fronts, each of a distinct and highly picturesque character. In both cases the face of the elevation is broken up by projecting wings at either extremity, while the centre also protrudes beyond the face of the

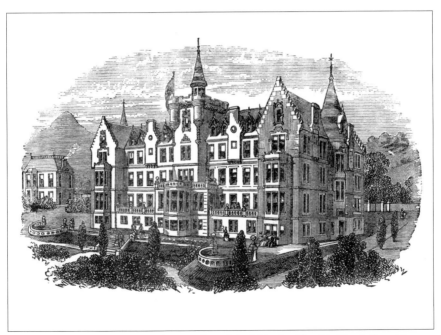

The only image known to exist showing the original Marine Hotel in North Berwick (© East Lothian Local History Centre)

main building. The projecting centre is on the sea side carried upwards beyond the roof, and finishes in a massive square tower, from one corner of which a round turret, with sloping roof and minaret, rises still higher, and crowns the whole edifice at an altitude of 102ft from the level of the ground.

In addition it was, paradoxically, accessible and isolated; it was only a few minutes walk from the railway station but removed from any public thoroughfare. The building was situated on five floors with the attic space housing staff. Visitors would have a choice of 120 rooms, throughout the 160 foot-by-60 foot building. Bay and side windows ran up three floors of the corner wings and allowed light to flood into these rooms whilst those wishing to take in the sea air could exit onto a balcony running from one corner wing to the other. The wings were a focal point. On the ground floor of the southern side, for example, was a billiard room with two tables in one corner, and a golfers' hall, where players could rest after a game in the other. The north-facing corner wings housed a ladies' drawing room and coffee room.

Baths, extremely popular in the late nineteenth century, were included in the design, with water drawn from the sea by steam power. Fresh water was supplied from a well in the grounds. The grounds had bowling and croquet lawns, tennis courts and a putting green designed by Ben Sayers. There was also ready access to the local golf courses.

The hotel was officially opened in July 1876. A disappointingly short newspaper feature notes that those present toasted 'Prosperity to the Hotel'. The first manager was a J.J. Mephius. It is unclear if the hotel lived up to early promises of success, but by early 1880 it was presented for sale and eventually went for £15,000. The new owners were 'a small company of gentlemen interested in the prosperity of the town'. They improved the facility for drawing water 400 yards from the sea into the hotel, whilst storage was created to hold 6,000 gallons of water (heated by a Cornish boiler). In 1881 substantial works were undertaken on the building, with a gable being added to each end, this work designed by Frederick Thomas Pilkington and costing around £10,000. Soon after the hotel was reviewed positively by the *Whitehall Review* in an article titled 'The Northern Biarritz' (perhaps the basis for North Berwick being known as the Biarritz of the North):

The splendid *Marine* is altogether one of the best hostelries we have ever visited. It is close to the Links; and contains all that the heart of man could desire – from French cookery to electric bells. It is

superior to the *Roches Noires* at Trouville; in short, it may be said to combine the excellence of the *Bath* at Bournemouth, with the taste of the *Norfolk* at Brighton.

Just prior to the next visitor season disaster befell the hotel. At 5.30 a.m. on 13 March 1882 a fire was discovered in an attic room. Armed with only a one-inch hose the manager and staff tackled the blaze whilst some attempted, success-fully, to save furniture. Messages were sent to fire brigades as distant as Edinburgh. It was soon clear, however, that all was lost and the hotel could not be saved, the *Courier* noting that 'nothing beyond the bare walls remain standing to bear witness to the fierceness of the agency that has for a time consigned it to destruction'. By midday the building was burnt through and the roof had caved in, along with three of the building's four turrets. Fortunately the building was insured and hardly had it been razed to the ground than it was noted by the *Courier* that it would be rebuilt. Its replacement, which still stands today, was opened in May 1883.

ROXBURGHE MARINE HOTEL, DUNBAR

Building of the Roxburghe Marine Hotel, or the Roxburghe Lodge Hotel as it was originally known, began in September 1885 at a cost of around £2,000. It was built as a dower house for the aged Duchess of Roxburghe. Situated at the south-eastern end of the town on Queen's Road the foundation stone was laid by John Anderson of the George Hotel. He undertook the ceremony in his Masonic regalia and this caused great controversy amongst Lodge members, as permission had not been given. The first owner (when it was a dower house) was John Michael, but he had gone by 1889. Over the next seven years it would come up for sale three times and for let once, with the upset price gradually dropping from £1,800 to £1,600. At this time it was described as having three public rooms, ten bedrooms, a bar, kitchen conveniences, a tennis court and uninterrupted sea views, as well as adjoining the West Links. During this uneasy period the effects of the hotel were put up for sale – from tablecloths to towels to cutlery and doormats.

In April 1894 the owner John Sutherland was in front of the licensing court pursuing a licence, arguing that it was in his interests to operate a well-run hotel and that he intended to increase the number of rooms by eight. The Chief Constable recommended that the licence be refused due to over-provision and

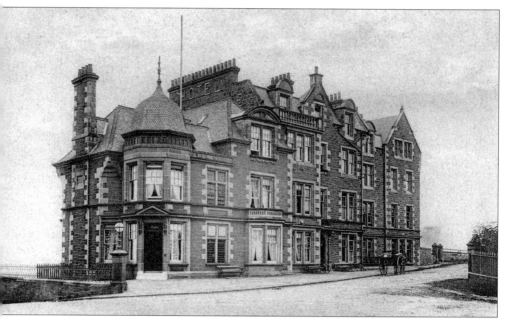

Roxburghe Marine Hotel, Dunbar (© East Lothian Local History Centre)

the hotel's remote situation. Local residents concurred; 15 noted their opposition in writing. At the meeting it was highlighted that the hotel had been badly run in the past and that the bar was considered 'a disgrace'. After great discussion between members of the board, and on the proviso that there be no bar and that the number of rooms be increased, the licence was granted. The hotel was soon bought over by the Roxburghe Marine Hotel Company (RMHC) which proposed to extend it to include additional bedrooms and a sea-water bath. Two thousand shares were issued at a cost of £5 each. By March 1895 the board had received estimates for the work and were viewing the plans, which included a swimming pool of 48 feet by 22 feet. The baths were to consist of 'a suite of hot and cold sea water slipper baths, Turkish, and a hot "wave" room'. Also proposed was the reversal of the hotel – from facing the street to facing the sea.

In the company's second annual report to its shareholders it was noted that the building work was not yet completed, but that every room was full soon after opening. The profit at this time was £365 2s 9d. By 1903 it had 80 rooms and was employing a masseuse. Such luxury did not, however, ensure its success as in November 1905 RMHC was voluntarily wound up. The following year the building was sold to an Alfred J. Hitchman for £5,500 and, in contrast to its early years, so began a prolonged period of stability. Although

Hitchman was to die of pneumonia at only 33 years old in 1911, his wife Agnes would take over the running of the concern and her association with the building was to last until the mid 1930s when the hotel was sold to Green's Hotels. At this time it had 60 bedrooms, hot and cold water, central heating, a garage and was fully licensed. This company sold it within a few years and it was run, for the duration of the Second World War, by Donald McLean and housed an army officers' cadet training unit.

In 1947 McLean, in turn, sold it to John Anthony Herbertson, better known as the newly retired comedian Jack Anthony. He undertook a complete refurbishment and adverts proclaimed it 'The House that JACK built'. Upon his death in 1962 his wife took over the running of the hotel until the late 1960s when she sold it to Eugene Marcel who had been the hotel's chef. Soon after Marcel took over the hotel, an advert described it as having 'sumptuous comfort [and] delicious cuisine'.

Its final years were not covered in glory and by the mid 1980s it had come to the attention of the Licensing Board on a number of occasions. In August 1985 it came in for stinging criticism from the East Lothian Tourist Board after complaints from residents. One had noted the building's 'general dilaptitude', adding a lengthy list of complaints. The complaints led the Licensing Board to visit the premises and in October the hotel's licence was refused with Marcel being described as 'incompetent to manage the hotel'. The following years saw a number of suggestions mooted as to the best use for the building. In 1987 there was a proposal that it be used as a retirement home, the following year that it be converted into 19 flats. In 1992 the flats proposal was still considered an option but with the householders being redundant army officers. By 1993, however, it was clear that the former hotel was in a bad way, with the Scottish Civic Trust warning that £1 million of essential work was needed if the building was to be saved. A rescue package was not forthcoming and the building was finally demolished in March 1996.

STEAMBOAT PIER, NORTH BERWICK

With the ever-rising visitor numbers to North Berwick it was clear that there was a potential for profit. One way of cashing in was to expand the steamboat trips on the Forth. These were already popular by the mid nineteenth century, focusing on popular visitor stop-offs such as Leith, Aberdour, Inverkeithing, Kirkcaldy, Portobello and Inchcolm. The trips were soon taking in East

Lothian, stopping at Prestonpans, Cockenzie, the Bass Rock and the Isle of May. By 1866 the company of Steedman, Hansen and Dykes ran a tug called *Powerful* into North Berwick. The route to the town was soon monopolised by George Jamieson and it was not until the late 1880s that serious competition was provided; in April 1886 the Galloway Saloon Steam Packet Company (also referred to as Leith Steam Packet Company) applied to erect a temporary landing and footpath at Platcock Rocks. The council agreed to allow its erection on the condition that its owner, M.P. Galloway, maintain the structure, only allow its use by his own steamers, and ensure that it not be used on a Sunday. Galloway took a 21-year lease, agreeing to pay £5 rent per year. Building work was underway by April 1887. The structure consisted of a foundation upon which the iron pier was erected. In order that the boats could be accessed during different tide heights, and on separate decks at one time, the pier was on three levels. The first trip from the pier was made in June 1888 when magistrates and councillors from the town boarded the *Stirling Castle* and were taken on a trip to Elie in Fife.

Those boarding from the pier in this era could expect sumptuous surroundings – the *Tantallon Castle* cost £15,686, was 210 feet long and could hold 800 people. It was 'panelled in oak with Greek pilasters, in walnut and gold. The couches upholstered in gold Utrecht velvet.'

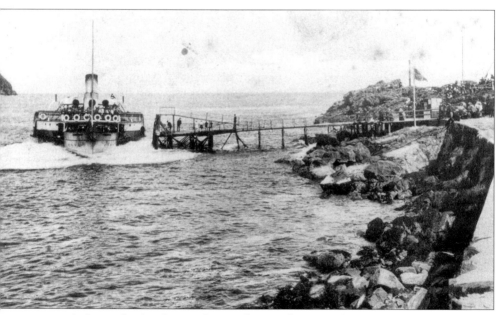

An image showing the steamboat Stirling Castle *approaching the pier at North Berwick (© East Lothian Local History Centre)*

The steamboat pier as it looked at the latter end of the twentieth century
(© East Lothian Local History Centre)

In 1907 Galloway was offering trips to the Bass Rock, the Isle of May, Elie, Methil and Leith. Sailings stopped during the First World War and this marked the beginning of the end for the venture. In 1919 the pier was put up for sale, but failed to attract any buyers; two years later the Galloway company went into liquidation.

The following years saw various attempts to resolve the future of the pier, to little avail. In 1924 a report was obtained from Messrs Morrison & Carfrae, chartered engineers, regarding restoration. The scheme, to cost £800, was turned down by the town council. The following year the Friendship Holiday Association, proprietors of Tantallon Hall, wrote to the town council to outline their desire to hold pleasure sailings the following summer. Councillor Thomas Minto noted that the pier was 'in a dilapidated state, and should either be barricaded or dispensed with altogether unless something were done to repair it'. By February 1926 proposals were being put forward to build a concrete pier, but this never came to fruition. It was at this time that it was 'in a state of considerable disrepair' and was let out to the Stanley Butler Steamship Company for £40 per annum. Despite a 1933 proposal by this company to restore the pier it was, by 1940, in such poor condition that the sum of £40,000 was required to make it safe for public use. By 2000 the 'lower level [was] still being used to take launches to Bass Rock and Fidra', but most of the structure had been removed. Only the foundations remain.

SWIMMING, BOATING AND
BATHING PONDS, DUNBAR

One of the first calls for adequate bathing facilities in Dunbar came in the *Courier* in 1884, when a correspondent called 'Visitor' argued that a swimming pool would lead to 'a large increase of visitors whose presence would not fail to be of benefit to the townspeople'. In the following year there came a flurry of letters calling for improved bathing facilities. This seems to have had an effect as by March 1886 there was agreement by the Town Council to proceed with a ladies' bathing pond. Work was speedy as the pool, situated at the west of the harbour, was completed around three months later. Despite being 'very handsome and inviting' with brick and concrete dressing houses, this was not viewed as the finished product and 'improvements on a much larger scale are intended'. The authorities were clearly worried that the expected congregation of women would draw a crowd. Over the following years this fear would prove to be well founded. The tables were turned, however, when a complaint was made that a woman was watching male swimmers, at their pool, using a pair of opera glasses.

A new pavilion at the ladies' pool was approved in May 1904 and opened in August of the same year. Designed by Mr Thomson of Edinburgh, and costing £300, it sat on pillars, and consisted of 14 dressing rooms and a seated verandah.

In 1923 the pool was given an extensive upgrade. The ladies' pavilion remained but the changes included the raising of the wall separating sea and pool, and the creation of a promenade. The day of the opening was one of meteorological extremes with brilliant sunshine offset by a biting, cold wind. Despite this a few hardy souls braved the elements and tested the waters for the first time.

A mere five years after the 1923 upgrade it was clear that capacity had been reached, both in terms of swimmers and spectators. As a result Dunbar Town Council acquired the Glebe and foreshore. They began to upgrade and extend, blasting into the surrounding rock. This paved the way for the opening, in July 1928, of a boating pond attached to the swimming pool. The cost was £2,250. It was capable of holding 100,000 gallons and covered an area of 1,793 square yards, its depth rising from 1 inch to 18 inches. The contractor was John Monteith of Dalkeith. The first paddle boat was launched by Mrs Sinton (the Provost's wife) and steered the full 286-feet length of the pond by Miss Kathleen Brooke (daughter of the Town Clerk). But work did not end there.

A year later a further extension to the pool was undertaken by L.G.

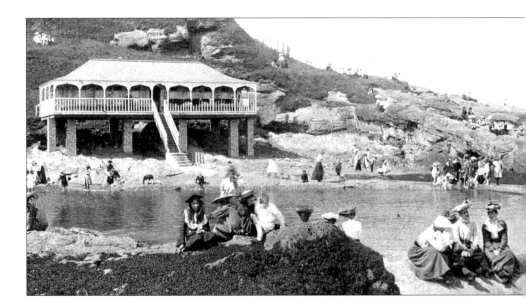

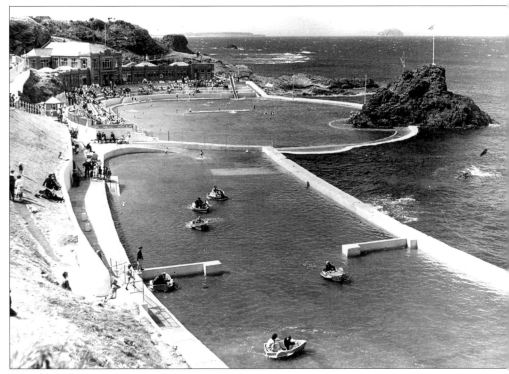

Two views of the outdoor swimming pool at Dunbar. The top picture shows the Ladies Bathing Pond after the erection of the pavilion in 1904. The one above was taken after the addition of the boating pond in 1928 and the extension of the pool and the erection of a bigger pavilion in 1931 (© East Lothian Local History Centre)

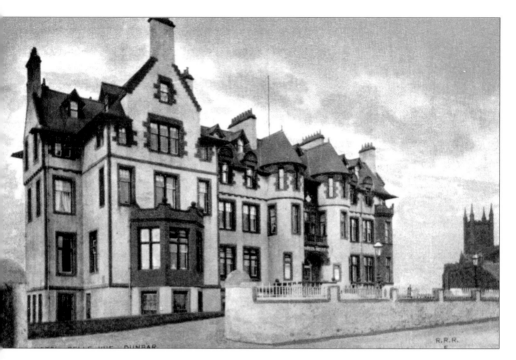

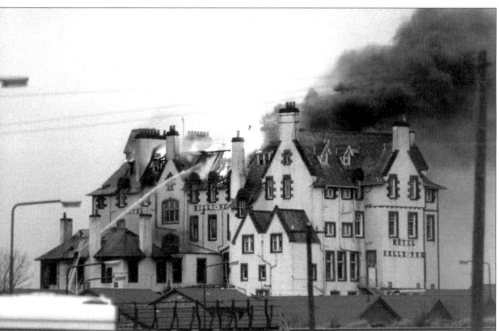

Two images showing the Hotel Belle Vue – one in its heyday in the early twentieth century (top), the other (above) in 1989 with firefighters attempting to contain the flames that would eventually cause extensive damage (© East Lothian Local History Centre)

Mouchel & Partners using the Hennebique ferro-concrete system, with the contractors being Baird Brothers of Port Glasgow, and the estimated cost was £7,000. At 240 feet by 151 feet, with a capacity of 733,716 gallons of sea-water, it was the largest in Scotland. The depth varied from 2.5 feet at its shallowest up to 5.5 feet at its deepest. There was a 7.5 feet depth at the diving area and it was anticipated that would later be deepened when an Olympic-standard diving stage was built. The upgraded pool was opened on 15 June 1929 by Provost Sinton. The array of swimming champions on hand to open the pool was headed by Ellen King.

Two years later, in May 1931, the old pavilion was replaced by a larger, more modern structure that curved around the western end of the pool. The building was substantial, with 170 cubicles, a hall containing seating for 300 people and seating on the terrace around the pool. Six large cupular windows allowed the sun to shine into the pavilion all day. During his speech, the pavilion architect, George Simpson, noted that the numerous improvements in Dunbar of late made it 'the most attractive health resort and watering-place on the East Coast, if not in Scotland'.

When the pool and pavilion were in their dying days the local MP, John Home Robertson, called it 'undermined and eroded'. In November 1984 the site was dismantled and the arguments then moved to whether a new pool would be built in Dunbar.

HOTEL BELLE VUE, DUNBAR

Mrs Fleck, once proprietor of the Royal Hotel in North Berwick, made her way to Dunbar at the end of the nineteenth century and built the Hotel Belle Vue facing Queen's Road. Designed by Dunn & Findlay, its frontage was 120 feet long, it was faced with corncockle stone from Dumfries and redstone from Broomhouse, and it was built in the Scots baronial style. At a cost of over £11,000 it was an extensive venture – around 50 bedrooms accommodated 70 people and the dining room was capable of holding 100. A *North Berwick Advertiser* report at the time of its opening noted that it was calculated to do for Dunbar what the Marine Hotel did for North Berwick. Indeed, an industry journal described it as 'one of the finest and most complete high-class residences anywhere to be found out of London'. The opening ceremony took place on 20 June 1897 – Queen Victoria's diamond jubilee.

Mrs Fleck was described as a woman of sound judgement, business

acumen and much energy. She was also a perfectionist and this can be seen in the 'extras' that pervaded the building – curtains specially made for the hotel, telephones in every corridor, a billiard room, a ladies room furnished with Chippendale and, somewhat ironically as we will learn, fire alarms. Before the hotel's first year of business was over, Mrs Fleck was talking of adding further bedrooms. Her time was, however, limited. In February 1911 she appeared before Edinburgh Bankruptcy Court and left the hotel in May that year. She was obviously still held in high regard by the staff as she was presented with a silver toast rack on her leaving. In November 1911 the hotel came up for public roup with an upset price of £5,100. At this time it had five public rooms, three private parlours, a private bar, a billiard room, a lounge, 45 bedrooms as well as numerous servants' rooms and a motor garage – the last of these having been added in 1903. Locals have recalled that the days, weeks, months and seasons in the year were reflected in its 365 windows, 52 bedrooms, 12 public rooms, seven bathrooms and four floors respectively. It is unclear whether this was actually true or simply an interesting apocryphal tale.

Around 1986 the hotel was taken over by new owners – John and Christine Ward. Less than a year after opening the hotel was once again up for sale. Although the Scottish Development Agency had provided part of the £200,000 necessary for the building's redevelopment, Mr Ward blamed them for not providing the level of financial support they had promised.

In February 1989 a fire tore its way through the building, leaving it a shell. It was believed to have started when a blowlamp being used by a roofing contractor set some timber alight. It spread rapidly as the flames were fanned by high winds, and so severe was the blaze that at one point a dozen fire crews, consisting of 70 firemen, were fighting it. As the building became unstable, with a wall collapsing and a dormer window crashing to the ground, firefighters were removed from the building – two were hospitalised with minor injuries. So severe was the blaze that the flames could be seen in North Berwick. The aftermath revealed that the third floor, function suite and roof had been completely gutted, whilst smoke damage was prevalent throughout much of the remainder of the building. By 1991 the sale of the building was said to be imminent at an asking price of £130,000. In 1992 the hotel was purchased by W.A. Gillespie & Co. and early the following year an application was lodged to create 31 luxury flats within the building, with local builder Billy Gillespie promising an investment of £2 million. By December 1993, whilst attempts were being made to repair the damages caused in 1989, fire struck the hotel once more. Starting in the basement, it took three fire crews several hours to extinguish it, but the damage was limited.

By 2003 attempts were being made, once more, to convert the hotel into apartments whilst retaining the original façade, although council demands for developer contributions were deemed excessive. This, in tandem with poor market conditions, saw the proposal come to nothing. In February 2006 demolition of the B-listed hotel, described by the *Courier* as 'the town's infamous eyesore', finally got underway. Former owners, William and Elizabeth Martyn, were invited to the start of the work and were presented with a stone balustrade from the building. In its place were built 52 apartments; the façade of the new building almost exactly replicates that of the former.

SWIMMING POND, NORTH BERWICK

In late 1899 there was a drive by the North Berwick Swimming Club and Humane Society, backed by the wider community, to raise money to build a swimming pond east of the harbour. It was thought that the sum required to complete the pool was £250. Within a month public subscription had raised this sum and more, with monies coming from a wide array of individuals including a member of the Saxe-Weimar royal family and the MPs R.B. Haldane and J.B. Balfour. In February 1900 the town council approved the

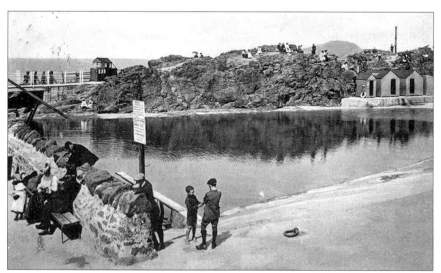

An early twentieth-century view of the outdoor swimming pool at North Berwick (© East Lothian Local History Centre)

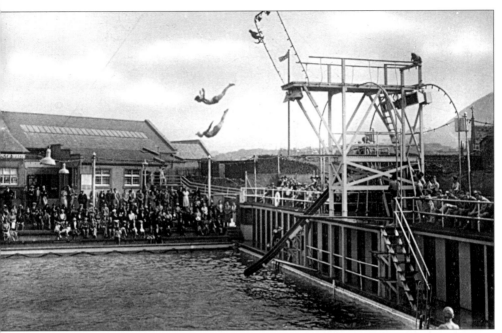

*Synchronised divers perform to a crowd at North Berwick's outdoor swimming pool
(© East Lothian Local History Centre)*

scheme and put almost £40 towards it. Seven months later the pool, designed by Belfrage & Carfrae, was opened – 75 yards in length, 50 yards in breadth, 9 feet deep, with a diving board. The cost of the scheme was not fully covered at this time, but when it was finally met the pool was passed to the town council. One of the concerns, commonplace when new swimming facilities were erected, was that the new pool 'can never be taken advantage of by any lady with a regard to the decencies attending such matters'.

In June 1963 the pool was re-opened after the installation of a £5,000 gas-heating unit. 'The chill,' proclaimed the Provost, 'has been taken off the water.' By the mid 1990s the pool was in its dying days, and the council offered an alternative in an indoor pool. A campaign group called Save The Outdoor Pool (STOP), which included the future leader of the council, Dave Berry, collected signatures for a petition against its closure. Around 4,000 signatures were collected in under a month. In addition an open meeting at St Andrew Blackadder church hall attracted a crowd of those opposed to its closure, with Sir Peter Heatly, the former Olympic diver, in full support. The pool finally disappeared from view in January 2000 when a £130,000 infill scheme got underway. Rocks from Bangley Quarry near Haddington were laid in the hole and this was topped by tarmac.

GULLANE BRANCH LINE
AND RAILWAY STATION

Over 40 years after the opening of the North Berwick branch line, an imbalance still existed whereby the majority of tourists wishing to visit the East Lothian coast mainly headed for North Berwick. This was primarily due to it having its own branch line, and the ease of access that brought. It could be argued that other towns on the coastal strip between Longniddry and North Berwick offered equally attractive options for holidaymakers. Thus, in 1892, it was proposed that a line linking Longniddry and North Berwick, passing through Aberlady, Luffness and Gullane, be built. The scheme was to be overseen by the Aberlady, Gullane and North Berwick Railway Company (AGNBRC). Opposition came from the North British Railway Company (NBRC), despite two of their directors promoting the scheme, and Henry Walter Hope, owner of Luffness Mains, which, he claimed, would be adversely affected by the proposed line. The NBRC was soon brought on board – they would work, maintain and manage the line for 50 per cent of the gross revenue and a dividend of 4.5 per cent for its ordinary shareholders. Mr Hope was appeased by a change in the route of the line. The work was split into two parts: No.1 ran from Longniddry to Gullane and No.2 extended from Gullane to North Berwick. Work started on the first part in 1897.

The station houses at both Aberlady and Gullane were described as 'neatly finished with the usual modern equipments and each has a passenger platform 140 yards long, while ample siding accommodation has also been provided for goods traffic'. The first public train reached Gullane at 8.11 a.m. on 1 April 1898. The line to Gullane seems to have been profitable, and the shareholders received their dividends. It was perhaps this success that drove the NBRC to offer to buy the AGNBRC. On 14 October 1899 stockholders of the AGNBRC were offered stock worth £123,885 in the NBRC. Agreement was rapidly reached and the line came under full control of the NBRC on 6 August 1900.

The success of the venture is without doubt. From 1891–1901 the resident population of Gullane, static for so many years, more than doubled from 243 to 575. The number of passengers arriving at Gullane Station in 1900 was almost 21,000.

The No.2 line from Gullane to North Berwick had not come to fruition in the years immediately after the opening of No.1. A bus service had run from the summer of 1905 until the end of the summer of 1910. In 1915 a petition by the Provost and magistrates of North Berwick calling for the commencement

of work on line No.2 was started. It proved popular, attested by the fact that over three-quarters of the residents of Gullane added their signatures. Then little more is heard of the line; it is argued that its inauspicious end was due to the rise of the bus and motor car, adding that rural lines were, by 1915, a thing of the past, but it may have been due to a lack of funds or as a result of the amalgamation of the AGNBRC with the NBRC.

In 1923 the existing line passed into the hands of the London & North Eastern Railway Company (LNER). The number of passengers in 1925 was a healthy 28,000. By 1929 this had dropped to 4,132. The numbers were almost identical in 1930 and the half-year figures in 1931 showed no improvement. Of the three stations on the Gullane branch line, Luffness was the first to close, in June 1931. Aberlady Station, whose passenger figures had dropped to an average of around 11 per week, and Gullane Station, closed to passengers in September 1932 (the latter would open in later years only for excursions and special railway enthusiast trips). Despite local protestations, organised in part by author and Gullane resident Annie S. Swan, and alternatives being given a seemingly serious hearing by LNER, the line would not re-open to passengers.

The emergence of the bus and car had ended the heyday of the train. The station house became redundant. In order to exact some profit from the line the LNER split it into two and rented it out to holidaymakers. In 1948 the railways were nationalised and the branch line came under the auspices of the Scottish region of British Railways. It closed completely in 1964.

REDCROFT HOTEL,
NORTH BERWICK

The building that was to become the Redcroft Hotel was built at the start of the twentieth century on Ibris Place by the Rev. Robert Brown at a cost of £4,500. Almost immediately Brown sold the building, then a private hotel known as Dunsyre, to the Fourth Provident Investment and Building Society. There was an attempt to sell the hotel in 1905 for an upset price of £4,400, but no buyer was forthcoming and attempts were ongoing to sell the hotel for the next few years until, by 1909, the upset price had dropped to £3,000. At this time it was noted as having six sitting rooms and 26 bedrooms. No tenant, or manager, is noted in the Valuation Rolls until 1909 when a Miss Snowdon is listed. In fact there were two Miss Snowdons – spinsters who ran the hotel until 1919. With the arrival of the Snowdons came the name with which the hotel would be most commonly known – Redcroft.

In 1919 the establishment was purchased by a Maltese hotelier called Maurice Paul Vlandy. Vlandy was an interesting character whose skills extended further than running a hotel; in 1925, along with Bernard Sayers, he patented a golf club that was said to slide more easily across the ground than existing clubs. In 1928 Vlandy oversaw alterations made to the hotel when a conservatory was added, the architect being William James Walker Todd. Vlandy remained the owner for around 26 years. Soon after it came under the control of Redcroft Hotels Ltd. During the 13-year tenure of the group at least two families ran the concern on its behalf – Mr and Mrs H. McD. Turner, and Major and Mrs O. Rees Jenkins. Around 1950 it had three tennis courts, a putting green and a private entrance to the railway station. In 1964–65 the building was taken over by Edinburgh Corporation and run as an old people's home.

In October 1991 the council agreed to demolish the building and replace it with 12 houses and 22 flats. This did not immediately come to fruition and by May 1999 it was being used as a reception area for Kosovan, and later Bosnian, refugees. In October 2001 councillors once again gave permission for the building to be demolished.

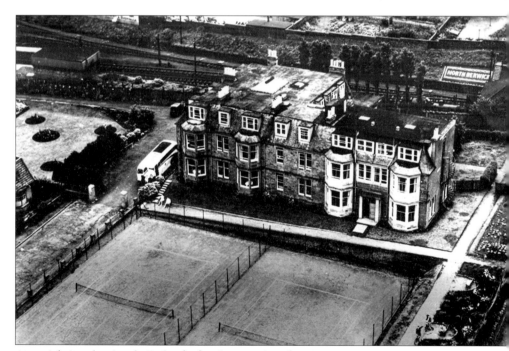

An aerial view showing the Redcroft after the extension of 1928
(© East Lothian Local History Centre)

BEACH HUTS,
GULLANE

Until recently, little had ever been written about the huts on Gullane beach. Research by local historian Bill Nimmo unearthed much information. Most huts were owned by one of two groups – local families looking to supplement their income by letting them to visitors, and families from out of town who would holiday there annually.

It is unclear when the huts were first erected, but it would seem likely that the vast majority came into being after the creation of the Gullane branch railway in 1899 as this provided a source of potential users. A postcard sent in August 1905 shows a plethora of huts lining the front of the sand dunes. By 1935 it was noted in *The Scotsman* that there are 250 huts. The styles of the huts varied considerably, from the standard wooden affair resembling a rectangular garden hut to upturned clipper ship hulls; the Marine Hotel had an extra-large affair complete with verandah. It is likely the interior varied too; Jean Himsworth remembered that one had hanging rails, cupboards, table and bench. The hut owned by the Hoffie family had deckchairs and a Primus stove. The *Haddingtonshire Courier* noted that many huts were capsized in a severe storm in February 1953 and as a result most were destroyed or ultimately removed to build garden huts. Some families rebuilt their beach huts but the less crime-ridden days of pre-war Scotland were gone and vandalism meant that the lifespans of the new huts were short-lived.

TANTALLON HALL,
NORTH BERWICK

The rise of tourist numbers in the twentieth century led to an increased demand on North Berwick's two golf courses. This was addressed to some extent in 1894 when a nine-hole course was opened between Rhodes Farm and the Forth. In order fully to accommodate visitor demand, plans were put in place to build a major new hotel and to extend the Burgh Course from 9 to 18 holes. The upgraded course was opened on 8 June 1908.

The venture to create a hotel overlooking the first hole began in earnest in September 1907 when a joint stock company called the Tantallon Hotel Company was created. Early the following year, land of '2 acres 1 rood 22 poles 4 square yards' was purchased by James Charles Calder on behalf of the company. The opening ceremony took place in brilliant sunshine, preceding the

opening of the new golf course by around a week. The ceremony was chaired by Sir William Gardiner Baird, who toasted the expected success of the venture. The *Haddingtonshire Advertiser* noted:

> The principle façades are towards the west and the north, and have been designed to take advantage of the best views. The entrance is on the west side; in the centre is the entrance porch with a very large verandah on top of [a] terrace for sitting out. At the north angle is a large circle tower surmounted by an embattlement parapet and flag staff. From the top of the tower a very extensive and fine view is obtained. The north elevation shows [a] circular tower on the west side and the five-sided tower on the east. All the building is tinted white, with a red base and string courses. The woodwork is green and white and the roof of red tiles. The design of the building is the simple English style. The grounds extend to nearly three acres, which are laid out with drive and walks. There are also tennis and croquet greens. In a gulley in the face of the cliff has been constructed a special path and stairway, so that visitors in the hotel can get ready access to the new golf course beneath.

The interiors were equally grand, placing it in the top rank of the county's hotels – timber-panelled walls above which sat an Egyptian yellow frieze, dark oak beams in the ceiling, a billiard room and bespoke mantels and fittings. Much of the work was carried out by North Berwick companies; Wilson & Sons (masonry), J. Lumsden (plasterwork) and Thomas Arundel (grates and finishings). Most notable of the non-local contractors was Harrods of London which supplied the fittings. On a plaque above the main door was the name 'Tantallon Hotel'.

During the war it had served as a billet for soldiers who left it in need of extensive restoration. By June 1917 they were gone and the hotel was auctioning off much of its furniture and fittings. Barely a month later the company went into liquidation and by 1919 it was 'empty and awaiting new owners'.

On 18 July 1921 the building was re-opened by an organisation called St Dunstan's, to provide a convalescent home for blinded soldiers from Scotland and northern England. The ceremony was chaired by Sir William Gardiner Baird who had opened the hotel 13 years earlier. He toasted the expected success of the venture. The ex-soldiers who frequented the home would also be taught skills such as writing shorthand, typing and basket making. St Dunstan's was an organisation founded by Sir Arthur Pearson and it was he

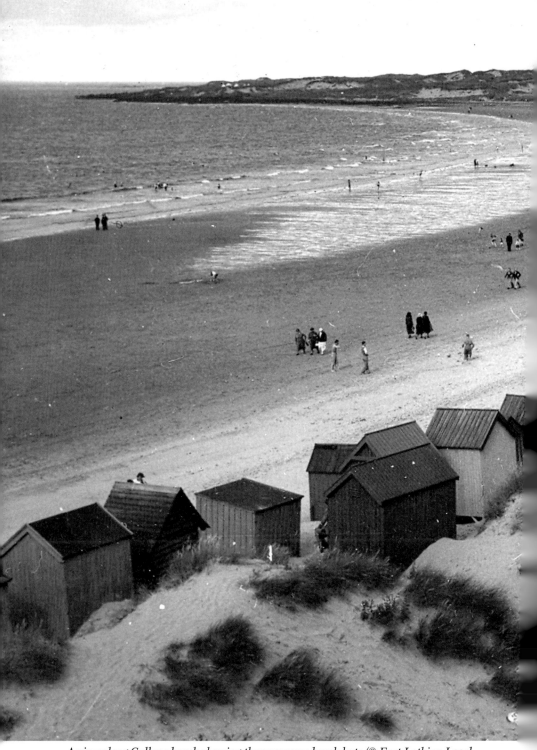

A view along Gullane beach showing the numerous beach huts (© East Lothian Local History Centre)

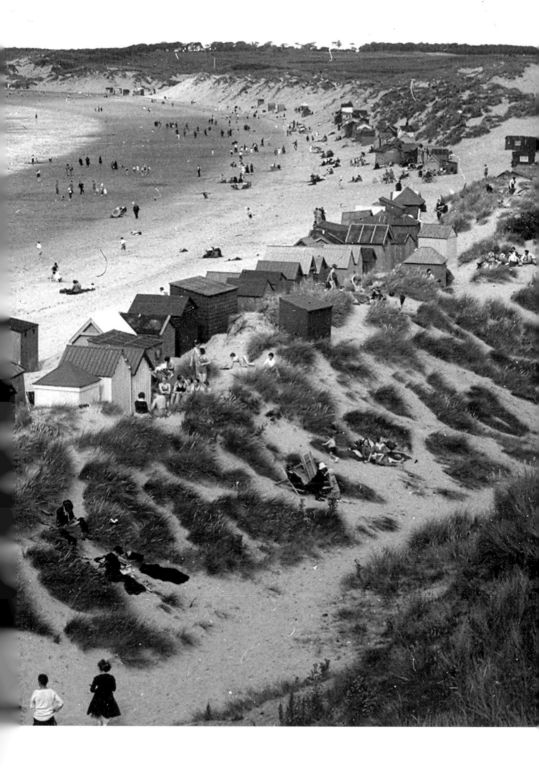

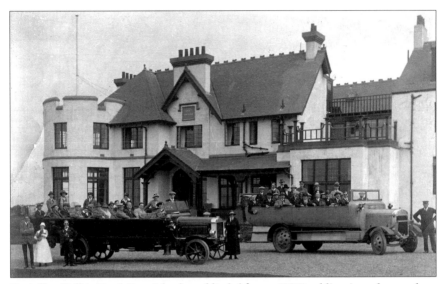

Tantallon Hall in North Berwick, shows blinded former WWI soldiers in and around charabancs at the time it was run by St Dunstan's (Reproduced by kind permission of St Dunstan's Collections & Archives)

who opened the home at North Berwick. The *St Dunstan's Review* gives detailed information about the opening. In attendance were Provost and Mrs Farquharson, Major and Lady Baird, and Lady Polwarth. The plaque above the door was changed to read 'Saint Dunstan's'.

The colourful paints of the earlier hotel, including reds and greens, were replaced by a cream. Chairs and couches were of wicker and brown leather. Although some individual rooms were retained the house now included two dormitories.

Within four years of taking over the building, St Dunstan's let the house out to a group called the Friendship Holidays Association (FHA). This organisation soon purchased the building, using it as a hotel. FHA also hired it out for conferences and meetings; in 1931 the evangelist Theodore Austin-Sparks spoke to an audience at the hotel. The owner of FHA, Henry C. White, called it 'one of our most popular houses'.

In July 1959 North Berwick Town Council, viewing it as a possible clubhouse for the Burgh Golf Club, offered to buy it from White, but swiftly laughed off his valuation of £20,000, noting that it was worth less than a quarter of this. White noted that his desire to sell was purely due to the difficulty in obtaining 'staffs, cooks and manageresses'. At this time several improvements, including roof repairs and the washing of the outside of the building, had been undertaken and the hotel was 'full of guests'. In 1961 Lord

Glentannar's Trust attempted to purchase the building for use as an approved school, but this fell through.

The following year the council had the building valued. At this time it had nine bedrooms, two large rooms, three bathrooms and ample toilet facilities. The general condition was described as 'fair', the internal decoration as 'poor' and the central heating boiler as 'inadequate'. The council finally took over the hotel in 1962, having purchased it, and its contents, for £9,500. Soon after it was purchased it was vandalised by children and numerous windows were broken. The Burgh Golf Club soon dismissed the hotel as a potential clubhouse and this led to the council contacting numerous groups to see if they would take over the building, including the Scottish Caravan Club, Ranco Motors, Marantha Christian Youth Centre, North Berwick Tennis Club, North Berwick Rugby Club and North Berwick Country Dance Club; it was also considered for a sports centre. All refused for one reason or another, with H.J. Cadoux of Ranco noting that there was 'a general air of poor quality about the buildings'. An air of desperation is evident as the council realised that their financial outlay was now a white elephant. Indeed, it was only after they purchased it that they hired Rentokil to survey the building; the estimated cost for disinfestations treatment and renewal of defective timbers and roofs was £5,990. It soon became clear that serious action had to be taken and in October 1965 demolition work was begun by Costello & Sons at a cost of £1,400. By early November the southern end of the building had been demolished and work was expected to be finished by the end of the year. The rubble from the demolition was used to extend the car park at the Law; the remainder was dumped at Rhodes Farm.

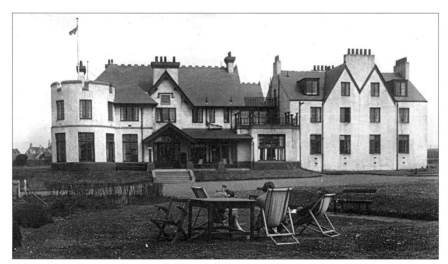

Tantallon Hall in North Berwick (© East Lothian Local History Centre)

CHAPTER 7

SPORT
AND LEISURE

Some sporting and leisure activities have been detailed in the tourism chapter. But whilst certain facilities were built with the sole purpose of attracting tourists many others were created primarily for the benefit of the local communities.

Sport has long played a part in the lives of the people of Scotland. As far back as 1457 early incarnations of golf and football were banned in Scotland by King James II. Shooting for the Silver Arrow at Musselburgh was taking place as early as 1647. Just over a decade later 16 fishwives from the town took part in a foot race to Canongate Cross – the winner being awarded 16 pairs of lamb's harrigals. Around the same time bowlers were playing beside the River Tyne at Haddington. In the early eighteenth century, Gullane was considered to be 'the Scottish Newmarket' as horseracing and training flourished. A golf club was in place in Musselburgh as early as 1774, although it wasn't until 1832 that the first opened outside that town, at North Berwick. In the *Old Statistical Account*, written in the 1790s, Rev. Dr Alexander Carlyle notes that each Shrove Tuesday in Musselburgh a game of football was played between the married and unmarried women of the burgh (the married always emerging victorious). Soon after this date, the Ba' Alley was erected as a sporting venue in Haddington.

Organised sport was beginning to take hold. The county's first curling club opened at East Linton in 1837. From the latter half of the nineteenth century bowling clubs began to spring up, mainly in the east of the county, although early examples can be found in the west at Musselburgh. A plethora of golf courses were founded from the 1850s onwards. So popular was this sport in the county that W. Roberts, writing in 1932, called it 'The Holy Land of Golf'.

At the same time, there was also a growing desire for people to have some leisure time. This was achieved in a range of ways.

Public houses litter the history of East Lothian. In the seventeenth century the small Prestonpans suburb known as Cuthill had 11 such establishments. Many early East Lothian public houses have almost disappeared into obscurity with only their names and sparse snippets of information remaining. The Heather Inn in Haddington was the haunt of the Lammermuir hill farmers. Lucky Vint's in Cuthill was frequented by Lord Grange and Lord Drummore. The White Horse in Dunbar, demolished in 1897, was party to many all-night drinking sessions. It is said that in 1745 the Jacobites arrested government supporter John Home at The Thatched House Tavern in Musselburgh. On the land where Prestonpans Public School was later to stand, was once a 'puny little building' called Preston Tavern.

It was clear, however, to the temperate members of society that workers had to be dissuaded from spending their wages in public houses if social decline was to be combated. Thus we see a rise in outlets where people could take part in social activities without any negative impact. From the late nineteenth century, swimming pools, bathing ponds and boating lakes began to emerge throughout the county, some aimed at attracting visitors from outwith East Lothian, but others built with local residents in mind.

Masonic halls and trade incorporation halls had held a place in many towns for, in some cases, centuries. By the nineteenth century, community halls also began to emerge in great numbers. Look to any town in East Lothian in the nineteenth century and they had some form of community meeting place.

Movies were being shown in East Lothian as early as the first decade of the twentieth century, although these were shows set up in existing buildings such as Tranent Public Hall, Haddington Corn Exchange and Cossar's Yard in Musselburgh. It appears that the first permanent picture house was opened in Musselburgh in 1910 or 1911, whilst two were being constructed in Tranent – one at the Heugh and one at the top of Well Wynd – in November 1912; one in Prestonpans had also been agreed. The emergence of this art form in the county was driven, in great part, by entrepreneurs such as the Codona and Scott families. All of the cinemas erected in East Lothian are now gone (either demolished or transformed) – a victim of changing lifestyles. Cars and improved public transport led to people travelling to picture houses in Edinburgh.

BOWLING GREENS,
MUSSELBURGH AND
HADDINGTON

The bowling green situated at The Sands in Haddington can lay claim to be one of the oldest, if not *the* oldest, in Scotland. It is first mentioned in the burgh minutes of 28 December 1657 when the town council noted that it was to be laid at The Sands and would be enclosed by a wall. Nothing else is heard of this scheme until August 1662 when Patrick Young is paid £160 to lay a green. The next mention of it in the burgh minutes is not made until 1667, when it was put up for roup. The resulting profit was to benefit the town of Haddington. Robert Millar, an apothecary, was successful with a bid of £15. He would renew the contract in October 1669. On the adjoining land he built a three-storey house. The upkeep of the green proved, however, to be prohibitive and Millar gave up his investment. It is not known when the green ceased to be played on, but the creation, around 1749, of a new green 'between the East Port, the water of Tyne and the bridge' suggests that the earlier green was either out of use, or close to being so. This green now hosts the Normandy Remembrance Garden.

To the west Musselburgh boasted greens that pre-date the nineteenth century – one at the east end of the town approved by the town council in 1761 (it is not known whether this was ever erected) and the other west of Inveresk which was in existence by 1783. The remains of neither exist. These are, however, rare examples of early greens and it was not until the nineteenth century that they became widespread. Musselburgh was again prominent, with two greens – beside what is now the car park behind the Bridge Christian Centre and opposite what is now the car park on Dalrymple Loan. Both had been built over by the 1870s. Most of the other examples exist in the east of the county, with one of the earliest clubs being opened at Belhaven in 1840.

WHALE INN, CUTHILL,
PRESTONPANS

The Whale Inn was situated in Cuthill to the west of Prestonpans. Little is known of this tavern other than the fact that a whaler called Thomson was proprietor. Given his profession, neither the name of the inn nor the sign outside that depicted one of these great beasts comes as a surprise. One story, perhaps apocryphal, was that a local minister (some tales say John Davidson,

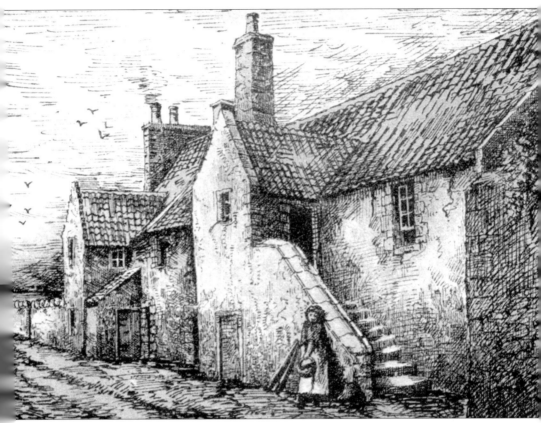

A rare image of the Whale Inn at Cuthill, on the edge of Prestonpans
(© East Lothian Local History Centre)

some say Alexander Carlyle) led a crowd through the town by playing the pipes. Stopping at the Whale Inn he bought beer for those in tow. The parishioners were asked to reciprocate by attending church the following day. This they did and the church was unable to hold all attendees. The Whale seems a logical place for a minister to come and attempt to save souls as it was a haunt of hard-drinking miners and salters. But according to Tulloch it was the oyster fishers who created a song, a sea shanty, about the inn:

> Yo, ho and away we go, revelling amidst the gale, O
> And if guid luck, our lot should be,
> We'll drink the milk of The Whale, O.

When the inn was demolished is unknown but its days as an inn had ended many years previously.

RACECOURSE
AND GALLOPS,
GULLANE

Horseracing in East Lothian today is wholly confined to the town of Musselburgh, but in years past this was just one of a number of racecourses and training centres dotted around the county, with West Barns and Haddington having facilities. The most famous of them all, however, was Gullane.

Lying just west of the Gullane and sitting on a promontory jutting into the Firth of Forth was the Gullane racecourse and training gallops. When it was put in place is unclear, but certainly it appears on Forrest's 1799 map, but not on Roy's military map from the middle of the same century. As a racecourse it garnered the greatest plaudits. As well as being known as 'The Malton of Scotland', it came in for praise from those immersed in the intricacies of the horseracing world. In 1828 respected equine writer Richard Darvill pronounced that Gullane 'is the best, and I believe the only ground in Scotland which will answer the purpose of training racehorses. The surface of this ground is a sandy soil, plentifully covered with moss, which makes it very soft and elastic for horses' feet.' The famous quartet of Dawson brothers believed it to be the best course they had come across. Such legendary horses as Lanercost and Chanticleer were trained there.

In the early 1890s a horse trainer called Richard Cowe, who used the gallops to train his horses, was taken to court by Mrs Mary Georgina Constance Nisbet Hamilton Ogilvy of Belhaven in an effort to remove him from the land. Ogilvy claimed she owned the land, known as Gullane Common, whilst Cowe contested this assertion. In September 1892 the judge found in favour of Mrs Ogilvy, thus signalling the end of horse racing and training at Gullane.

In the first quarter of the twentieth century, many years after the course had succumbed to the nineteenth-century obsession with golf, what had once been the gallops were visited by Major J. Fairfax-Blakeborough who expressed awe at the 'cushion-like velvet turf . . . as old, deep, and springy as that at Hambleton in Yorkshire'.

KING'S ARMS,
HADDINGTON

The King's Arms was situated at Haddington, in the Hardgate, opposite the George Inn stables. It was a plain building set back from the pavement and fronted by a low wall. Seven windows, two of them dormers, were unevenly situated across the façade looking out onto the street. Henry Laidlaw, once a stipendiary magistrate in Jamaica, started up the Haddington coach from the inn in the early nineteenth century and this continued until 1828. The approach of a coach was heralded by a blast of the trumpet. It was later occupied by Mr Whitehead. During this time a farmers' club, known as Whitehead's Club, frequented the hostelry. Some years later it was described as home to 'scenes of mirth, hotly-contested debates, and political and municipal scenes of excitement'. The building was no longer an inn by 1855. In 1908 the building was owned by Rosina Laidlaw, niece of Henry, and she had split the building into 11 separate dwellings. At the start of the First World War it was noted as being 'in a decayed condition' and 'now occupied by the working class'. From 1917–29 much of the building was in the hands of the Holy Trinity Church who let out rooms for a month at a time. It was pulled down in 1930 or 1931, a rather forlorn-looking structure, to make way for a more modern building.

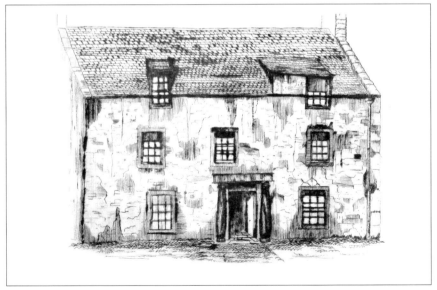

The King's Arms public house in Haddington's Hardgate (© East Lothian Local History Centre (Groome Collection))

STAR INN, HADDINGTON

At the eastern end of Mid Row in Haddington (the clutch of buildings between High, Market and Court streets) once stood a school. In later years it became a 'respectable hostelry' called the Star Inn, or Star Hotel, and served as a meeting place for Haddington Agricultural Club. On the front of the building, facing down the High Street, was a yellow star. For around 30 years its landlord was a Mr Scott. After he gave it up it passed to the Roughead family who used it as a private house. Part of it at this time was used as a dispensary by Dr John Welsh, father of Jane Welsh Carlyle. It was then taken over by Stephen Murray who once again used it as a hostelry. It was demolished around 1858 and replaced by the current building which originally served as the City of Glasgow Bank.

BA' ALLEY, HADDINGTON

The Ba' Alley, or Ball Alley, is believed to have been a gift to Haddington's youth from subscriptions raised by soldiers quartered in the town. It was erected around 1819 or before, originally in front of Swinton's House, but later moved to The Sands. It seems that this had traditionally been a place where, each Shrove Tuesday since 1799, masters and students from the Grammar School would play each other in a ball game.

In March 1873 the *Courier* provides the first evidence that all is not well with the area. Councillor John Burleigh proposed that any holes should be filled in time for the season's play. In July 1882 it was again noted that it was being neglected. By 1892 certain members of the council had clearly had enough of the structure. In a speech described by the *Courier* as a 'deed of derring-do', Bailie Watson proposed that it be removed, arguing that its principal use was 'sheltering tramps'. Mr Stirling added that it was an 'eyesore'. Others moved that it should be retained and that its previous neglect by the council should be reversed by a general scheme of improvement. Those proposing removal of the structure were defeated by twelve votes to four. A decade later little had changed and the matter was once again being debated. Once again the committee agreed to improve the ground. In 1900, during the second Boer War, a giant bonfire, 60 feet around the base and 15 feet high, was built to celebrate the surrender of Pretoria. It was topped with an effigy of President Paul Kruger, the face of Boer resistance. But the Ba' Alley's days

Two images of the Ba' Alley in Haddington. The top picture shows it standing just prior to its demolition in 1904, the other just after (© East Lothian Local History Centre)

were numbered and in March 1904 it was once again debated as to whether it should be removed. Those proposing its removal won out by ten votes to six. Despite a later attempt to rescind the result on 28 April, the structure was removed and Mr Coulter, a local builder, purchased the fabric for around £3.

WHITE SWAN INN AND RIFLE ARMS, HADDINGTON

At Skinner's Close on Hardgate, next to where the garage now stands, once stood the White Swan Inn, the oldest public house in the burgh. Above its door was the message:

> As swans do like the water clear
> Step in here and drink good beer

Run by a Mrs Telford and then Willie Nisbet (known as 'Stitches') it was likely not the most respectable of the burgh's pubs, its licence being denied for 'the good of the community'. In 1861 the inn was taken over by David Philip, a Crimean War veteran, and swiftly renamed The Rifle Arms. He ran it as such until 1876 when he retired. It was taken over by a Peter Flynn who seems to have turned it into a dwelling house. The building was demolished in 1915 by local builder Richard Baillie. After its removal the site soon housed the New County Cinema.

HADDINGTON GOLF COURSE, GARLETON HILLS

The Haddington Golf Club came into being in 1865 and still exists today. For the majority of its history it has played at Amisfield. The club's home was here in its early years, playing only in the winter months. Its tenure lasted 16 years when permission to use the land was withdrawn and the members were forced to look for alternative arrangements. In December 1881 they moved to a new course situated on Byres Farm at Garleton. It was 'rocky, and here and there interspersed with whins' and only used from October to February 'owing to the very exposed situation and the roughness of the turf'. The members viewed this arrangement as not altogether satisfactory and in 1886 representations were made to the Earl of Wemyss regarding moving to land between Gosford

A plan of Garleton Golf Course, near Haddington (© East Lothian Local History Centre)

estate and the Forth. He refused. In 1894 permission was granted to use the course all year round. One of those who granted this permission was the Earl of Wemyss and on his first visit to the Garleton course he made a hole in one at the fifth. In May 1931 the club, after further attempts to move from Byres, returned to Amisfield where they remain today.

LUFFNESS OLD GOLF CLUB, ABERLADY

The founding of the Luffness Golf Club came in 1867 when a number of 'persons interested in golf' met to discuss the creation of a club. From this meeting came an approach to Henry Walter Hope for permission to use his land. Hope granted it, the cost to the club being 1 shilling per annum. To reach the course one would cross the Timmer Brig from Aberlady. Immediately in front of the bridge was the clubhouse – the south side covered in earth and turf so it did not interrupt the views from Luffness House – the ruins of which were not demolished until 1946. The holes, laid out by the legendary 'Old' Tom

A plan of Luffness Old Golf Course at Gullane (© East Lothian Local History Centre)

Morris, had for the most part mundane names, the anomaly being Jovas Neuk. An eighteenth hole was not created until 1872 – prior to this games were played over 17 holes with one respected local golfer noting of the seventh hole that it was 'the most difficult in the world bar none'. In 1869 a match was hosted between Bob Fergusson of Musselburgh (a future triple Open winner) and 'Young' Tom Morris (the reigning Open champion). Morris would win by 10 shots over the two rounds. The membership roll of the club included some of the great and good of the golf world, including 'Old' Tom Morris and John E. Laidlay.

The course garnered praise from many quarters. A pre-1896 poem by Alexander Gilmour, a master at Edinburgh Academy, read:

> The wide expanse along the hill,
> Wi' bunkers neither few nor sma',
> The view of Aberlady Bay,
> Mak' Luffness Links the best of a'.

However, all was not well. In 1883, Hope, who had given his land over to the players, was disturbed at the number of golfers playing at the club. Negotiations saw a new lease being drawn up with clauses to stop non-

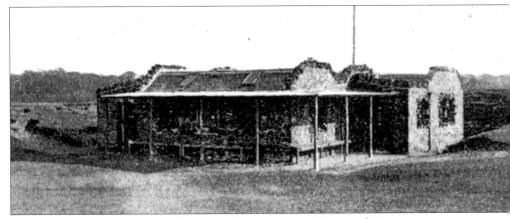

The clubhouse at Luffness Old Golf Course, Gullane (© East Lothian Local History Centre)

members playing, and also to stop dogs being brought onto the course. In 1892–93, Hope had 'Old' Tom Morris design another course, to be called the Luffness New Golf Club (a name that resulted in Luffness Golf Club becoming known as Luffness Old). Hope used the following years to attempt to persuade the members of the old club to move to his new venture. This failed. The members of the old club were determined to remain at their present home. In 1897 they offered a rent of £120 per annum for a 21-year lease. This offer was refused by Hope. The club then approached the Earl of Wemyss with a request to take over the lease of the Craigielaw Links. This was agreed and in 1898 the club moved into its new home.

CRICKET PITCHES, HADDINGTON

The Haddington Cricket Club was founded in 1872 and its early years were transient. The first pitch was at Byres in the Garleton Hills and the team thereafter played on pitches at Clerkington Acredales, the Haugh and West Hope Park. In 1882 the team moved to Brewery Park, behind the County Buildings, and this was to remain their home for 32 years. The pitch was re-turfed soon after the club took it over at a cost of over £51. The ground was still, however, considered too hard and matting was put down when necessary to help avoid injuries. In 1912 it was decided to apply clay to the wicket and this resulted in some incredibly low scores – Pentland, for example, being beaten 30–27. In 1914 the team vacated Brewery Park as it was being used in the war effort.

Unbeknown to the club they would never return. They were offered a home at Neilson Park and duly accepted. This remains their home, although their tenure there was interrupted by a 30-year sojourn to Knox Academy Playing Fields brought about initially by the need to use Neilson Park to grow vegetables during the Second World War.

FORESTERS' HALL, NORTH BERWICK

From the early nineteenth century, friendly societies began to emerge in great numbers throughout the country, driven by a desire by communities to protect themselves against the financial difficulties brought about by sickness, death and unemployment. At the same time they provided a strong social outlet, taking part in annual fairs and organising all manner of entertainment for their members. Often the halls created for friendly societies were of a substantial build and as a result many remain today, such as the Foresters' Hall in Haddington (now the Masonic Hall). Others stood in the way of 'progress' and succumbed to the developers' hand.

One of these was the Foresters' Hall in High Street, North Berwick. Work on the building began in December 1886 when the foundation stone was laid. When the structure was being erected a bottle was inserted into a cavity. Inside it was a copy of the *Haddingtonshire Courier*, various documents and a gill of whisky from the local Golfers' Rest tavern. One of the documents noted that attempts had been made to include a coin, but one with an appropriate date could not be found. Designed by J.W. Hardie in the Scots baronial style, the *Courier* noted that it would be 'an ornament to this part of the town'. The red sandstone façade rose 40 feet from the pavement and was topped by castellated features, a turret and crow-stepped gables. On the ground floor, flanking the front door, were two shops. The upper floor was made up of two houses. The main hall measured 60 feet by 40 feet with walls 8–10 feet high, had a stage 25 feet wide by 15 feet deep and was capable of holding a capacity of over 800 people. It was decorated with varnished pitch pine. There was an apartment at the rear of the building. The total cost was around £2,100.

The work was soon finished and the opening took place on 8 April 1887. Despite opposition from local ministers to the event taking place on Good Friday, a vast array of societies and groups proceeded through the town, led by Robin Hood on a horse, always a central figure in Forester ceremonies. On completion of the march the attendees made their way into the flag- and

bunting-draped hall where they were entertained by local MP R.B. Haldane, who spent much of his speech poking fun at Rev. F.L.M. Anderson, ringleader of the protest. The meeting was followed by dancing that started at 11 p.m. and did not end until 6 a.m. the following morning.

In 1904, J.W. Hardie, the hall's architect, drew up plans for an extensive addition to the building and this, as at the ceremony 17 years previously, was opened by R.B. Haldane. The hall was extended by 26 feet in length and the stage to the full width of the hall. The heating was upgraded to allow the building to be heated from hot-water pipes. Behind the hall a tenement of four houses was erected facing St Andrew Street, and a dressing room, armoury and refreshment room were added. The cost was over £2,800 – more than the original build. Costs were recouped, to some extent, by letting the building out to societies and groups. In 1909 the hall was being used by roller skaters. In 1910 it hosted a suffragist meeting that was disturbed by youths, and by 1923 it was a full-time movie theatre.

When the hall was being demolished in March 1938, the bottle that had been deposited in the foundations 52 years earlier was found.

HEDDERWICK HILL GOLF COURSE, DUNBAR

Hedderwick Hill came to prominence as a golf site in 1890 when the Honourable Company of Edinburgh Golfers, seeking a new home due to overcrowding on the course at Musselburgh, highlighted it as a potential links course. This land had been known as the West Barns Links and had previously housed the Dunbar Golfing Society. The interest of the Company came to nothing. Railway access has been noted as a reason for rejection, although a newspaper article of the time notes that one obstacle was the landowner's reluctance to give a long lease. In 1895 it was noted that local worthy St Clair Cunningham was to lay out a nine-hole course on the site and this came to fruition in 1897. So involved was Cunningham that it is believed that he designed the course as well as paying for it. He soon realised that the course would require 18 holes if it were to attract the best of clubs and players. Thus, in 1901, the extended course was opened. A report in the *Courier* hailed it as 'an interesting one from start to finish', highlighting its fine views, good quality sand, tough, elastic turf and unique island hole – a hole that was just that, on an island. Despite the unexpected death of Cunningham in 1906 the course continued to flourish. It was widely considered to be 'a tricky course' but that

did not stop James Braid setting a world record low round of 57 in 1912. The course was not home to a specific club, but attracted clubs from across East Lothian and the east of Scotland.

The war years led to the land being damaged by troops practising the digging of trenches. It took some time to re-establish, first as a nine-hole course and then, in 1924, to the full 18 holes. In the 1930s two events occurred that signalled the end of the course. In 1934, the Winterfield Links was opened, the third course in the Dunbar area. Three years later Elizabeth Cunningham, the widow of St Clair Cunningham, announced that she would no longer continue to fund the upkeep of the course. The greens from Hedderwick Hill may well have been transferred to Winterfield Links, although whether this actually happened is unclear.

THE SCRATCHER, PRESTONPANS

Work on a cinema at Prestonpans was underway by October 1912. In 1913 the 495-seat cinema, owned by the Codona family, was opened. There were plans to erect a second cinema at nearby Cuthill but this does not seem to have come to fruition.

In 1919 fire caused £1,000 of damage, but fortunately patrons exited the building safely and no-one was injured. By 1931 it was known as Biddall's Picture House. The management prided itself on introducing the latest innovations before neighbouring towns. In 1954 Cinemascope was introduced and

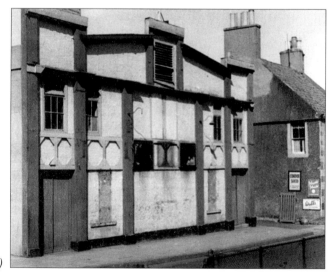

Prestonpans Picture House, also known as The Scratcher (© East Lothian Local History Centre)

top-of-the-range seating was fitted. Falling attendances, brought about by women customers flocking to bingo halls, saw the beginning of the end for the cinema. That it was not the most hygienic of interiors is clear from its colloquial name – The Scratcher. If any further proof was needed, Janet Neilson recalled people claiming that you went in with a jersey and came out with a jumper, whilst Janet McCran noted:

> But all you folk that still recall the Scratcher seats when winching
> Remember, please, the hordes of fleas, that surely got a lynching!

By 1960 the town council was intent on widening the High Street, and as a result of this The Scratcher was closed on 6 August 1960 and demolished soon afterwards. The final film was *Follow A Star* featuring Norman Wisdom.

VICTORIA BALLROOM, DUNBAR

The central section of Lauderdale House, also known as Dunbar House, was built in the early eighteenth century at the behest of Captain James Fall, and was extended at the end of that century by James Adam. The house was purchased by the military in 1855 with a view to creating a barracks where members of the militia and the Volunteers could be trained. From 1909 until 1912 the existing buildings were upgraded and new ones erected. Opened in 1913, the old wing of Lauderdale House had been reconstructed, while a forge,

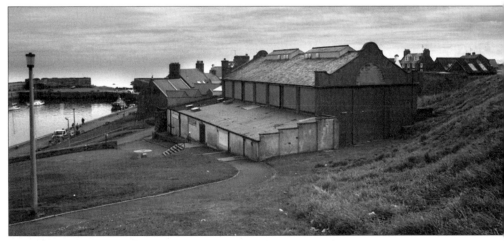

The Victoria Ballroom in Dunbar, in the years just prior to its demolition in 1989
(© East Lothian Local History Centre)

shoeing shed, guardhouse and gymnasium had been built from scratch. Only the gymnasium was not built of stone, being constructed of harled bricks. And it is this building in which we are interested.

Standing to the north of Lauderdale House, it measured a substantial 80 feet by 40 feet and was capable of holding large numbers of people – this facilitated its conversion, in 1963, into the Victoria Ballroom. In 1962 the War Department sold the barracks to the county council and the following year contractors gutted the building and sanded the otherwise excellent floor. A car park was added by knocking down part of the wall facing the harbour. Architect Douglas Laird advised on furnishings and decoration. The conversion cost over £12,000; the vast majority was paid by the county council and the remaining £2,000 paid by the town council. At the opening ceremony on 22 November, which took place only two hours after the assassination of President John F. Kennedy, Provost H. More said 'this is a place in which the young people of the burgh and their friends can enjoy themselves'. He then handed over to Larry Marshall, comedian and star of *The One O'Clock Gang*, who formally opened the building and then called for the band to play a twist. The following years saw it play host to a number of up-and-coming and established bands such as Sweet and The Yardbirds. The ballroom almost came to a premature end in August 1967 when a gas explosion blew the town's publicity officer, J. Cairns Boston, through a plate-glass window. The following weekend's music, to be provided by Dave Berry and the Cruisers, was postponed. The Ballroom was still in use as late as December 1985 when it hosted a Live Aid-style concert.

In 1986 the South of Scotland Electricity Board approached the district council with a view to utilising the building as a media briefing centre should an emergency occur at Torness Nuclear Power Station. Councillors raised initial concerns that it was hoped to once again use the building as a leisure facility, as part of the Dunbar Initiative, a project whose aim was to regenerate the local economy; the proposed scheme was thought to be detrimental to this aim. But the ballroom's days were numbered and it was finally demolished on Christmas Eve 1989, making way for new housing as part of, ironically, the Dunbar Initiative.

CINEMAS, HADDINGTON

The early history of cinema in Haddington is not clear. An advertisement in February 1913 noted that a cinema would be re-opening at the Ball Alley,

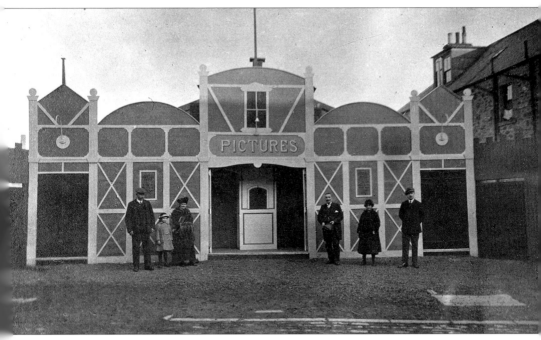

Codona's Picture House in Haddington, 1914. Mr Codona is the gentleman holding the hat (© East Lothian Local History Centre)

suggesting that one had existed prior to this date. This cinema, owned by the Codonas, was still open in January 1915. Another existed in the Corn Exchange at least as early as October 1913. This one closed in October 1914 when the building was used to house troops at the start of the First World War. Almost immediately the owners of the cinema applied to open another at Hardgate, although no further detail could be found. Cinemas would remain in this spot for over 75 years.

In February 1918 a temporary affair opened in the Hardgate. Most newspaper reports gloss over its temporary nature, only the *Haddingtonshire Advertiser* making mention of this. The intention was to rebuild as a permanent structure when masons and tradesmen were not wholly focused on the war effort. Despite its wooden façade, it was not as ramshackle as one might think. The 450 movie-goers would sit on tip-up upholstered chairs and the *Advertiser* called it 'a tidy, nice comfortable place to pass an hour or two . . . cosy, compact and well designed'.

After much debate within the town council, and the gentle persuasion of local lawyer William Murray, it was decided that Haddington would build its first permanent cinema, in the Hardgate – to be called the New County Cinema.

The cinema project was undertaken by Scott & Paulo, and was formally opened in March 1933 by Provost William Davidson, who praised all involved and added that he would like to see 'pictures which would instruct, amuse and elevate' and none to which 'even the most fastidious could take exception'. The architect, W.W. Reid, designed it on 'modern cubist lines', and it was built of white cement with a black base. Cinemagoers would enter through three swing doors into a large foyer, from which a wide staircase would lead up to a lounge decorated in silver and pink. The cinema interior was decorated in 'blending shades of orange and yellow, with black dado panelling in red Japanese lacquer', while the proscenium had 'Chinese blue walls stippled in gold at the sides of the curtain'. The building could hold between 500 and 700 cinemagoers, 150 of whom would be seated in the balcony area. Most of the work on the building was done by local contractors, and by the end of the project 97 workmen had been employed in bringing it to fruition.

Disaster almost struck in March 1941 when a German bomb fell only yards from the cinema, whilst numerous people sat enjoying a movie. The cinema's days were, however, numbered. Up to the early 1950s it was common for film to be made of cellulose nitrate, an extremely flammable substance that is difficult to extinguish when on fire; even submerging it in water does not always put it out. It was probably this type of film that was running at the cinema on the evening of 1 December 1944. The film ignited in the projector and was thrown from the operating box into the adjoining passageway. A fire was soon raging through the building and by the time the fire brigade arrived it was out of control, burning from one end of the building to the other and hot enough that the asbestos slates were crackling. Although unable to save the building, the fire brigade did stop its complete spread, saving the foyer and lounge, and preventing it setting alight the neighbouring Rose's Garage.

The damage was extensive and the building was demolished. It was clear that the town required another cinema and within a week of the fire the owners of the building placed an advert in the *Courier* announcing plans to rebuild.

The new cinema, designed in an art deco style with long yellow windows in the frontage, was opened on 18 February 1946. Strangely the opening only warranted a few words in the local press, which noted that it had 'modern projecting apparatus, [an] up-to-date sound system, and wide spaces between the rows of seats'. It stopped showing films in 1966 and began to run bingo from Friday through to Sunday. There was talk that the council might run the cinema but this came to nothing. It was finally demolished in July 1991. Just prior to demolition, its façade was white with red doors.

SMEATON WELFARE INSTITUTE,
INVERESK

In the 1920s an organisation called the Central Welfare Committee was set up, its aim to upgrade 'recreation, health and education in the mining areas'. To facilitate this, 1 pence was levied on every ton of coal produced. The monies raised went towards, amongst other things, creating welfare institutes, either by building anew or refurbishing existing buildings. In general these were substantial structures and as a result many still stand today.

Given its small size, the mining village of Smeaton was relatively well endowed with amenities for those who lived there. As well as its own co-operative store (p. 128) it also had a Miners' Welfare Institute. Built on land gifted by the Duke of Buccleuch, and designed by Colonel Gavin Paterson, the Institute was opened in November 1925. The £2,500 it cost to build paid for a hall, a recreation room with two billiard tables, retiring rooms and an operator's room for a cinematograph. The building was formally opened by Mrs A.G. Moore, wife of the owner of Dalkeith Colliery, who gifted a piano. The building remained in use until it was demolished around the same time as Smeaton Village in the 1950s (p. 68).

PRESTONGRANGE WELFARE INSTITUTE,
PRESTONPANS

The Prestongrange Welfare Institute, situated at Cuthill, was known locally as the West Welfare Institute, and was designed by Alexander Murray Hardie, the architect of its sister institute at Prestonlinks. It was opened in December 1925, having cost around £4,500 to erect. The Institute at Cuthill primarily served miners from Prestongrange Colliery, many of whom lived in the rows of terraced houses situated in the area. Built of brick and roughcast, it housed a reading and recreation room, the billiard room that graced most institutes, and a hall capable of seating 400. Attached was a caretaker's house with three apartments. It was demolished around 1989, along with much of Cuthill, to enable the widening of Prestonpans High Street and the building of modern housing.

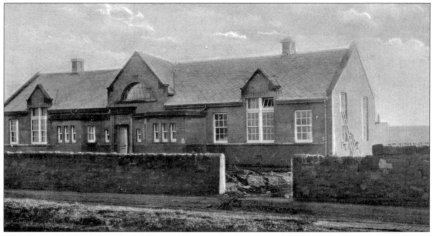

The Prestonlinks Miners' Welfare Institute, also known as the East Institute, around the time of its opening in 1926 (© East Lothian Local History Centre)

PRESTONLINKS WELFARE INSTITUTE, PRESTONPANS

The Prestonlinks Institute, known locally as the East Institute, was a purpose-built one-storey rectangular building fronted by a bank of windows facing the Forth and located midway between Prestonpans and Cockenzie. It was designed by Alexander Murray Hardie, at a cost of around £5,000, and opened in January 1926. The largest of its windows, along with the doorway, were topped by gable roofs. The material was terracotta brick, red stone and yellow plaster. The roof tiles were a mix of blue-grey asbestos and terracotta. The building housed the standard requirements of any self-respecting welfare institute, including a library, billiard room and games hall. The 'East' Institute was demolished around 1962 to make way for the Cockenzie Power Station.

SWIMMING POOL AND POND HALL, PORT SETON

On a sunny day in June 1932 an open-air swimming pond at the east end of Port Seton was opened. Proceedings began with the throng of spectators being entertained by the Prestonlinks Colliery Band. The opening ceremony was performed by Major Gilbert Rowan, general manager of the Edinburgh Collieries Company, who had played his part in the construction by providing

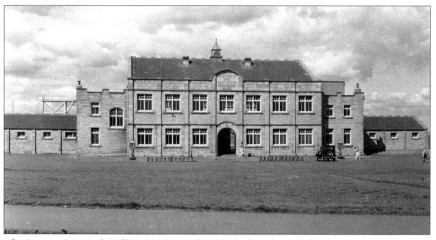

The impressive Pond Hall at Port Seton (© East Lothian Local History Centre (Gordon Collection))

the use of wagons to transport bricks to the building works. Great praise was given to Bailie Weatherhead without whom, it was noted, the scheme would not have happened. The pool cost £3,000 and whilst much of it was built by contractors, local volunteers did lend a hand. It is made clear in newspaper articles detailing the opening that Port Seton was attempting to compete with neighbouring towns in attracting visitors and it was felt that the new pool would go some way to achieving this goal.

After the success of the new open-air pool, plans were laid to create a hall adjoining it. The Pond Hall, designed by local architect John McAra, was opened in 1933 and consisted of tea rooms, a committee room, a town council room and a recreation hall with stage capable of holding 600 people. This room had a floor of pitch pine to enable it to be used by dancers. Bathers were provided with cubicles. Hot-water pipes heated the whole building. On the northern side of the hall was a 70-foot-long by 25-foot-wide verandah and a covered stand 130 feet long by 30 feet wide, capable of holding up to 3,000 people. Most of the contractors came from surrounding towns. The final cost of the hall was around £5,000 and was opened by Captain J.H.F. McEwan, MP for Berwick and Haddington. The ceremony was followed by a swimming gala, the premier event of which was the Scottish Women's Diving Championship. Ellen King, better known for her exploits as a swimmer, won the competition.

In 1963 the town council, looking with envy at the huge crowds at North Berwick's heated outdoor pool, began to consider whether theirs should be heated too. It was felt that a failure to heat the pool would have a negative

impact on tourism to the town. The following year heating was introduced.

By 1989, however, the future of the Pond Hall was in doubt and plans were being drawn up for alternative uses, one of these being an ice rink. The pool was used for the last time in August 1993, although it was not known at the time that its days were over. In the final week before the council decided to close the hall, painters had been working in the building, suggesting that the closure was unexpected in council circles. In late 1995 a community organisation called the Pond Hall Action Group (PHAG) put forward a £3 million business plan to resurrect the hall – this included a swimming pool and sports hall. With the support of the local MP, John Home Robertson, a petition was collected with 4,000 signatures. There was a final attempt to halt the demolition when PHAG's lawyers requested the Court of Session review the decision by East Lothian Council to demolish. Their appeal was turned down and within a month the bulldozers had moved in and were flattening the building.

THE PLAYHOUSE CINEMA,
DUNBAR

Dunbar's second cinema, The Playhouse, was formally opened in June 1937, although it had been showing films for a month prior to this. The genesis of the building can be found a year earlier when Caledonian Associated Cinemas Ltd was asked to provide the town with a 'super cinema'. Designed by Alexander Cattanach and opened by J.H.F. McEwan, MP, it was capable of holding over 1,000 moviegoers and was shaped in such a way as to remove echoes and reverberations. It was described by McEwan as 'magnificent and palatial'. One of the films shown at the opening was the coronation of King George VI.

By the 1980s The Playhouse was struggling and was closing its doors during the winter months. The final programme was shown in November 1984 and the building was pulled down in May 1985 to make way for a new health centre.

THE PLAYHOUSE CINEMA,
NORTH BERWICK

The closure and subsequent demolition of the Foresters' Hall in North Berwick allowed the building of a modern cinema capable of holding 863 patrons (although the manager Tom Scott later revealed that many were allowed to

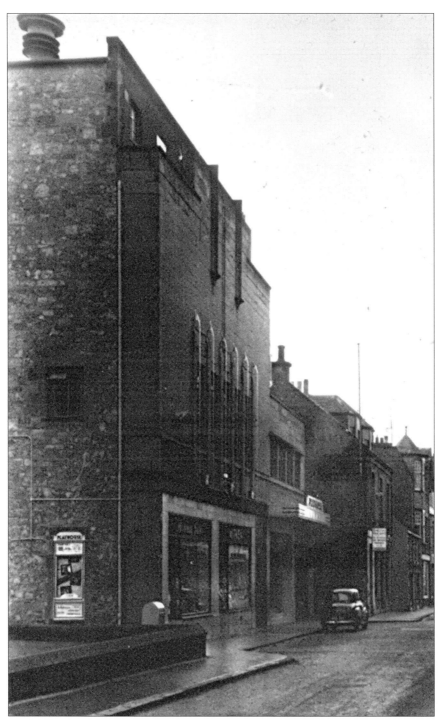

North Berwick Cinema (© East Lothian Local History Centre)

stand, frequently bringing the number in the hall to around 1,000). As detailed on p. 174, a time capsule was found when the Foresters' Hall was being demolished. A new capsule was inserted into the foundations of the new cinema and included was a bottle of whisky and, this time, some coins.

Designed by John Ross McKay, it was built of pink sandstone in an art deco style, similar to many other cinemas of the time. It was opened on 7 July 1938 by Lady Colquhoun of Luss. The owners certainly attempted to keep up with the latest developments, with a 22-foot-wide screen being placed within the proscenium to allow the showing of Cinemascope movies. The opening night's two shows attracted a total audience of 2,000 people. Soon after, its advertisements in the *Courier* revealed its subtitle – 'The House of Pleasure'.

In March 1973 an attempt was made by Caledonian Associated Cinemas to use the building for bingo. This created controversy and a petition was raised against it. The cinema was closed in August 1983 after operating at a loss for some years. According to Tom Scott, whose family had opened the cinema and run it for its whole tenure, its demise came as a result of high heating bills and falling attendances due to the rise in popularity of the television. The building was demolished in December 1986 and, some might say, was helped along with a little divine intervention. In the church next door to the cinema Rev. Walter Ferrier was reading a passage from St Matthew's Gospel. When he read the line, 'verily I say unto you not one stone shall be left standing on another before the end comes,' the eastern wall of the cinema collapsed, some of it falling into the church grounds.

CHAPTER 8

EDUCATION

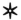

Before the Reformation, education was mainly available for those who intended to enter the church. It was primarily the sons of the wealthy who saw the benefits. An Act passed by James IV in 1496 called for the sons of 'Barons and freeholders' to be well educated in Latin before passing to university. Others did, however, benefit. An exchequer roll of 1384 notes the king paying for 'the sustenance of a certain poor scholar presently at the schools in the town of Haddington'. The first major step towards an inclusive education system came in the immediate wake of the Reformation. John Knox's *Book of Discipline* held that every parish should have a school. This failed to be fully implemented but the post-Reformation leaders did attempt to ensure a better educational grounding for young men, allowing, as one writer put it, 'the soul of Knox's policy [to go] marching on'. The Education Act of 1696 finally enforced this aspiration, making it incumbent on the heritors of each parish to provide a school and pay a schoolmaster.

By the eighteenth century landlords, driven by the agricultural revolution, were aware that in order to progress their estates they would need to hire educated men – men who could manage finances and could understand the complexities of growing crops and building agricultural machines. As a result, schooling of the masses became more widespread. The number of schools began to grow throughout the county in the nineteenth century and by the latter half of that century there were more children being educated in Haddington than anywhere outside Edinburgh. Some of the schools were small, private affairs, there was a Ragged School and, from 1878, the Knox Institute catered for all classes.

Whilst the state began to implement a more rounded education system, men took it upon themselves to supplement this. A School of Arts opened in Haddington in 1821. Mutual Improvement Societies, Literary Societies and all

manner of libraries sprang up throughout the county. In the twentieth century almost all Working Men's Institutes had a reading room filled with books and newspapers.

The introduction of the Education Act in 1872 brought about vast changes to education in Scotland. Parochial schools were taken under the wing of school boards. Prior to this date many children slipped through the net of education. In the aftermath of the Act it was a legal requirement for all children to receive, at the very least, an elementary education. As a result three secondary schools were established, in Haddington, North Berwick and Dunbar. In 1918 the Act was superseded and school boards were abolished in favour of local education authorities. When the East Lothian Education Authority came into being the following year, it took over three secondary schools and 38 primary schools. Pupils numbered 7,800. An audit was undertaken, highlighting the poor state of many of the rural buildings, the lack of books in some schools and the ridiculous system that saw, in one case, a single teacher instructing nine classes. By the time the Annual Congress of the Educational Institute of Scotland met at North Berwick in 1934, many of the buildings had been replaced or upgraded. The High School at North Berwick was soon to be replaced and there was an understanding that the Knox Institute was 'an anachronism' – its pupils would move to the newly built Knox Academy in 1939. The education authorities were taken over by the County Council in 1929, but in these ten years had performed a wealth of duties, the benefits of which, in many cases, are still felt today. That many of the late nineteenth- and early twentieth-century schools still exist attests to their solid and durable nature. Most of those that no longer exist succumbed to fire or necessary removal due to development.

SCHAW'S HOSPITAL/MISS MARY MURRAY'S INSTITUTION, PRESTONPANS

The early history of Schaw's Hospital is detailed on pp. 37–38. In 1830 funds were substantial enough to commission William Burn to erect a purpose-built building at the south of Prestonpans – it was opened two years later. The school closed around 1881 leaving the building vacant. Around this time a bequest, made by Mary Murray, became available to educate young girls of poor, but deserving, parents with a view to them entering service. The trustees were looking for a building to house the school when the former Schaw's Hospital became available. And so, on 2 February 1883, Miss Mary Murray's Institution (or Mary Murray's Institute, as it was known) was opened, leased

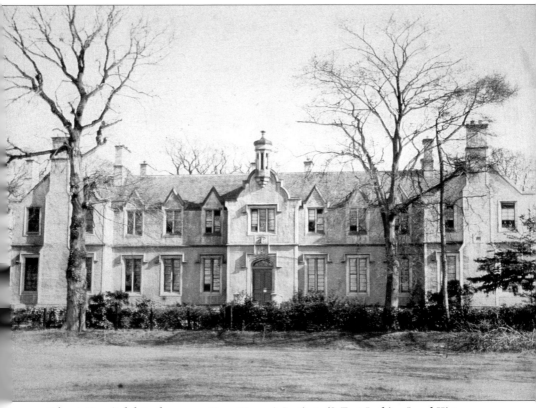

Schaw's Hospital, later known as Mary Murray's Institute (© East Lothian Local History Centre)

from the governors of the Schaw Bequest. The first matron of the Institute was Isabella Meikle, who had 17 girls under her charge. In 1888 the school had 46 girls. Two wings were added in 1890 and the numbers jumped to 68. The Institute closed in the 1930s.

Thereafter it was used as a community centre, a nursery, and as accommodation for pupils after Preston Lodge High School burned down. By 1976 the building was making an annual loss of around £9,000 and was, according to Councillor Douglas Allan, 'in a bad state of repair'. At this time it was hosting a number of local meetings, including the Eastern Star, the Co-operative Women's Guild and the Salvation Army. Once the building closed it became a haven for vandals and thieves. It was demolished in the late 1970s.

ELPHINSTONE SCHOOL,
ELPHINSTONE, TRANENT

It is unclear exactly when the school at Elphinstone was built, but the Valuation Rolls suggest the late 1860s. It is believed to have originally served as a subscription school. Alterations were made to the building in 1890 from plans drawn up by John Whitelaw. The five-room school could accommodate over 150 children. A little after 6 p.m. on Christmas Day 1919 a fire was discovered in the building. Despite the attendance of Haddington Fire Brigade the school was completely destroyed with only the bare walls remaining. The blaze was thought to have started when a gale outside forced some coals from a grate onto the floor, with the flames then catching hold of the wooden partitions in the building. The damage was estimated at £3,000.

KINGSIDE SCHOOL,
WHITTINGEHAME

Kingside School was erected as a shepherd's cottage in the late 1880s, consisting of one room and a kitchen. In 1892 the building was gifted to the school board by the Marquis of Tweeddale and subsequently became a school to serve the children of the Lammermuirs – the byre was converted into the school and the remainder into a schoolhouse. The refurbishment was undertaken by Mr Fraser, a builder from East Linton. Thirteen potential teachers were interviewed; the favoured candidate was a Miss Muir from West Linton. Miss Muir opened the new school.

In 1913 the building was upgraded by installing a water supply and adding a lean-to to act as a scullery, washhouse and bathroom.

By June 1930 East Lothian County Council was aware that the building was unsuitable. In June 1931 the council invited tenders for 'additions and alteration' to the building, and by November 1932 it was described as 'recently enlarged' having been transformed from a traditional stone-built farm building to an unrecognisable, flat-roofed monstrosity, wholly at odds with its surroundings.

From the 1950s discussions were underway to create an extensive reservoir to supply the county. This came to fruition on 19 March 1965 when the first blast to create the Whiteadder Reservoir was set off. It would eventually lead to the doubling of the county's water supply. Sitting in the path of the reservoir was Kingside School and as such its days were numbered. A prize-giving and tea party marked the closure of the school and on the same

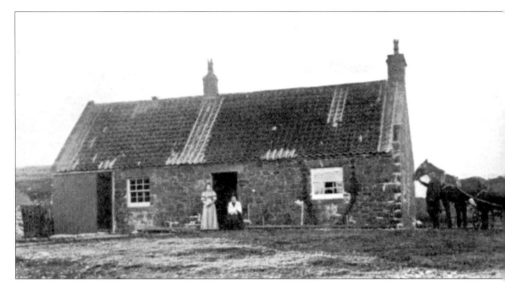

Kingside School before and after it was upgraded and an extension added in 1932
(© East Lothian Local History Centre)

day workmen began removing furniture from the building. To mark the occasion each child was presented with a book by Miss Elliot of Priestlaw. On 5 May 1968, Mr William Anderson, chairman of the East Lothian Water Board, began the flooding of the Whiteadder Reservoir. So ended Kingside School's place as an educational establishment. It was demolished before being covered over by the waters of East Lothian's largest reservoir.

PUBLIC SCHOOL, TRANENT

In August 1874 the Tranent School Board agreed to purchase the properties known as Pigeon Square (p. 75) for £560, with the land to be used to house the soon-to-be-built Public School. At that time the *Courier* described Pigeon Square as 'a mass of ruins'. By October 1875, with demolition underway, the *Courier* had not changed its opinion, calling it 'an eyesore and a nuisance'. The letter writer Veritas, in letters that both praise and denigrate Pigeon Square in an effort to avoid Tranent Public School being built in its place, disagreed, arguing that it was 'not old, nor dilapidated, neither is it ugly'. Regardless of the writer's views, Pigeon Square's days were numbered. The building company of P. & D. Bryson were soon moving hundreds of cartloads of rubble from the land; the quality of the stones meant that their re-sale would more than cover the cost of the work. With the work underway Veritas wrote a further letter to the *Courier*, clearly looking for a new angle to halt the school's erection, this time arguing that it would 'contaminate [the children's] morality', presumably because it was being built in an area capable of housing a block of houses as disreputable as Pigeon Square.

Work on the building on the west side of Church Street, designed by John Starforth, was soon underway. In 1876, the nearing of the opening of the school elicited a brace of poems. One of these, comparing the new school to what

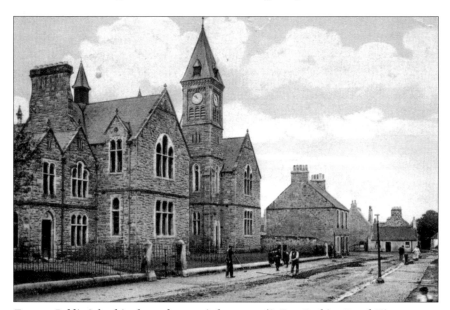

Tranent Public School in the early twentieth century (© East Lothian Local History Centre)

must have been an impressive educational building in Galashiels, noted Tranent's superiority, with a sly dig at the ever-growing cost:

> It's bigger, grander, higher, dearer,
> To perfect beauty it comes muckle nearer

The new building was finally opened on 8 March 1877, having cost £6,700 to build despite early assurances that it would be around £4,500. It was capable of housing 557 pupils. The high cost paid for an architecturally impressive building – a mix of old baronial and Gothic, built of freestone. The following years progressed quite smoothly bar an argument that the lettering on the weather vane showed Edinburgh lying north of Tranent. An extension, designed by Robert Wilson in a style complementary to the existing building, was added in 1886. Two new rooms were erected on the ground floor and a classroom above had the ability to house 200 children. The cost was £1,000.

At around midday on 12 February 1958 lessons were interrupted for what pupils thought was a fire drill. All 400 students were out of the school within two minutes. Unfortunately it was not a drill, and an easterly wind fanned the flames of a fire that had started to spread through the roof of the building. The fire brigade was called and units from Tranent, Musselburgh and Leith were soon on the scene. There was a problem accessing water and this delay allowed the fire to catch hold. Eventually firefighters surrounded the building and stood atop a turntable ladder, flooding the building with water. By 1.30 p.m. the fire was almost extinguished, but the amount of water used meant that it had caused almost as much damage as the fire itself. Eight of the 14 classrooms were destroyed whilst the remainder were smoke- and water-damaged. It was clear that might not simply be a case of refurbishing the building, and this proved to be true as within a week the County Council had announced that they were to erect a new building – something that the people of Tranent had been calling for, to no avail. This was in great part due to the total cost of the damage being £30,000, and parts of the building being rendered dangerous.

PRESTON LODGE HIGH SCHOOL, PRESTONPANS

The idea for a new school at Prestonpans was first mooted at the end of the nineteenth century. When this idea eventually came close to fruition it was argued that it should be built by a company called Cowieson, with the cost

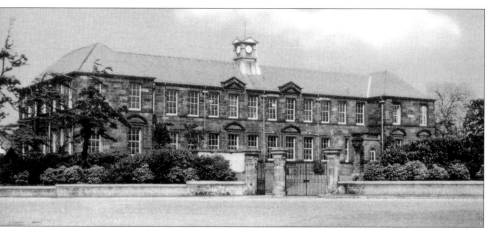

Preston Lodge School, Prestonpans (© East Lothian Local History Centre)

being a mere £5,791. This, however, was shelved in favour of a scheme costing £19,000. Work on the new building did not progress as expected. In September 1924 two temporary premises, courtesy of the Parish Church and the United Free Church, were opened by Dr Duncan R. MacDonald. Chairman of the East Lothian Education Authority, he expressed his regret at the slow progress of the work on the new school.

The school was designed by Francis William Hardie, East Lothian's county architect, and primarily built by Richard Baillie using materials (including polished ashlar, ornate pediment windows and oak window frames) from Amisfield House in Haddington and the Earl of Balfour's quarry near Garvald. It was finally opened in September 1925 by the Earl of Balfour who was presented with a gold key to open the door (although he never had the chance to use it as the door opened as he approached it). Made up of two buildings it consisted of classrooms, laboratories, a gymnasium and staff rooms. It was capable of accommodating 380 students. There was also a semi-permanent building used as a mining and technical school (later known as Preston Lodge Mining School). The full cost of all buildings and grounds was around £20,000.

By the mid 1960s plans were underway to build a new school at Sheepfield. Only a week after the work started, at the end of January 1967, a fire raged through the old school ending in the almost complete destruction of the building. Hundreds of onlookers watched as the upper seven classrooms were completely destroyed and the lower seven rendered unusable. Later that morning pupils turned up for school and cheers rang out as they were told there would be no classes.

PUBLIC SCHOOL (GREY SCHOOL),
PRESTONPANS

The first school in Prestonpans dates from around 1604 and came about as a result of money endowed by John Davidson, minister in the town. For the following 200 or more years the town had a variety of schools, but these were not wholly adequate. Just prior to 1881 there were schools in Prestonpans – the parochial school, the Free Church School and a works school at Morrison's Haven. It was felt by the school board that a single school would better serve the town and so a large public school was planned.

On 5 September 1881, as a result of the amalgamation of Public Schools 1 and 2 (the parochial school and the Free Church School), Prestonpans Public School was opened by Lady Susan H. Grant-Suttie. Designed by J. & R. Farquharson, and erected at West Loan directly opposite the Free Church, it was described as being of a 'tasteful architectural design' built of rubble from Tranent and hewn stone from Burntisland.

The building, capable of holding 500 people, ran north (where the boys entered) to south (the girls' entrance). The mixed schoolroom (roughly 80–90 feet long by around 30 feet wide) had an open ceiling fitted with Boyle's venti-

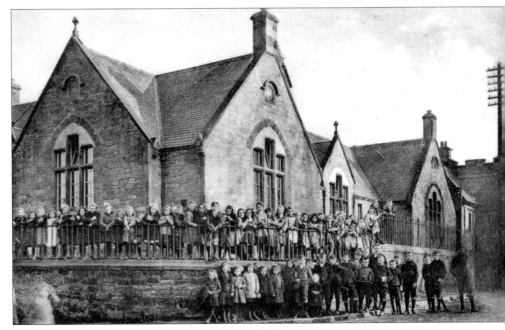

Children pose for a photograph outside the Grey School in Prestonpans, 1921
(© East Lothian Local History Centre)

lating apparatus. This part of the building could be divided into three classrooms by glass partitions. When necessary the glass partitions would be pulled into the hall to create smaller areas. On the west side of the hall were three classrooms, each measuring 30 feet by 22 feet. There was also an infant school with two adjoining classrooms. The building was heated by 'Captain Galton's heated stove grates', which pumped warm air through the structure.

When it earned its colourless moniker is unknown, but it was likely in response to the opening of the Red and White schools in 1908 and 1935 respectively. Each of these schools was given their informally colourful names due to the colour of the exterior stonework or plaster of the building.

By 1959 it was being used by a variety of learners including pupils from Preston Lodge High School and children with learning difficulties. At this time the Scottish Education Department condemned it as unfit for educational purposes, although it continued to host classes until 1973. Once Lothian Regional Council was implemented in 1975 it found that the building was suffering from extensive dry rot. In 1979 one local called it 'a rotten old building which was falling apart at the seams even when I was at school – and that wasn't yesterday!' It was demolished in October 1980.

PRIMARY SCHOOL,
TRANENT

The most recent 'lost building' in this book is Tranent Primary School, demolished as late as May 2009. When the decision was made to erect the school at Sanderson's Wynd it was clear that the derelict mine workings sitting 50 feet below would require the building to have structural work to ensure that subsidence would not be an issue. This was achieved by placing four metal stanchions between the subterranean stoop and room shafts. The school, built above these supports, was opened on 29 April 1964 at a cost of £146,000. It included 12 classrooms, a gymnasium, library, assembly hall and clinic. In addition there was a block where children with a disability would be taught. The opening ceremony was conducted by Provost John Robertson and in an unusual break from an unwritten tradition his words were not all positive, noting that 'architecturally this new school cannot compare with the old one'.

The school closed in 2008, marked by an exhibition detailing the history of the school. When the new school was opened the following September, pupils and parents, dressed in purple, walked in a 'purple parade' from the old building to the new.

The existence of asbestos in the building meant that tearing it down quickly was not an option. By December 2008 it was still standing and concerns were raised by the Tranent and Elphinstone Community Council about anti-social behaviour in the area. Fears were allayed in May 2009 when demolition finally began. As with the demolition of many buildings in this green age all that could be recycled was carefully stripped out, with the rubble, for example, being used in the building of roads.

CUTHILL SCHOOL, PRESTONPANS

In 1876, Dr Struthers, a minister in Prestonpans, wrote to Sir George Grant-Suttie and asked what he was willing to provide for the influx of mining families at Cuthill. Sir George's reply intimated that he would be willing to build a school. Unfortunately for the area this school does not seem to have come to fruition and the residents had to wait another 27 years for an educational building.

The architect, Peter Whitecross, designed a building of red sandstone. A white wooden sign designated the structure as Cuthill Public School, whilst carved above the appropriate entry points were 'Girls' Door' and 'Boys' Door'. Capable of housing a total of 240 children it was formed around a central assembly room which led to four classrooms, each of which had three recessed windows. In poor weather waves would crash over the sea wall into the school playground. In later years Elizabeth Neilson would recall the hall's parquet flooring, and the headmaster's tiered classroom. The cost of this relatively plain structure was £3,500 and provision was made for future extension to the east. The school was closed in 1950. From 1955 until 1967 it was once again used for educational purposes when it served as a school for St Gabriel's RC Primary. The relief of their finally moving from Cuthill to a new school was almost palpable as the headmaster, George Reynolds, noted that staff and pupils 'had done little more than exist in the grubby conditions at the old Cuthill school'. It was demolished around the beginning of the 1970s.

CHAPTER 9

RELIGION

The impact of religion, especially in the pre-Reformation period in East Lothian, should not be underestimated. Historian Peter Hume Brown has gone as far as to argue that the deeply ingrained Catholicism in the Haddington area, fed by the numerous religious houses in the surrounding lands, led the town to linger in its acceptance of the new religion. Haddington alone hosted at least six chapels – dedicated to St Martin, St Ninian, St Ann, St Katherine, St Laurence and St John – a Franciscan friary and a Cistercian abbey. And the vast number of religious establishments were not restricted to Haddington. In the parish of Inveresk we find at least four such buildings: near the Tolbooth (St James's), at New Hailes (Magdalen), another at Market Gate and one called Our Lady of Loretto. In North Berwick we find a Cistercian monastery (perhaps founded as a Benedictine monastery), at Dirleton a Trinitarian monastery (St Andrew's), at Luffness a Carmelite monastery, whilst near the sands at Gullane are the remains of the little-known St Patrick's Chapel. At Skateraw once stood a chapel dedicated to St Dennis, the last remains being washed away by the sea in the early nineteenth century. Others can be found (or not as the case may be) at Herdmanston (St John's), Drem (St John's), on the Bass Rock (St Baldred's), Samuelston (St Nicholas's), Tranent (St Clement's) and Dunglass (St Mary's).

The Scottish Reformation swept away these centuries of history. Catholicism did remain but its followers were subjected to persecution, evident in the wholesale destruction of most reminders of the religion in the post-Reformation period. This destruction and the ravages of time have colluded to ensure that few remains, and no complete buildings, exist to highlight this era in East Lothian (although St Mary's in Haddington is intact the current building is a more recent incarnation). Erected in their place were staid formations, designed to reflect the austerity of the new religion. Although

many of these churches still exist in their original form others have been demolished and rebuilt in order to upgrade or meet growing demand.

The new religion proved strong when faced with the threat from the old, but not so when faced with internal fissures. The following centuries saw the emergence of a number of religious groups intent on imparting their concept of how the Scottish people should worship. Thus we see the emergence of the Episcopal Church in 1582. In the first half of the eighteenth century the Methodist movement gained support – indeed, there opened several Methodist chapels in East Lothian, some of which still remain. The Church of Scotland underwent its largest schism in 1843 in what was known as the Disruption; the Church of Scotland split into two – the existing church and the Free Church. All this led to the erection of new places of worship.

Despite the outlawing of the celebration of Mass in post-Reformation Scotland, Catholicism did not disappear completely and would occasionally lift its head above the parapet to announce its existence. This happened most notably during the Jacobite rebellions of 1715 and 1745–46 when the Stewarts attempted to usurp the throne.

The influx of Irish families around the time of the potato famine, in the mid nineteenth century, saw a more serious re-emergence of Catholicism in East Lothian and many of the county's Catholic churches were erected after this time.

The decline in popularity of religion in the latter half of the twentieth century has resulted in many churches being closed. Some have been converted to other uses and some have been demolished. In a few cases, however, larger churches with more modern amenities were erected to accommodate growing congregations.

ST PATRICK'S CHAPEL,
GULLANE

Situated just south of Gullane Beach and north of Muirfield Golf Course at the Black Rocks are the remains of St Patrick's Chapel. This is perhaps the twelfth-century Cistercian nunnery alluded to by Martine, although at the time of writing he noted that no remains existed. The structure was first excavated in the early years of the twentieth century by Major Younger. Until then it had remained almost completely buried in sand and turf. So hidden was it that it had to be located from an old estate plan. It was excavated again in September 1928 by the Borders Boys' Brigade.

The excavations reached 1.6 metres below ground level, revealing a rectangular building measuring 11.2 metres by 5.5 metres, with the remaining walls standing to a height of 1.8 metres.

PARISH CHURCHES OF
ST ANDREW, NORTH BERWICK

The Parish Church of St Andrew in North Berwick was built, according to D.B. Swan, prior to the reign of David I (1124–53). Little is known of its early history but it gained great notoriety in 1590 when it played host to a great gathering of over 100 witches and warlocks, an event later described by the war poet Robert Graves:

> North Berwickwards in flight they came
> Nutcracker face and knobbled back

It was viewed as a suitable gathering place due to its remote situation.

The building was made up of a north and south aisle, a nave, a chapel and, by the seventeenth century, a belfry and burgess loft. At high tide it stood on what was essentially an island between the harbour and the town. By 1649 the structure was in good repair. A mere seven years later the burgh was petitioning the heritors for help to 'erect their bulwark (harbour)' as the church was 'a totall ruine' due to a great storm that had engulfed the town. This was mostly due to the removal (over hundreds of years) of stones on the east of the island. The decision to move to a new building, rather than repair the old, was taken after a mason provided his findings. By 1780 it was described by Grose as a 'picturesque little ruin'. At various times sea-water has wasted away parts of the building, whilst the north side was removed in 1845 to make way for the town's gasworks. In 1924 RCAHMS noted that 'the only portion remaining is a small one-storey vaulted structure built of rubble'. This remnant was roughly 19 feet by 18 feet.

After the last service in the old church in 1656 the heritors were slow in agreeing to the erection of a new structure, failing to act until 1659. Building work started at Kirk Ports in May of that year, but the structure was still bereft of a roof in January 1661, although the walls had been erected. It would be another three years before a Minute of Session would note that 'this day ye paroch mett in the new kirk for worship'. Parishioners had gone without a church for eight years. Smaller than the old church, it was rectangular in shape

with lofts at either end, each of which was entered by an external stair. At the time of its opening entry was achieved through doors in the north, east and west. The northern door was later replaced by one to the south. Only the heritors had their own seats and the parishioners had to supply their own. A rule was implemented by the heritors that no grave should be placed within 12 feet of the building. This allowed, in 1770, for a substantial rebuild and enlargement of the building, including the construction of the belfry. The interior was 'wholly renewed' in 1819. In 1869 one member of the congregation noted that 'the present church should be entirely taken down and rebuilt in a style commensurate with the times, and suited to the needs of the congregation'. A petition requesting a new building was soon presented to the presbytery, although it was at pains to make clear that it was not this incarnation of the church that was the 1590 meeting place of East Lothian's witches and warlocks. The tardiness that was so prevalent when the second church was built reared its head once again, and it was to be another nine years before the final service.

North Berwick Kirk, 1590. Later known as St Andrew's Church (© East Lothian Local History Centre)

THE MONASTERY,
NORTH BERWICK

The remains of the Cistercian monastery at North Berwick – also known as the Nunnery, the Abbey and the Priory – lie between Old Abbey Road and Glenorchy Road. When it was founded has been widely debated but the weight of evidence seems to point towards the time the lands were owned by Duncan, 4th Earl of Fife, in the first half of the twelfth century. The earliest known charter to mention the monastery is dated 1177. In 1242 it was dedicated to the Virgin Mary by David de Bernehan, the Bishop of St Andrews. Its importance is outlined by the fact it held sway over a number of parish churches reaching from the Fife coast to as far west as Maybole.

It was a large structure, as evidenced by the extent of its foundations, and was built of freestone. Mackenzie Walcott, writing in 1874, noted the remains of a 'refectory, cellarage, kitchen with a fireplace, [at the] east end of the chapel; and an entrance arch'. The largest number of nuns known to have served there at one time was 21. George Parkyns, writing in 1816, noted that it did not

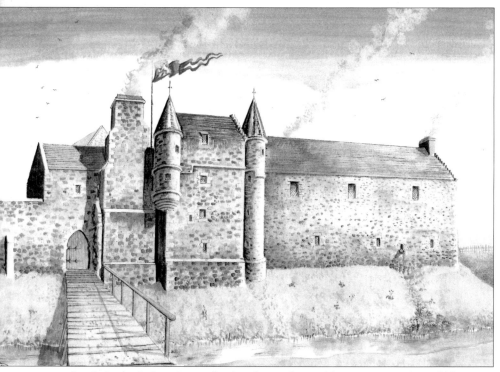

A painting by Andrew Spratt showing the North Berwick Monastery as it would have looked around the late sixteenth century (© Andrew Spratt)

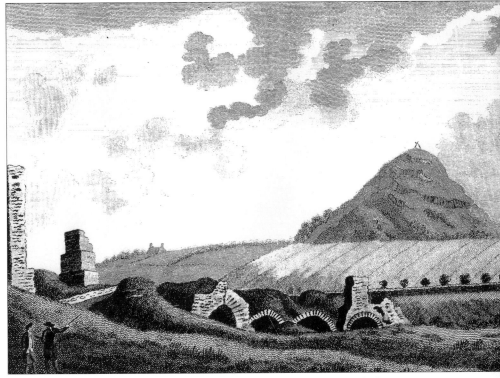

North Berwick Monastery as it would have looked after its demolition in the late sixteenth century (© East Lothian Local History Centre)

'appear to have been a splendid building' but that it was 'most delightfully situated'.

The aforementioned arch, part of the remains of an enclosing wall, was erected around 1375 at the command of the Pope due to the prioress and nuns being 'much molested'. His order noted that they were to live permanently within the enclosure. In 1529 the structure was attacked, most likely by the forces of King James V during his siege of Tantallon Castle.

The Scottish Reformation in 1560 would have been the beginning of the end of the monastery. By this time it was owned by Sir Alexander Home, brother of the prioress. The monastery was finally dissolved in 1597 and Home set about building a house from the stones. He called it Newark, or New Work. It is probable that the ruins of the building are from both the monastery and the house. In 1926 D.B. Swan noted that many of the stones from the building were used in surrounding erections, most notably in buildings at Abbey Farm and at the manse, whilst some of its glazed tiles are held by the National Museums of Scotland.

THE ABBEY,
HADDINGTON

The structure of the abbey of Haddington no longer exists, its remains having succumbed to centuries of ploughing. The Cistercian nunnery had been founded in 1178 by William the Lion and Countess Ada, about a mile east of the burgh of Haddington, on the north of the River Tyne. Landowners and the church bestowed upon it a swathe of surrounding lands, including Begbie, Clerkington, Athelstaneford, Byres and Harperdean.

In 1356 the abbey, along with many of Haddington's buildings, was attacked by King Edward III in an event that was part of the invasion known as Burnt Candlemas. Two years later a flood approached the building. Having swept away trees, houses and even whole villages (an example being the Nungate) a nun is said to have run from the building with a statue of the Virgin Mary in her hand and 'threatened to throw it in the water, unless Mary protected the house from destruction'. Apocryphal or not, it is said that the waters immediately began to recede.

Walter Bower notes that King Henry IV stayed at the abbey in August 1400 on his way to Edinburgh, and was well entertained. Relations with England soon deteriorated. A charter dated 1458 notes that it was frequently plundered by the English as a result of their ongoing enmity with Scotland.

Almost a century later the building housed the Scots Parliament, which signed the Treaty of Haddington, a response to the Rough Wooing, and it was here they contained the momentous decision that Mary, Queen of Scots would marry the Dauphin of France a decade later. As with many such early ecclesiastical buildings, the coming of the Scottish Reformation was probably the event that saw its end. Certainly it was a ruin by the time Daniel Defoe laid eyes upon it in the 1720s.

The East Linton author and poet James Lumsden, also known as Samuel Mucklebackit, put its history into verse around 1903. One verse details the remains:

The silence o' the Past is there,
A' things show the trail o' Time
The rank gerse flaunts o'er 'stane' and 'lair',
Of whilk there's hardly left a styme.

ST MICHAEL'S CHURCH, INVERESK

Two years before the present St Michael's Church at Inveresk was opened in 1805 its predecessor had been demolished. It is said to have been built from the ruins of a Roman fort. Its prominent situation, at the western end of Inveresk looking down over the town of Musselburgh, led Lord Stair to describe it as 'The Visible Church'.

The church, cruciform in shape, was 102 feet long by 24 feet wide with two aisles. Evident in this image (which some believe to be fanciful), showing the church in 1547, is a square tower to the south, to which is attached a round turret, to the north. In front of the tower is a porch. Until 1708 another porch had existed on the opposite side of the building but it was ordered to be removed by Musselburgh Town Council. The survival of the southern porch can be attributed to the rather odd arrangement which saw the town council control the northern side and the heritors the southern side.

In 1546, one year before the date of this image, the Protestant reformer George Wishart preached at the church, accompanied by an armed guard. This was just prior to his execution in March of that year. In its latter years the church's minister was the renowned Alexander 'Jupiter' Carlyle. He described the building as being 'in a ruinous condition . . . truly a disgrace to the parish'.

St Michael's Church, Inveresk, in 1547 (© *East Lothian Local History Centre*)

And so it was that in 1803 the building was demolished. One reason given for the demolition was that it was draughty, a problem almost certainly caused by the building having 13 doors. The foundation stone of the new church was laid, according to Masonic tradition, in the north-east corner of where the church would stand. Carlyle died soon after the opening of this new church and never preached there.

PARISH CHURCHES, GLADSMUIR

There have been three Gladsmuir parish churches, the first two of which have now disappeared or are in ruins. The first was founded at Thrieplaw, directly south of Gladsmuir, on land belonging to Robert Hodge. Despite opposition to the location of the building Hodge ploughed ahead and the first sermon in the 'Hodges' Kirk' was given in 1660. Soon the country was beset by 'the killing times' when Presbyterian Covenanters were persecuted. Secret conventicles

Gladsmuir Parish Church (Crown copright © RCAHMS)

were arranged after the restoration of episcopacy by Charles II. The 'Hodges' Kirk was host to some of these meetings. The situation returned to normality upon the succession of William and Mary to the throne. Attempts were undertaken to create a larger parish with a new, larger, kirk at its centre in Gladsmuir. Opposition came from the minister at Haddington (who foresaw a reduction in his stipend), the Earl of Winton and some heritors, but their complaints fell on deaf ears and the parish of Gladsmuir was founded in 1695. The extended parish first met in the 'Hodges' Kirk but the new church was completed soon after and the parish had a new church building. The 'Hodges' Kirk fell into disrepair and for a time its walls were incorporated into colliers' cottages. These were removed around 1878 and no visible evidence remains of this building.

The walls of the second of the three churches had been completed by 1695, and no doubt a roof was added soon after. Alterations were made a century later. Cruciform in shape, it was used until 1839, by which time it was considered too small, being as many as 200 seats short of what was needed and as such it was replaced. Its ruins are relatively well preserved and sit in the churchyard of the present church.

PARISH CHURCH,
TRANENT

It is believed that a place of worship has existed on or around the site of the present parish church of Tranent for over 1,000 years. The original chapel was dedicated to St Peter. In its early years it was made up of a choir and nave, with aisles extending to the north and south, the latter of which was topped by a square tower. In 1544, and then again in 1547, the building was burned by English forces during the Rough Wooing. It was to exist without a roof for the next 50 years.

In the early eighteenth century much work was carried out on the church, and by the time of the *Old Statistical Account* in the 1790s it was described as 'resembling three oblong buildings placed sideways the middle being considerably larger at each end . . . a square tower rises from the centre of the whole supported by two cross arches'. One local described it as being 'like a cuddy wi' twa creels hung over its sides'. By the end of the century there were calls for a new building. In 1799 the calls of the congregation were answered when work began on a new structure, on the site of the old, only the sub-structure and foundations being retained.

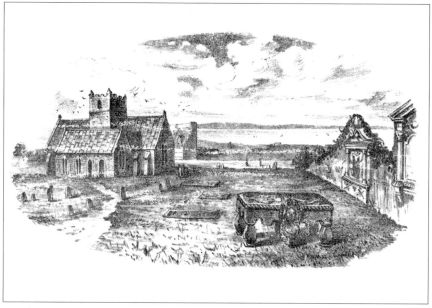

Parish Church, Tranent (© East Lothian Local History Centre)

PARISH CHURCH,
DUNBAR

Dunbar Parish Church was erected as early as 1176. Cruciform in shape, it was 123 feet in length and around 25 feet in breadth, whilst the transept was 83 feet long. It was noted in the *Old Statistical Account* that this shape made for poor acoustics. A 50-foot-high square tower with turrets stood over the building and was topped by a 30-foot-high steeple which had been added by John Cochran, a local mason, in 1739. In the 1730s Richard Pococke noted the building's 'small narrow Gothic windows'.

The church was granted its Collegiate Church foundation charter in 1342 by Patrick, Earl of March, husband of Black Agnes, who was already famed as the defender of Dunbar Castle. A later charter suggests that the patron saint was Baes.

Renovations took place in 1657 and then again in 1669. In 1718 or 1719 the church windows were repaired and in 1724 alterations were made that resulted in a further 37 seats being added at the pulpit. Despite these expenses, by 1779 the structure was in a poor state of repair and renovations were made to the roof, a new deal floor was installed, seating was added and a partition was introduced into the main body of the church. Lofts were also added above

three of the sides of St John's aisle at the southern end of the building. In 1859 Miller reminisced of the old building that 'the venerable fabric had all the appearance of being the workmanship of different ages'; this was doubtless the reason why it has been referred to as any one of a number of architectural styles – Gothic, Norman and Saxon.

By 1810 a further £53 10s had been spent on repairs but a short six years later the procurator of the Church of Scotland noted that the building was in a 'ruinous state incapable of repair and ripe for condemnation'. A committee was set up to consider how to deal with the church's lack of size and comfort. It found that there was a 'great current that at present blows through the church'. A census of the town's inhabitants was taken to illuminate the need for a larger building. In April 1818 a meeting between the heritors and the presbytery was held in the churchyard to decide the church's future. Once concerns about protecting the burial aisles were assuaged, it was agreed that a new church, capable of holding over 1,500 worshippers, 'shall be built forthwith'. Rev. John Jaffray conducted the final sermon in March 1819, quoting from Psalm 84, verse 1: 'How lovely is your dwelling place.' The new church was built on the site of the old.

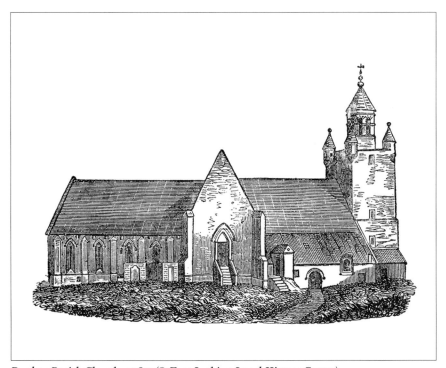

Dunbar Parish Church, c.1819 (© East Lothian Local History Centre)

ST PETER'S EPISCOPAL CHURCH,
MUSSELBURGH

The earliest evidence of Episcopal worship in Musselburgh, espousing government of the church by bishops, comes in the late seventeenth century when Rev. Arthur Millar and his congregation had a place of worship on the corner of High Street and Newbigging. It is likely that he had some support from the town council and this allowed him to preach in the town before

St Peter's Episcopal Church, Musselburgh. Top: the building from the south-east, 1956.
Below: the interior of the building

Episcopalians were given full right in worship in the 1712 Toleration Act. At the time of the Jacobite rising in 1745 the minister was William Forbes whose Jacobite tendencies were made clear when he kissed the hand of Bonnie Prince Charlie at Pinkie House. The following year, after the Stuart defeat at Culloden, the church and parsonage were burned to the ground by Cumberland's forces as revenge for this support. Despite this setback, Episcopalian services continued in the town at a small house on Pinkie Road.

In 1771 Rev. William Smith took over as the minister in Musselburgh. Within a few years plans were brought forward to erect a chapel in what was then a quiet street, now called Millhill. A survey in the 1950s revealed the date of 1785 on a keystone on the east window. The structure at the time of the survey was plain, with three arched windows in the southern wall and another in the semi-circular alcove that formed the altar. In the 1850s it had been capable of holding 200 worshippers.

The church continued to house the town's Episcopalians until 1866 when Lady Archibald Hope built St Peter's Church at the east end of the town, where it still stands today. The old chapel became redundant and in 1870 the building was taken over by the Bruntsfield Golf Club. In the 1880s it was re-purchased by Sir William Hope and the three-room building became St Peter's Church School. A Deed of Gift was drawn up making the school the property of St Peter's Church. Borrowing money on the security of the building, a substantial extension was added. A further enlargement was made to the building in 1903 and the three existing classrooms were significantly upgraded, making the school capable of educating 450 children. The opening ceremony was performed by Lady Hope. In 1919 the school was handed over to the education authority. By the late 1930s conditions in the six-room school were clearly deteriorating and the headmaster Gavin Hamilton Smith repeatedly called for new accommodation. A meeting was organised to address the issues and was attended by over 80 people. Councillor Peter Hamilton, who was at the meeting, said, 'It is impossible for any child to get the benefit of education in winter because of the cold. I've seen them coming from the school, their wee noses red. This school is a slum.' Despite this damning assessment it was another four years before the pupils moved into the newly built Pinkie-St Peter's Primary School and a further year before the building was finally demolished.

METHODIST CHAPEL,
HADDINGTON

Methodism had been preached in Haddington since 1800 or before when a Thomas Preston walked from Dunbar to address the town's Methodists, and the faith was considered strong enough that by 1816 discussions were underway to build a chapel in the town. Land was purchased in Sidegate for £130 and in 1818 a declaration was made by the trustees of the land that noted 'a commodious chapel has been built'. This is supported by Wood's town plan of 1819 which shows the chapel set back from the main road. The following years saw the chapel plagued by financial difficulties. As early as 1827 senior Methodists reported that Haddington was 'so deeply involved in debt, as to afford not the least rational hope that they can ever be so effectually relieved as to be brought into a manageable state'. This obligation culminated, in 1852, with the building passing into the hands of Thomas Nicolson, in lieu of his claim on the building. Clearly this transfer had not filtered through to the creators of the 1853 Ordnance Survey map (or the map was drawn prior to the transfer) as a detailed building is shown with a note added that it is capable of holding 300 people. Comparison of this map with Wood's shows that the building may well have been added to in the intervening years with an extended frontage and an extra adjacent building. From 1855, by which time it had been sold to a Robert Richardson, it seems to have been used as a warehouse. What happens to the building after this date is somewhat unclear. In 1866 the warehouse is no longer listed in the Valuation Rolls. In 1883 John Martine notes that it had been 'taken down some years ago' and it is not evident on the 1893 town plan.

METHODIST CHAPEL,
MUSSELBURGH

John Wesley, one of the founders of Methodism, first came to Scotland in 1751. On 24 April he arrived in Musselburgh and was persuaded to preach. He would visit the burgh a further five times in the following 14 years. It was not, however, until 1832 that a meeting of the Edinburgh District of Methodists sanctioned the building of a chapel in the town. The following year land was purchased on the east side of the Vennel in Fisherrow, at the apex of the triangle formed by South Vennel (now South Street) and Bridge Street, roughly where the Hayweights Public House now stands. The chapel cost £160 to erect,

measured 33 feet by 27 feet, and had no gallery. The chapel's existence seems to have been a relatively problem-free one. In 1841 it was noted that 'it pays its way'. Or so it seemed. The £160 loan used to erect the building in 1833 had never been paid back. Once Thomas Hughes died the debt fell to his nephew, Thomas William Nicholson, who swiftly called it in. The chapel was finally sold, in the late 1840s, to Peter Taylor, a baker. It no longer looks to be in place by the OS map of 1853.

ST MARTIN OF TOURS ROMAN CATHOLIC CHURCH, TRANENT

The number of Catholics in the Tranent area began to grow rapidly in the latter half of the nineteenth century, increasing from 160 in 1851 to 400 in 1882. In the 1880s the town was served by a priest who would visit fortnightly, a Catholic Industrial School was set up and a mission created. In 1887 a permanent priest was appointed. On 11 November 1891, on the Feast of St Martin (Martinmas), the foundation stone of a new church, St Martin of Tours Roman Catholic Church, was laid by Archbishop William Smith on a piece of land at the eastern end of the town known as 'McKinley's feu'. The guests were later treated to a meal at St Joseph's Industrial School. The church, designed by John Biggar at a cost of around £1,600, was opened in July 1892. By this date both Smith and Biggar were dead, serving as a metaphor for the future of the building.

Built in the Gothic style of architecture its walls were of plain masonry, it had four windows on each of the side walls, whilst the main door was flanked by two windows with a circular one above. The building could hold around 420

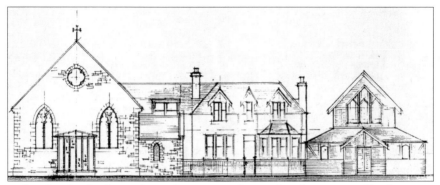

A plan showing the first and second St Martin of Tours churches, separated by the presbytery

worshippers. The interior had two rows of pews facing a large archway behind which lay a chancel and an altar. The altar was impressive, designed by A.B. Wall of Cheltenham and including the statues of six saints. Situated next door was the chapel house. The cost of the church and house was £2,000.

The celebrations of the opening were followed by 30 trouble-free years of celebration until a bombshell struck in 1922. The church, like many buildings in and around Tranent, was built on top of old mine workings, and had fallen victim to subsidence. The building literally began to crumble around the ears of worshippers. One Mass attendee recalled, 'The plasterwork opened out directly above the altar-boys and the choir and collapsed.' Another remembered the roof opening up by two inches. It was clear that the building was structurally unsound and its days were numbered. An August 1923 newspaper report noted:

> the present Roman Catholic Church is gradually breaking up, and is in danger of collapse. Already daylight may be seen through gaping cracks in the walls. The arches of the sanctuary have been buttressed by temporary supports, and on a wet day water finds its way into the interior. Experts have condemned the building as incapable of restoration.

In 1923 the land at Stair Park was purchased but no serious attempt to build a new Catholic church on it was undertaken. Given the serious situation at the church it is surprising that it took six years from the masonry collapse to the opening of a new building. The new building, initially considered a temporary structure, was constructed of wood and sat adjacent to the old church, separated only by the presbytery. It was capable of holding 500 worshippers who were treated to the modern conveniences of electric lighting and central heating. Despite being deemed temporary it was to play host to Catholic worshippers for the next 30 years.

The days of the original stone building were, however, not over. During the Second World War there was a need for substantial buildings in which to house troops and this led to it being called into action it housed the RAF Maintenance Unit based at Macmerry.

In May 1968 the two churches and presbytery were demolished to make way for the erection of a new church. As it was built on the same ground there was a period of time when the congregation had no place of worship. This was solved by a temporary move to the Drill Hall in Well Wynd, at this date owned by Tranent Town Council.

CHAPTER 10

MISCELLANEOUS

So far I have attempted to organise each history into neat themes. As with much in life, however, not everything fits tidily into a box. As such this final chapter will deal with the anomalies that I have failed to incorporate into the earlier chapters. At a push some could have been shoehorned into an existing theme – the Willow Cathedral could have fallen into the *Religion* chapter, the Tranent Water Fountain into the *Health* section, whilst the two POW camps could perhaps have been in the *Defence* chapter – but this would have made chapters seem contrived and unbalanced. This final chapter has been created to house those miscellaneous histories; in my opinion, they are some of the most interesting in the book – from the thorn tree around which the penultimate battle was fought on British soil to a cathedral sculptured out of willow branches.

COUNTY JAIL, HADDINGTON

The County Jail was erected just off Haddington's King Street (now Court Street) in 1847, behind the County Buildings. It was described as 'a handsome building' although it was bounded on three sides by a 14-feet-high wall, and on the fourth side by the County Buildings. It had 12 cells, a sick room, an exercise galley, a kitchen and four garret rooms. In what was described as 'a singular disregard to delicacy' the kitchen included a wash-house and bath and this meant that the cook was required to work whilst 'some unseemly vagrant, with all his filth, is brought there to unrobe himself for the bath'. By 1957 it was antiquated and new cells were built in the police station at the eastern end of Court Street. The building was used thereafter to store files. It was demolished

in August 1963 with one onlooker declaring of the scene that 'it looks a bit like the blitz'.

THORN TREE, PRESTONPANS

As the government troops and Jacobites clashed at what became known as the Battle of Prestonpans, in the midst of the battle grew a young hawthorn tree. It is believed to be near this tree that Colonel Gardiner was mortally wounded. Unlike Gardiner, it emerged unscathed from the carnage and its place in the history of Prestonpans had begun. It warranted a mention in Adam Skirving's song 'The Battle of Prestonpans':

> At the thorn-tree, which you may see
> Bewest the meadow mill, man
> There mony slain lay on the plain,
> The clans pursuing still, man.

Whether the tree was actually a single tree with three branches or three separate trees is unknown. Two local historians, Peter McNeill and John Sands, certainly believed it to be the latter. Indeed, McNeill later revised this view to argue that it was actually *four*, or perhaps even *five*, separate trees. During its lifespan it stood as a testament to the dead, but hawthorn trees tend to live only two centuries. By 1881 it was 'buttressed with iron rods and bands' put there at the expense of the Earl of Wemyss. On 18 October 1898 a storm saw the largest of the three limbs being blown down. The final years of the tree are detailed by the East Lothian Antiquarian and Field Naturalists' Society who visited the site in 1924 and then again in 1929. The 1924 visit found only one of the three stems remaining but it was dead. A *Courier* report of the visit noted that 'a withered branch waves in the breeze like a tattered ensign'. The second visit found 'a dead and blackened stump . . . about twenty feet high'. This was eventually removed with the permission of the Earl of Wemyss and a section of it, around three feet in height, was presented to the Naval and Military Museum at Edinburgh Castle. It currently resides in temperature-controlled conditions at the National Museums of Scotland's storage unit at Seafield.

At the visit a suggestion was made that a memorial replace the tree to mark the site of the battle. As a result a cairn was erected by the Society for the

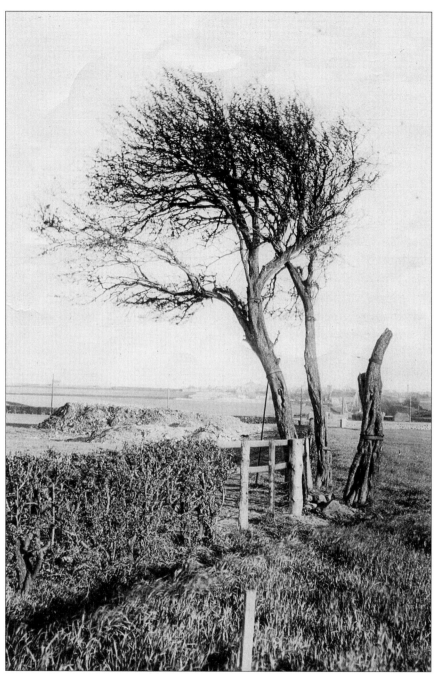

The thorn tree that stood on the battlefield as the Jacobites defeated the government forces at Prestonpans. The two extant branches of the tree and the 'iron rods and bands' are clearly visible and date this image between 1898 and 1924 (© East Lothian Local History Centre)

Preservation of Rural Scotland, although it was placed in a more visible position. Built into the cairn is a casket containing miscellany relating to the thorn tree, including a cutting from the tree. It was also proposed to transplant a tree, grown from an offshoot, in its original position, although this never happened. It is possible that the tree to be transplanted was to come from the garden of John R. Borrowman's house – St Michael's at Gilmerton.

WILLOW CATHEDRAL,
OLDHAMSTOCKS

The Willow Cathedral, commissioned by Sir James Hall, was an enigmatic, temporary structure erected at Dunglass. After 16 years of gathering and fomenting ideas about Gothic architecture, which included a 150-page essay titled *Essay on the Origin, History and Principles of Gothic Architecture*, he came to the conclusion that the arches and decorations which so define the Gothic style could be traced to early wattle structures. In the mid 1790s he set about proving his theory. He employed a local cooper to create a 'cathedral' from willow rods and thatch. The result was detailed eloquently by Sally Smith:

> It was like the Collegiate Church with a nave, transepts, and a square tower above the central crossing. Tracery windows filled three arched bays at each side of the nave and on all three facades of each transept. This profusion of windows not only imbued the structure with light and air, but as each window was differently designed, also tested willow construction on a whole vocabulary of Gothic tracery styles. Walls below and around the windows were closely woven wickerwork but the roof was thickly thatched, cut to a rounded shape and finished off with overlapping willow hoops as a decorative ridge-line. As a final flourish, each side of the central tower had two arched windows filled with tracery and the whole was crowned by a lantern dome, not unlike that of St Giles' Cathedral in Edinburgh. Visitors entered at the foot of the nave, through a prettily decorated open arch.

And visitors it did indeed attract, with large numbers detouring from their trips to Scotland on the Great North Road. The experiment, described by Patricia Payne as 'rustic folly', was recorded in watercolour by the artist Alexander Carse. His introduction of a craftsman into one of the scenes allowed Payne to calculate, to a reasonable accuracy, the structure's dimen-

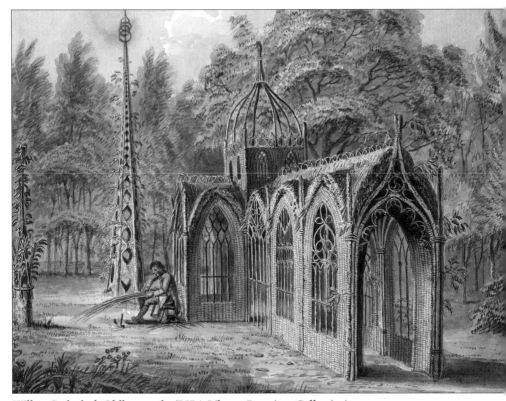

Willow Cathedral, Oldhamstocks (RIBA Library Drawings Collection)

sions. The transepts, she asserted, were 8 feet high, the nave 10 to 12 feet and the tower around 20 feet.

DOOCOT,
ABERLADY

Doocots, or dovecots, have existed in great numbers in Scotland for many centuries and it was, by the fifteenth century, the legal right of religious orders and castles to erect one. In order for the inhabitants to flourish they required agricultural land upon which they could feed. East Lothian provided just such a platter, and this resulted in large numbers of structures scattered throughout the county. Many still survive, albeit in a dilapidated state. Some have disappeared. The tall, elegant doocot at Amisfield House, for example, was demolished at the same time as the house in 1928.

The doocot at Aberlady was situated in The Wynd. It was a square three-

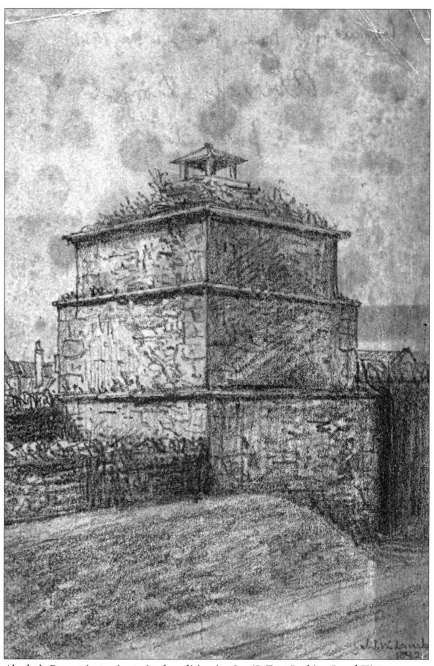

Aberlady Doocot just prior to its demolition in 1892 (© East Lothian Local History Centre)

tiered structure topped with a square cupola. Since its erection it seems to have elicited little controversy. This changed dramatically when, in 1892, word reached Hippolyte J. Blanc, the noted architect and antiquarian, that it was to be demolished to make way for the building of a new United Presbyterian Church. Blanc argued that 'a love of whatever material history remains to us should, I feel, stir us to preserve rather than destroy such an interesting relic'. The following week three letters appeared in the *Courier* regarding Blanc's stance. The first two were simply letters of support, the most notable being from the artist William Darling McKay who noted that the structure 'gives such a quaint character to the shore road'. The third was written by A.C. Wedderspoon, one of the church ministers, noting that there was a general agreement with Blanc's letter amongst the church congregation. A request, he added, should be sent to the proprietor urging its retention. Nothing further is noted in the newspaper for two months until, at the end of October, a short piece details its demolition. A later report noted that this happened 'to the regret of many'.

WATER FOUNTAIN, TRANENT

Before a substantive water supply was introduced into Tranent, it was common to hear the washerwomen boast, 'I can wash tripe with as little water as any woman in Tranent.' At this time the town was supplied by a single spring diverted to the town via wooden pipes and transported to those in need by barrel. The wooden pipes were eventually upgraded and the barrel replaced by wells and the town continued to be fed with the purest of water. However, the sinking of a pit shaft in the 1830s right at the heart of the spring saw the water supply dry up. Messrs Cadell, the mine owners, were forced, via the Court of Session, to line the shaft with iron plates and the water supply returned. The supply was intermittent, due in great part to the constant sinking of pit shafts which seemed to be tapping the water supply.

By 1880 the spring supply was described as 'quite insufficient to meet the wants of the inhabitants, while its quality has of late years greatly deteriorated'. Thus, in the early 1880s the burgh of Tranent paid £7,000 to obtain a water supply from a source at Crichton in the Midlothian parish of Cranston. Dr Stevenson Macadam considered it to be somewhat hard, but more than acceptable for domestic purposes. The proposal was put forward by the Police Commissioners' Office but they were unable to borrow enough money to

afford the whole cost of the scheme. It was decided to raise the remainder through public subscription; the largest donation came from Mr Polson who gave £500 plus 25 per cent of all other sums collected. The opening ceremony took place on 10 May 1883. Part of the day included the opening of a cast-iron fountain in Winton Place, just off the High Street. Built by George Smith & Co. at the Sun Foundry in Glasgow it comprised a central pillar and two cherubs built on top of a mock-horse trough. Atop the pillar was a street light. The cherubs held jars from which water flowed into the trough. It is not known exactly when the fountain was removed but it is believed to be around the time that the war memorial was erected on 9 April 1922, in almost exactly the same spot. What appears to be a near-identical fountain still exists in Durban, South Africa.

TRAMWAYS

In 1899 a syndicate from London proposed the creation of a light railway in Musselburgh. Despite approval by the town council the scheme was refused by the Light Railway Commissioners. The syndicate then proposed a tramway and this was accepted. Work laying the lines at Musselburgh began in May 1904. Weighing 90lb per yard, they were laid in 4 inch-by-5 inch whinstone setts, quarried in Kilsyth. As an electric system it required a power house. The building measured 21,000 square feet and sat on the High Street, next to St Peter's Church, and has since been demolished. It was made up of a boiler house, engine room, two battery rooms, car sheds, repair shops, stores and offices, topped by a 120-foot-tall chimney. On 12 December, in heavy snow, a double inauguration ceremony was held for the electric tramway and the connected electric lighting system. The tramway ran from Joppa in the west to Levenhall in the east, the line being part-double and part-single line. The poor weather failed to deter the 300 attendees who were given a tour of the power house. The current was then turned on by Provost Simpson's wife, allowing the tramway to start and the lights to be turned on.

The first journey was taken by the dignitaries and those who had watched the proceedings – 240 of them filled four tram cars. The day was followed by dinner at the Musselburgh Arms Hotel. The scheme proved highly popular; in the four months after its opening the tramway was used by 639,471 passengers. News of its popularity spread quickly and within a year of its opening there was talk of extending the scheme to Prestonpans, Port Seton and Tranent. In 1909 the line was extended on from Levenhall to Port Seton via Prestonpans.

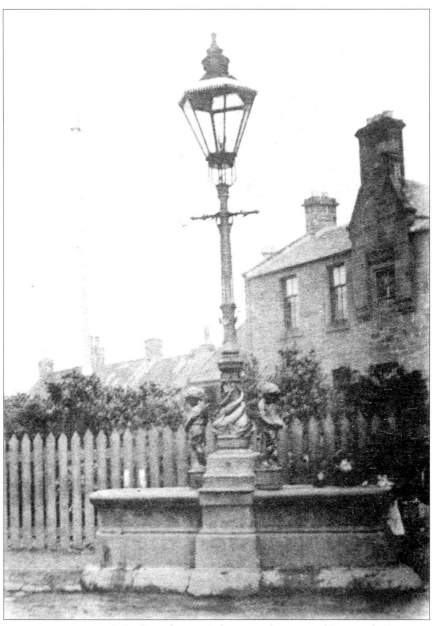

Tranent Water Fountain in the early twentieth century (© East Lothian Local History Centre)

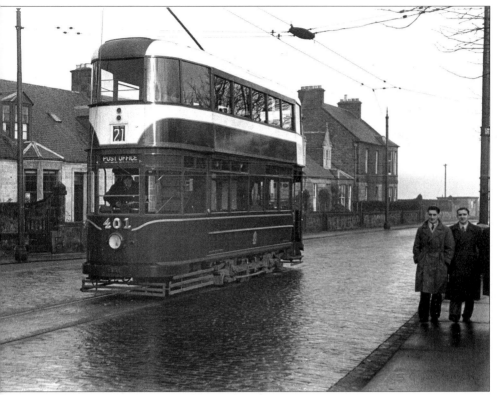

A tram at Levenhall, Musselburgh (© East Lothian Local History Centre)

The speed of the trams was 12 m.p.h., except in Prestonpans burgh where it was reduced to 8 m.p.h. Passengers wishing to continue on from Musselburgh into Edinburgh had to change at Joppa to cars pulled by cables; Edinburgh did not change to the electrified system used at Musselburgh until 1923. The Levenhall to Port Seton section of the line was closed in 1928, and in 1931 the Musselburgh section was taken over by the Edinburgh Corporation.

Slightly less than 50 years after it was introduced into Musselburgh, the tramway closed. At just before midnight on 13 November 1954 over 500 people gathered as 'Auld Reekie's dear old 20s and 21s' (the numbers of the trams) made their final journey through Musselburgh. Although the 21 should have been the final tram to make the journey, it was followed by a private tram run by the Portobello Masonic Lodge to raise money for charity. This tram was 'packed to the gunwales and gaily bedecked with coloured streamers'. When it stopped at the depot in the High Street it was surrounded by the gathered

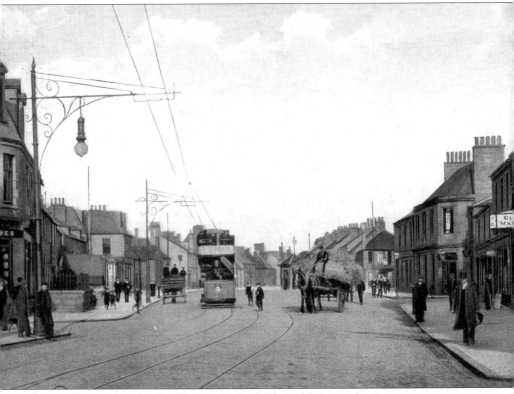

The tram lines and overhead cables are clearly visible in this image showing a tram heading west along Musselburgh High Street in the early twentieth century (© East Lothian Local History Centre)

crowd who linked arms and sang Auld Lang Syne, whilst tins were drummed, whistles blown and a one-man band played. Within months the Town Council was calling for the rails to be removed in the interests of road safety and work began to achieve this in January 1956. A 58-metre-long double section of the track with original setts, near Prestongrange Mining Museum, still exists, retained for educational purposes.

GOSFORD POW CAMP, ABERLADY

During the Second World War Allied troops were based at locations through East Lothian. Once troops began landing in Europe from June 1944 these camps became obsolete. However, German troops were soon being taken

Two views of Amisfield POW camp at Haddington showing the camp gates and POWs sitting outside their Nissen huts (© Jack Tully-Jackson)

prisoner in huge numbers, and camps were urgently needed to house them. As a result camps that had previously housed Allied troops were converted to house prisoners of war. Gosford POW Camp, or Camp No. 16 as it was formally known, sited in the grounds of Gosford House, housed around 3,000 German troops in a series of huts. There were genuine attempts to create a comfortable environment for the interned, with access to a theatre, cinema, football pitch and musical instruments. That the prisoners were treated well is further attested to ended. Some of the brick buildings and Nissen huts still remain, some used by a sawmill that is based on the site.

AMISFIELD POW CAMP, HADDINGTON

Overcrowding at the Gosford camp, which saw some prisoners sleeping in tents, eventually led to the creation of a satellite camp at Amisfield, formally known as Camp No. 16A, at the eastern end of Haddington. As at Gosford, the prisoners slept in huts. Unlike Gosford, most of the prisoners, who numbered almost 1,000, were non-German: they were mostly Ukrainian and Austrian. Many of the same social elements existed at Amisfield as existed at Gosford. There was 'a choir, orchestra, drama company, and a full programme of sporting events'. The camp continued in use after the war, by 1948 known as Amisfield Park European Voluntary Workers' Hostel, housing Ukrainians who had elected to remain in Scotland. By this time the accommodation was noted as being 'in urgent need of a new coat of paint', whilst the sanitation was 'spotlessly clean, but of the most primitive order'. It was thought impossible to upgrade the toilet facilities as it was believed that the camp would be abandoned in early 1949.

SETTS, HADDINGTON

By October 1953, when the regeneration of Haddington was underway, it was argued that tarmac must replace the town's setts, which had been worn down by traffic, and re-laid poorly. The County Planning Officer, Frank Tindall, railed against this slight on his vision. He was defeated, and in the process almost lost his job, saved only by the intervention of the Lord Lieutenant. The loss of the setts was, Tindall later recalled, 'a bitter blow'.

*The setts in Haddington High Street in the midst of being covered over with tarmac
(© East Lothian Local History Centre)*

FINGERPOSTS

Scattered throughout East Lothian are around 66 old-style signposts, or finger-posts, each detailing the distances to nearby towns and villages. This is a reduction from the 83 that existed at the time of a survey taken in 1986. The survey led to a £25,000 repair programme that has been kept up ever since. In most cases they are situated in rural areas close to the roadside, resulting in many being damaged by passing traffic; the Scottish weather has also taken its toll. Many fingerposts which once adorned the county's roadsides are gone completely. East Lothian Council, to their credit, have introduced a policy to replace, repair and repaint fingerposts in their original style wherever they can. Replacement limbs and finials are generally cast at local ironworks such as Ballantine's of Bo'ness. There are several styles of fingerpost with differing poles, fingers and finials.

Recent national legislation which allows only the repair and not the replacement of fingerposts on A and B roads means that we will unfortunately lose some of the finest examples of old East Lothian's structural heritage.

CONCLUSION

So what does the future hold for East Lothian architecture? At a high level there certainly seems to be a pride in the architecture of the county. It is likely that Frank Tindall's work in preserving the historical integrity of the county is still paying dividends. Planning officers are aware that a county that attracts so many foreign visitors can benefit greatly from its impressive buildings.

There is no doubt that the county will see changes in the coming years.

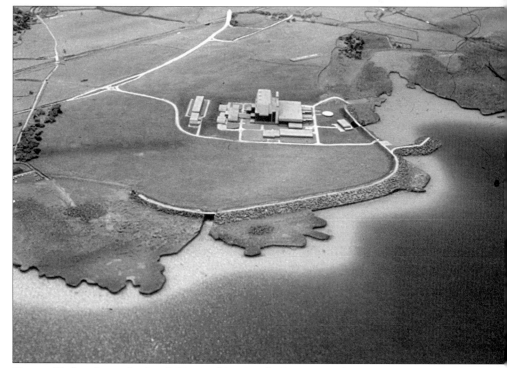

Torness Nuclear Power Station (© East Lothian Local History Centre)

Some of these, such as the possible demolition of Musselburgh's Jooglie Brig public house (an early twentieth-century building originally known as Mayfield) have led to protest from outraged locals. The dismantling of other landmarks has met with less opposition. Plans to upgrade Cockenzie Power Station were opposed by both local councillors and the community council. At a public meeting in February 2010 a number of reasons were cited in support of its closure – the need for greener energy, higher-than-national incidences of lung problems and heart illness amongst local people, and its cables and pylons being a blight on the county's landscape. Councillor Peter Mackenzie summed up the general mood, noting that 'it is the settled will of the East Lothian people that the power station will close'. It must close by the end of 2015. Also under threat is Torness Nuclear Power Station. When the Scottish National Party was voted into power in May 2007 it was made clear that the party would be actively pursuing an anti-nuclear agenda. While Torness will almost certainly outlive Cockenzie, the drive for greener energy will doubtless prove its undoing.

Cockenzie Power Station (© East Lothian Local History Centre)

BIBLIOGRAPHY

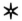

Adamson, Rev. Sidney, *St Michael's Kirk at Inveresk* (Inveresk, Kirk Session of St Michael's Inveresk, 1984)

Allan, Annemarie et al, *Prestonpans: A Social and Economic History Across 1000 Years* (North Yorkshire, Burke's Peerage & Gentry, 2006)

Baker, Sonia, *The Country Houses, Castles and Mansions of East Lothian* (Stenlake Publishing, 2009)

Baker, Sonia [ed.], *East Lothian Fourth Statistical Account 1945–2000: Volume Five: The parishes of Inveresk (with Musselburgh), Prestonpans, Tranent (with Cockenzie & Port Seton)* (East Lothian Council Library Service for the East Lothian Fourth Statistical Account Society, 2007)

Baker, Sonia [ed.], *East Lothian Fourth Statistical Account 1945–2000: Volume Four: The Parishes of Aberlady, Athelstaneford, Dirleton (with Gullane), North Berwick, Whitekirk & Tyninghame* (East Lothian Council Library Service for the East Lothian Fourth Statistical Account Society, 2006)

Baker, Sonia [ed.], *East Lothian Fourth Statistical Account 1945–2000: Volume One: The County* (East Lothian Council Library Service for the East Lothian Fourth Statistical Account Society, 2003)

Baker, Sonia [ed.], *East Lothian Fourth Statistical Account 1945–2000: Volume Six: The Parishes of Dunbar, Innerwick, Oldhamstocks, Spott, Stenton* (East Lothian Council Library Service for the East Lothian Fourth Statistical Account Society, 2008)

Baker, Sonia [ed.], *East Lothian Fourth Statistical Account 1945–2000: Volume Three: The Parishes of Bolton, Gladsmuir, Humbie, Ormiston, Pencaitland, Saltoun* (East Lothian Council Library Service for the East Lothian Fourth Statistical Account Society, 2005)

Baker, Sonia [ed.], *East Lothian Fourth Statistical Account 1945–2000: Volume Two: The Parishes of Garvald, Haddington, Morham, Prestonkirk, Whittinghame, Yester* (East Lothian Council Library Service for the East Lothian Fourth Statistical Account Society, 2004)

Bishop, M.C. [ed.], *Roman Inveresk: Past, Present and Future* (Duns, Armatura Press, 2002)

Brodie, Ian, *Steamers of the Forth* (Newton Abbot, David and Charles, 1976)

Cocker, Philip, *Gullane: Early buildings and people before 1930* (Gullane, Gullane and Dirleton History Society, 2008)

Cruickshank, Graeme, *Prestonpans Pottery: A Definitive Study of Scotland's Heritage* (Prestonpans, Prestoungrange University Press, 2007)

Cunningham, And. S., *Mining in Mid and East Lothian: History of the Industry from Earliest Times to Present Day* (Edinburgh, James Thin, John Orr, 1925)

Dalgleish, George and Forbes, Sheila, *Bellfield's History*

Dunbar Cottage Hospital 1948 Annual Report

Dunbar Parish Church: Tribute to the Past, Hope for the Future (East Lothian Antiquarian and Field Naturalists' Society, 1987)

East Lothian News, 1972–2010

The Educational Institute of Scotland, *Handbook to the 58th Annual Congress at North Berwick* (The Educational Institute of Scotland, 1934)

Fergie, John, *North Berwick: Shops, Shopkeepers & Tradesmen: Stories and Reminiscences* (Dirleton, Bramble Publishing, 2009)

Fife, Malcolm, *Scottish Aerodromes of the First World War* (Stroud, Tempus, 2007)

Fortune, Ailsa M., 'Seacliff House: Splendour Among the Ruins', *East Lothian Life*, vol. 70 (Winter 2009), pp. 42–44

Fulton, Dr T. Wemyss, 'An Account of the Sea-Fish Hatchery at Dunbar', *Twelfth Annual Report of the Fishery Board for Scotland*, pp. 196–209

Gow, Ian, *Scotland's Lost Houses* (The National Trust for Scotland, 2008)

Gray, W. Forbes, and Jamieson, James H., *A Short History of Haddington* (East Lothian Antiquarian and Field Naturalists' Society, 1944)

Green, Charles E., *East Lothian* (Edinburgh, William Green & Sons, 1905)

Groome, Francis H., *Ordnance Gazetteer of Scotland: A Survey of Scottish Topography, Statistical, Biographical and Historical* (Glasgow and Aberdeen, Thomas C. Jack, 1885)

Haddingtonshire Advertiser, 1890–1923

Haddingtonshire Courier/East Lothian Courier, 1859–2010

Haggarty, George Raymond, *Newbigging Pottery, Musselburgh: Archaeology, History & Bibliography* [Ceramic Resource Disc]

Haggarty, George and McIntyre, Alison, Excavation and watching brief at Newbigging Pottery, Musselburgh, East Lothian, *Proceedings of the Society of Antiquaries of Scotland*, 126 (1996), pp. 943–62

Hajducki, Andrew, *The North Berwick and Gullane Branch Lines* (Headington, The Oakwood Press, 1992)

Harris, J.V., *Dunbar Golf: The Story of the Links at Hedderwick and Broxmouth* (2007)

Hayes, Alan J., *The Extinct Methodist Societies of South-East Scotland: 2* (Haddington, 1977)

Hayes, Alan J., *The Extinct Methodist Societies of South-East Scotland: 3* (Musselburgh, 1977)

Hayes, Alan J., and Gowland, D.A., *Scottish Methodism in the Early Victorian Years: The Scottish Correspondence of the Rev. Jabez Bunting 1800–57* (Edinburgh, Edinburgh University Press, 1981)

Hill, Dora, *The Hayweights Clock and other verses* (1984)

Hopkins, Bob, 'St Michael's Inveresk: The Visible Church', *East Lothian Life*, vol. 69 (Autumn 2009), pp. 38–39

Hornsey, Brian, *A Cinema Miscellany: East Lothian: Dunbar, Haddington, Musselburgh, North Berwick, Ormiston, Prestonpans, Tranent*

Kerr, John, *The Golf Book of East Lothian* (Edinburgh, T. and A. Constable, 1896)

Kirkland, Hilary [ed.], *The Third Statistical Account of Scotland: The County of Midlothian* (Edinburgh, Scottish Academic Press, 1985)

Lang, Marshall B., *The seven ages of an East Lothian parish: being the story of Whittingehame* (Edinburgh, Robert Grant & Son, 1929)

Martine, John, *Reminiscences and Notices of the County of Haddington* (East Lothian Council Library Service, 1999)

Martine, John, *Reminiscences of the Royal Burgh of Haddington and Old East Lothian Agriculturists* (Edinburgh and Glasgow, John Menzies, 1883)

McDonald, John, *Burgh Register and Guide to Dunbar: Descriptive History of the Burgh, Castle and Battle* (Haddington, D. & J. Croal, 1893)

McGibbon, David, and Ross, Thomas, *The Castellated and Domestic Architecture of Scotland from the Twelfth to the Eighteenth Century*, vol. I–V (Edinburgh, Mercat Press, 1977)

MacLeod, Douglas, *Morningside Mata Haris: How MI6 Deceived Scotland's Great and Good* (Edinburgh, Birlinn, 2005)

McNeill, Peter, *Prestonpans and vicinity: historical, ecclesiastical, and traditional* (Glasgow; Edinburgh, John Menzies and Co., 1902)

McNeill, Peter, *Tranent and its surroundings: historical, ecclesiastical, and traditional* (2nd ed.) (Edinburgh and Glasgow, John Menzies & Co., 1884)

McNie, John, *Dunbar Parish Church: Place and People* (Dunbar, 2002)

McVeigh, Patrick, *Scottish East Coast Potteries, 1750–1840* (Edinburgh, John Donald, 1979)

McWilliam, Colin, *The Buildings of Scotland: Lothian except Edinburgh* (Middlesex, Penguin Books, 1978)

Millar, Sheila, 'Bothans', *East Lothian Life*, vol. 69 (Autumn 2009), pp. 40–42

Miller, James, *History of Dunbar: from the earliest records to the present time* (Dunbar, James Downie, 1859)

Miller, James, *The Lamp of Lothian, or, the history of Haddington: from the earliest records to the present period* (Haddington, James Allan, 1844)

Morris, Ruth, and Morris, Frank, *Scottish Healing Wells: Healing, Holy, Wishing and Fairy Wells of the Mainland of Scotland* (The Alathea Press, 1982)

Musselburgh News, 1889–2010

Nimmo, Bill, 'A Pictorial Puzzle', *East Lothian Life*, vol. 62 (Winter 2007), pp. 22–23

North Berwick Advertiser and East Lothian Visiter [sic.] 1887–97

Paterson, James, *History of the Regality of Musselburgh, with numerous extracts from the town records* (Musselburgh, James Gordon, 1857)

Payne, Patricia, 'The Willow Cathedral', *History of the Berwickshire Naturalists' Club*, volume 45, part 2, 1991, pp. 138–140

Perry, David R. et al, *Castle Park, Dunbar: Two Thousand Years on a Fortified Headland* (Edinburgh, Society of Antiquaries of Scotland, 2000)

Pugh, R.J.M., *Swords, Loaves & Fishes: A History of Dunbar from earliest times to the present* (Balerno, Harlaw Heritage, 2003)

Robertson, David M., *Longniddry* (East Lothian District Library, 1993)

Royal Commission of Ancient and Historical Monuments & Constructions of Scotland, *Eighth Report with Inventory of Monuments and Constructions in the County of East Lothian* (HMSO, Edinburgh, 1924)

Sands, J., *Sketches of Tranent: in the olden time* (Edinburgh, 1881)

Scott, W.R. [ed.], *The Records of a Scottish Cloth Manufactory at New Mills, Haddingtonshire 1681–1703* (Edinburgh, Scottish History Society, 1905)

Sinclair, Sir John [ed.], *The Statistical Account of Scotland 1791–99: vol. II: The Lothians* (EP Publishing Ltd, 1975)

Smith, Gavin Hamilton, *St Peter's, Musselburgh: A Short History of Episcopacy in Musselburgh from 1560–1966*

Smith, Sally, *Cockburnspath: a history of a people and a place: including: Cove, Dunglass, Old Cambus, Oldhamstocks, Bilsdean, Tower and Pease* (Cockburnspath, Dunglass Mill Press, 1999)

Snodgrass, Catherine P., *Third Statistical Account of Scotland: County of East Lothian* (London and Edinburgh, Oliver and Boyd, 1953)

Statham, Craig, *Old Haddington* (Stenlake Publishing, 2007)

The Statistical Accounts of Edinburghshire by the Ministers of the Respective Parishes (Edinburgh, William Blackwood & Sons, 1845)

Tindall, Frank, *Memoirs and Confessions of a County Planning Officer* (Ford, Pantile Press, 1998)

Transactions of the East Lothian Antiquarian and Field Naturalists' Society, vol. I–vol. XXVII (ELAFNS, 1924–2008)

Tully-Jackson, Jack, and Brown, Ian, *East Lothian at War* (Haddington, East Lothian District Library, 1996)

Tully-Jackson, Jack, and Brown, Ian, *East Lothian at War: vol. II* (Haddington, East Lothian District Library, 2001)

UK Censuses, 1841–1901

Valuation Roll, East Lothian, 1855–1974

Valuation Roll, Midlothian, 1855–1974

Whyte, Ian, and Whyte, Kathleen, *Discovering East Lothian* (Edinburgh, John Donald Publishers, 1988)

Wiseman, Rev. W.R., *The Parish and Church of Gladsmuir, East Lothian*

http://maps.nls.uk/index.html
http://www.maybole.org/history/castles/
http://www.northberwick.org.uk/
http://www.scottisharchitects.org.uk/
http://www.scran.ac.uk/

INDEX

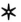

405 Searchlight Company 57
4th/5th Battalion, Royal Scots *see* 405 Searchlight
 Company 57
77 Home Defence Squadron 18
A.G. Moore & Co. Ltd 68
A1 129
Abbey Farm, North Berwick 203
Abbey, Haddington 204
Aberlady Bay 20
Aberlady Railway Station 154
Aberlady, Gullane and North Berwick Railway
 Company 153
Acheson, Alexander 118
Acheson's Haven Harbour, Prestonpans 118
Ada, Princess 25, 204
Adam, James 177
Adam, Robert 46
Adam, William 51
Agricultural Club, Haddington 168
Albany, Duchess of 6
Aldhammer House 80–81, 103, **80**
Alexander family 103
Alexander II, King (Scotland) 26
Alexander, Mr 80
Allan, Councillor Douglas 189
Alt Hamer House *see* Aldhammer House,
 Prestonpans
Amisfield 95
Amisfield House, Haddington 29–31, 46, 194,
 29–30
Anderson, John 141
Anderson, Rev. F.L.M. 175
Anderson, William 191
Angus, George 124
Annandale Jnr, Alexander 101
Annandale, Alexander 100
Anthony, Jack 143
Anti-glider poles 20
Anti-tank defences 20–21, **21**
Archerfield Golf Club 63
Arundel, Thomas 157
Associated British Maltsters 101
Asylum, Musselburgh 92
Auction Mart, Haddington 124, **124**
Auldhame 5

Austin–Sparks, Theodore 160
Ba' Alley, Haddington 168–170, **169**
Back Street, Prestonpans 67
Backet, Cockenzie *see* Inkbottle, Cockenzie
Bagnall, Rowland 103
Baillie, Gideon 44
Baillie, James 44
Baillie, Richard 31, 35, 85, 194
Baird Brothers 149
Baird, Lady 160
Baird, Sir William Gardiner 157
Balfour of Balbirnie, James 64
Balfour, Earl of 194
Balfour, John Blair 58, 151
Ball Alley, Haddington *see* Ba' Alley, Haddington
Ballantine's, Bo'ness 22
Balloch, Miss 86
Bangley Quarry, near Haddington 152
Bankfoot House, Prestonpans 83, **83**
Bankfoot Pottery, Prestonpans 103
Banks & Son, R. 107
Bankton House, Prestonpans 42–44, **42**, **43**
Bankton, Lord *see* Andrew McDouall
Baro Church, Garvald 92
Baro Graveyard, Garvald 91–92, **91**
Bass Rock Castle 11–12, **11**
Bath Street, Prestonpans 67
Bathing Pond, Dunbar 146–147, 149, **147**
Battle of Prestonpans 216–218
Baxter Snr, John 47
Beach Huts, Gullane 156, 158–159, **158–159**
Beaton, Cardinal 14
Beattie, William 139
Belfield, Charles 106
Belfield, James 106
Belfield's Pottery, Prestonpans 104–106, **105**
Belfrage & Carfrae 152
Belhaven Sands 107
Belhaven, Lord 115
Belton House, Dunbar 31–33, **32**
Beltonford Paper Mill, West Barns
 100–101, **100**
Berry, Dave 152
Biddall's Picture House, Prestonpans 176
Biggar, John 213

Binning, William 47
Black Agnes 208
Black Castle 16
Black Douglas 11
Black Douglases 6
Black, Colin 126
Black, Dr A.D.M. 125
Blackshiels 63
Blackwood, Robert 95
Blaikie, W.G. 133
Blanc, Hippolyte J. 221
Boating Pond, Dunbar 146–147, 149, **147**
Boer War 102, 168
Boglehill **x**
Bomb Disposal Unit 20
Bombing of Haddington 180
Bonnie Prince Charlie see Stuart, Prince Charles
 Edward
Borders Boys' Brigade 199
Borrowman, John R. 218
Bosnian refugees 155
Boston, J. Cairns 134, 178
Bothans, Yester 63–64
Bothwell Castle, Haddington 33–35, **34**
Bothwell, 4th Earl of see James Hepburn
Bothwell's Kitchen, Haddington 33
Bowe, John Hutchison 86
Bower, Walter 204
Bowling Green, Haddington 164
Bowling Green, Musselburgh 164
Braid, James 176
Brewery Park, Haddington 173
Brick Works, Wallyford 107
British Coal Board see National Coal Board
British Malt Products 101
British Red Cross 84
Brodie, Alexander 99
Brodie, William 108
Brooke, Miss Kathleen 146
Brown, Rev. Robert 54
Brown, Thomas 50
Browne, George Washington 58
Broxmouth Fort, Dunbar 5
Brumby, Sophie 60
Brunton Shaws 98
Brunton, John D. 57, 98
Brunton's Research Laboratory 98
Brunton's Wire Works, Musselburgh 95–98, **96–97**
Bruntsfield Golf Club 211
Bryce, David 50, 53
Bryson, P. & D. 192
Buccleuch, Duke of 181
Buchanan, John 120
Burgh Golf Course, North Berwick 156
Burleigh, Councillor John 168
Burn, James 122
Burn, William 45, 46, 188
Burnt Candlemas 204
Burt, Mr 113
Burton, John Hill 73
Byres Farm, Garleton 170
Byres, Garleton 173
Cadell, John 104
Cadell, Messrs 221
Cadell, William 104

Cadoux, H.J. 161
Calder, James Charles 156
Caledonian Associated Cinemas 184, 186
Campbell, Agnes 80
Campbell, Emily 136
Campbell, George 92
Campbell, John Colin 135
Canmore, Malcolm 8
Cant family 52
Carberry Colliery, Inveresk 110–111, **111**
Carclo Engineering Group 98
Carlyle, Rev. Dr Alexander 'Jupiter' 162, 165,
 205–206
Carse, Alexander 218
Carters' Play 75–76
Castle Gordon, Musselburgh 92, **92**
Castle o' Clouts, Prestonpans 82, **82**
Castle Park, Dunbar 3
Catholicism 213–214
Cattanach, Alexander 184
Cattle Market see Auction Mart, Haddington
Central Miners' Welfare Committee 112
Central Welfare Committee 181
Champneys, Basil 7
Charteris, Colonel Francis 29, 36, 95
Charteris, Francis Richard see 10th Earl of
 Wemyss
Charteris, Francis Wemyss see 7th Earl of Wemyss
Charteris, Hugo Richard see 11th Earl of Wemyss
Chesters Hill Fort, Athelstaneford 5
Chiesley, Rachel see Grange, Lady
Children's Employment Commission 113
Chirnside family x
Cistercian Monastery, North Berwick 202, 203,
 202–203
Cistercian Nunnery, Haddington 204
City of Glasgow Bank, Haddington branch 168
Civil Service Benevolent Fund 87
Clapperton, Brand & McNiven 124
Clerkington Acredales, Haddington 173
Clerkington House, Haddington 55–57, **55, 56**
Coal Industry Nationalisation Act 94
Cochran, John 208
Cochrane, Wull 69
Cockburn family 55
Cockburn of Ormiston, John 115
Cockenzie Power Station, Cockenzie 182, 230, **230**
Codona family 176, 179
Codona, Mr 179, **179**
Coffin House, Haddington 114, **114**
Colonel Gardiner's House see Bankton House,
 Prestonpans
Colquhoun of Luss, Lady 186
Colt, Robert 53
Comyn, Margaret 8
Congreve, Mrs 24
Connery, Sean 114
Cooper & Son, Francis 60
Co-operative Women's Guild, Prestonpans 189
Cope, General Johnny 78
Cope's House, Cockenzie see Inkbottle, Cockenzie
Corn Exchange, Haddington 163, 179
Cospatrick see Patrick, Earl of
 Northumberland
Cossar's Yard, Musselburgh 163

Costello & Sons 161
Cottage Hospital, Dunbar 86
Coulter, Mr 170
Country Dance Club, North Berwick 161
County Buildings, Haddington 173, 215
County Jail, Haddington 215–216
Covenanters 12
Craig, Deputy Superintendent William 60
Craigielaw Links 173
Crichton, James 28
Cricket Club, Haddington 173
Cromwell, Oliver 7, 14
Cross, Arthur 59
Cross, Marjory 59
Cunningham, Elizabeth 176
Cunningham, St Clair 175–176
Custom House see Hayweights, Musselburgh
Customs House, Dunbar 99, **99**
Customs House, Prestonpans 19
Cuthill 66–68, **66**
Cuthill House, Prestonpans 79
Cuthill School, Prestonpans 197
Cuthill, Prestonpans 66–68
Dale, John R. 55
Dalgleish–Gullane motor car 129
Dalrymple, Sir Hew 7
Dalrymple, Sir John 7
Dalrymple, Walter Hamilton 7
Dalymple, Bt, Sir Hew 134
Dannevig, Harald Christian 109
Dave Berry and the Cruisers 178
David I, King (Scotland) 25, 120, 200
Davidson, Provost William 180
Davidson, Rev. John 164, 195
Davie Dobson's House, Tranent 73–74, **73**
Dawson family 166
de Bernehan, David, Bishop of St Andrews 202
Deans & Moore 110
Defoe, Daniel 204
Denholm , George 86
Dickson, Agnes 45
Dobie family 36
Dobie, Lockhart 24
Dobson, Davie 74
Donaldson's School for the Deaf 28
Doocot, Aberlady 219–221, **220**
Douglas, William 5
Dovecot, Aberlady see Doocot, Aberlady
Dow family 77
Dr Barnardo's 59–60
Drill Hall, Tranent 16–17
Drummore, Lord 163
Duke of York see King James II 95
Dunbar and District History Society 44
Dunbar Castle 8–10, 109, **8, 109**
Dunbar Collegiate Church see Dunbar Parish
 Church
Dunbar Golfing Society 175
Dunbar Harbour 21
Dunbar House, Dunbar 177
Dunbar Initiative 101, 178
Dunbar Parish Church 208–209, **209**
Dunbar Town Council 146
Duncan, 4th Earl of Fife 202
Dunglass House, Oldhamstocks 26–28, **27**

Dunn & Findlay 149
Dunn, Matthias 119
Dunnet, Robert 115
Dunsyre Hotel, North Berwick 154
Durie, John 60
East Lothian Antiquarian and Field Naturalists'
 Society 46, 216
East Lothian Bank 104
East Lothian Care and Accommodation Project
 see Elcap
East Lothian Co-operative Society 127
East Lothian Council 44, 80, 228
East Lothian Education Authority 188
East Lothian Housing Association 17
East Lothian Planning Department 103
East Lothian Tourist Board 143
East Lothian Water Board 191
East Mains Farm, Saltoun 115–117, **116**
Eastern Star, Prestonpans 189
Eden Cottage, Musselburgh 78–79, **79**
Edinburgh Collieries Company Ltd 94, 107, 110, 112
Edinburgh District of Methodists 212
Educational Institute of Scotland 188
Edward I, King of England 10
Edward II, King of England 8
Edward III, King of England 204
Eglinton Hotels 136
Elcap 90–91
ELCO see East Lothian Co–operative Society 127
Eldbottle 63
Elliot, Miss 191
Elphinstone School, Tranent 189
Elphinstone Tower Farm House, Tranent 14
Elphinstone Tower, Tranent 14–15, **15**
Episcopalianism 210–211
European Regional Development Fund 44
European Voluntary Workers' Hostel, Amisfield
 Park, Haddington 227
Fairfax-Blakeborough, Major J. 166
Fairlie, Joanis 35
Fala 63
Falconer, Dorothy 60
Falconer, Eric 60
Fall, Captain James 22, 177
Farmer, James 75
Farmer's House, Nungate 74–75, **74**
Farquharson, Francis 54
Farquharson, J. & R. 195
Farquharson, Mrs 160
Farquharson, Provost 160
Felsenstein, Julius 57
Fergusson, Bob 172
Ferrier, Rev. Walter 186
Fingerposts 228
Fire Brigade, Dunbar 101
Fire Brigade, East Linton 101
Fire Brigade, Haddington 40, 61, 101, 189
Fire Brigade, Leith 193
Fire Brigade, Musselburgh 43, 47, 193
Fire Brigade, North Berwick 54
Fire Brigade, Tranent 61, 193
Flamme fougasse, Dunbar 21
Fleck, Mrs 149
Fleck, William 135
Fleets Colliery, Tranent 112, **112**

Fletcher of Saltoun, Andrew 115
Flood (1358), Haddington 204
Forbes, Barbara 81
Forbes, William 211
Ford, James Johnston 57
Ford, Ludovic 57
Forest, Dr 75
Foresters' Hall, North Berwick 174–175, 184
Forest's Bounds, Tranent 75
Forth Road Bridge 98
Fourth Provident Investment and Building Society 154
France, David 22, 107
Francis, Lord Elcho 122
Fraser, Mr 190
French Fort, Dunbar 3
Friendship Holidays Association 145, 160
Froge, Henry 33
Front Street, Prestonpans 67
Fullarton, James 62
Gallops, Gullane 166
Galloway Saloon Steam Packet Company 144
Galloway, M.P. 144–145
Galton, Captain 196
Gardiner, Colonel James 42, 216
Garleton Hills 16, 17
Garleton Rifle Range, Kae Heughs, Haddington 17–18, **17**
Garnock, Viscountess 59
George Inn, Haddington 121
George VI, King 184
George, 11th Earl of Dunbar 9
Gibson, James S. 122
Giffordgate 72, **72**
Gillespie & Co., W.A. 150
Gillespie, Billy 150
Gilmour, Alexander 172
Gimmers Mill Bridge, Haddington 123, **123**
Gladsmuir Parish Church 206–207, **206**
Glasclune House, North Berwick 58–60, **59**
Glasgow Overspill 69
Glassel, John 65
Golden signs, Haddington 130–131, **130**, **131**
Golfers' Rest Tavern, North Berwick 174
Gordon, George 103
Gordon, Robert 103
Gosford House (Old), Aberlady 45–46, **46**
Gosford House, Aberlady 227
Graham of Claverhouse, John 12
Graham, Rev. Robert Balfour 132
Grahame, James M. 86
Grand Metropolitan Hotels 136
Grange, Lady 36
Grange, Lord 36, 163
Grant, George 136
Grant-Suttie, Lady Susan H. 195
Grant-Suttie, Sir George 83, 197
Grant-Suttie, Sir James 104, 119
Grassmarket Mission 84
Graves, Robert 200
Gray, Alexander 107
Gray, William 107
Great North Road 132
Green Lady 78
Green, Charles E. 39

Green's Hotels 143
Grey of Wilton, Lord 24
Grey School, Prestonpans 195–196, **195**
Grey, Andrew 113
Grose, Francis 200
Gullan, Mr 124
Gullane branch line 153–154
Gullane Railway Station 153–154
Gullane Sands 134
Guthrie, Richard 85
Haddington and District Amenity Society 129
Haddington Golf Club 31
Haddington Golf Course, Garleton Hills 170–171, **171**
Haddington Light Industries see Ranco Motors 114
Haddington Motor Engineering Company 129
Haddington, Earl of 28
Haldane, R.B. 151, 175
Hall, Sir James 28, 218
Hall, Sir John 28
Hallis Wallis, Musselburgh 33
Hamilton, Alex 103
Hamilton, Councillor Peter 211
Hamilton, Dame Katherine 14
Hamilton, Effie 54
Hamilton, James 42
Hamilton, Sir John 14
Hammiltoun, Jacobi 36
Hardgate, Haddington 69–71, **70–71**
Hardie, Alexander Murray 181, 182
Hardie, Francis William 194
Hardie, J.W. 174
Harrogate Spa 137
Haugh, The, Haddington 173
Hawke, Lady see Marjory Cross
Hawke, Lord 59
Hay family 31
Hay Mackenzie family 51
Hay Newton family 57
Hay of Drumelzier, Robert 64
Hay, James 40
Hayweights, Musselburgh 125–126, **125**
Headland, Linda 91
Heather Inn, Haddington 163
Heatly, Sir Peter 152
Hedderwick Hill Golf Course, near Dunbar 175–176
Henderson, John 134
Henry IV, King of England 204
Henry VII, King of England 7
Henry VIII, King of England 1
Hepburn, James 14, 33, 73
Herbertson, John Anthony see Jack Anthony 143
Herdmanflat Hospital, Haddington 90
Herdmanston House, Saltoun 23–25, **23**, **24**
Herdmanston Mains Farmhouse, Saltoun 25
Hertford, Earl of 14
Hilcote, Anthony 103
Hill, Dora 126
Himsworth, Jean 156
Historic Scotland 44, 45
Hitchman, Agnes 143
Hitchman, Alfred J. 142
HMS Dreadnought 132
Hodge, Robert 206

Hodges Kirk, Gladsmuir 206
Hoffie family 156
Hogarth, Alexander 123
Holloway, Arthur G. 135
Holy Stop *see* Bankton House, Prestonpans
Home Guard, East Linton 20
Home Guard, Haddington 18
Home, John 163
Home, Sir Alexander 203
Home, Sir Thomas 28
Honourable Company of Edinburgh Golfers 175
Hope family 47
Hope, Henry Walter 153, 171–172, 173
Hope, Lady Archibald 211
Hope, Sir William 211
Hopetoun Unit, Haddington 90–91, **90**
Hotel Belle Vue, Dunbar 148–151, **148**
House o' Muir Colliery, Humbie 113
Houstoun, Alexander 57
Howden, Dr R. 122
Howden, Mr 106
Hughes, Thomas 213
Hume, Bailie 137
Hunter, Agnes 52
Hunter, Alexander 101
Hunter, Robert 52
Inchview, Prestonpans 69
Incorporation of Tailors 65
Industrial Revolution 93
Ingle, Councillor Charles 129
Inkbottle, Cockenzie 77–78, **77**
Jack, John 121
Jacobites 12
Jaffray, Rev. John 209
James I, King of Scotland 6
James II, King 95
James II, King of Scotland 162
James IV, King of Scotland 7, 187
James V, King of Scotland 7, 118, 203
James VI, King of Scotland 28
James, 2nd Earl of Douglas and Mar 6
Jamieson, George 144
Janefield Wood, Prestonkirk 20
Jelly, William 38
Jenkins, Major O. Rees 155
John Gray Centre, Haddington 71
Johnston, Isabel Henry 78
Johnstone, Charles 135
Johnstone, Gilbert 14
Jooglie Brig, Musselburgh 230
Kae Heughs, Haddington 17
Kennedy, James 78
Kennedy, President John F. 178
Ker, Mark 118
Ker, Mark (Earl of Lothian) 42
King, Ellen 149, 183
King's Arms, Haddington 167, **167**
Kingside School, Whittingehame 190–191, **191**
Kinnear & Peddie 58
Kinross, 1st Baron *see* John Blair Balfour
Kinross, John 52
Kinross, Lady 59
Kirk Street Pottery, Prestonpans 104
Kitchener, Lord 132
Knockenhair 16

Knox Academy Playing Fields, Haddington 174
Knox Academy, Haddington 188
Knox Institute, Haddington 187
Knox, John 72, 187
Knox's house, John, Haddington **72**
Kosovan refugees 155
Kruger, President Paul 168
L.G. Mouchel & Partners 146, 149
Laidlaw, Henry 167
Laidlaw, Rosina 167
Laidlay, Andrew 54
Laidlay, John E. 172
Laidlay, John Watson 54
Lambre, Nicholas 135
Lammermuir House, Dunbar 87
Land o' Cakes, Prestonpans 81, **81**
Land reclamation, Belhaven 107
Land reclamation, Prestonpans 120
Lang, Rev. Marshall B. 64
Lauder, Sir Thomas Dick 47
Lauderdale House, Dunbar 177–178
Lauderdale, Earl of 12
Le Mans 24 Hour Race 57
Lee, Lawrence 75
Lee's Bounds 75
Leith Dockers' Strike 113
Leithen Lodge, Peebles 44
Letham Filling Station, Haddington 129
Levenhall 20
Lindsay, Countess *see* Viscountess Garnock
Linlithgow, Marquis of 113
Linplum Farm, Garvald 92
Lochend House, Dunbar 44–45
Logan, William 106
London and North Eastern Railway Company 154
Longniddry 64–65
Longniddry Golf Club 31
Longniddry Golf Course 20
Lord Glentannar's Trust 160–161
Lord Lieutenant of East Lothian 227
Lothian Building Preservation Trust 44
Lothian Health Board 90
Lucky Vint's Tavern, Prestonpans 66, 163
Luffness New Golf Club, Aberlady 173
Luffness Old Golf Club clubhouse, Aberlady 171, 173, **173**
Luffness Old Golf Club, Aberlady 171–173, **172**
Luftwaffe 18
Lumsden, J. 157
Lumsden, James 204
Lyall, Alexander 78
Macadam, Dr Stevenson 138, 221
MacAdam, Robert 101
MacAdam, William 101
MacDonald, Dr Duncan R. 194
Mackenzie, Alexander 65
Mackenzie, Councillor Peter 230
Mackenzie, Mary Ann 57
Mackenzie, Miss 92
Magdalen's Chapel, Musselburgh 198
Maltings, The, West Barns 101
Marantha Christian Youth Centre 161
Marcel, Eugene 143
Marine Hotel, North Berwick 138–141, **139**

Market Cross, Haddington *see* Mercat Cross, Haddington
Marr, Peter 127
Marshall, Larry 178
Martine, John 108, 121
Martyn, Elizabeth 151
Martyn, William 151
Mary Murray Institute, Prestonpans 188–189, **189**
Mary, Queen of Scots 1, 9, 73, 204
Masonic Lodge, Portobello 224
Matthew, Sir Robert 69
Maybole 202
McAra, John 183
McClelland, Alexander 78
McCran, Janet 177
McDonald, John 133
McDouall, Andrew 43
McEwan, MP, Captain J.H.F. 183
McGonigall, William Topaz 6
McGregor, Alexander 135
McKay, John Ross 186
McKay, William Darling 221
McLean, Donald 143
McLeod, Charles 127
McNeill, G.F. 25
McNeill, John 120
McNeill, Peter 216
McNiven's large park, Haddington 124
Meadowmill, Tranent 65
Meek family 103
Meek, A.A. 80
Meikle, Andrew 115
Meikle, Isabella 189
Mellis, James 101
Mellis's Soap Works, Prestonpans 101–102, **102**
Mephius, J.J. 139
Mercat Cross, Haddington 120–121, **121**
Methodism 212–213
Methodist Chapel, Haddington 212
Methodist Chapel, Musselburgh 212–213
Michael, John 141
Midlothian Stone Ware Potteries 107
Millar, Joseph 78
Millar, Rev. Arthur 210
Millar, Robert 164
Miller, James 108
Miller, Sir William 52
Miller, William 106
Millknowe Farm and Farmhouse, Stenton 117, **117**
Milne, Mr 138
Milnhaven Harbour, Prestonpans 119
Miners' Welfare Fund 112
Miniature Rifle Club, Haddington 18
Minto, Councillor Thomas 145
Mitchell & Wilson 28
Mitchell, Andrew 106
Mitchell, Catherine Miller 45
Moir, David Macbeth 36
Moncreiff, Marianne Eliza *see* Lady Kinross
Montague, Earl of Salisbury 9
Monteith, John 146
Montgomery, George 126
Moore & Co., A.G. 129
Moore, Mrs A.G. 181
More, Provost H. 178

Morison, John 118
Morison, Sir Alexander 42
Morison, William 119
Morris, 'Old' Tom 171–172, 173
Morris, 'Young' Tom 172, 173
Morrison & Carfrae 145
Morrison's Haven Harbour, Prestonpans 118–120, **119**
Morrison's Haven Pottery, Prestonpans 103–104
Mother Julian 45
Mucklebackit, Samuel *see* James Lumsden
Muir, Miss 190
Muirhead, Nannie 76
Murray, Stephen 168
Murray, William 179
Musselburgh and Fisherrow Co-operative Society, Danderhall branch 128
Musselburgh and Fisherrow Co-operative Society, Smeaton branch 128–129, **128**
Musselburgh and Fisherrow Co-operative Society, Wallyford branch xii, 128
Musselburgh and Fisherrow Co-operative Society, Whitecraig branch 128
Musselburgh Arms Hotel 222
Musselburgh Wiremills Co. Ltd 98
Napoleonic Wars 2, 16
National Coal Board 44, 68, 94, 107
National Health Service 87, 89
National Museums of Scotland 216
Naval and Military Museum, Edinburgh 216
Naysmyth, Alexander 28
Neil & Hurd 136
Neill, Adam 26
Neilson Park, Haddington 174
Neilson, Elizabeth 197
New County Cinema, Haddington 178–180
New Mills Cloth Manufactory, Haddington 93, 95
New Mills Company 95
Newark, North Berwick 203
Newbigging Pottery, Musselburgh 106–107
Newhall, Yester 51, **51**
Newhaven Harbour, Prestonpans 118
Newton Hall (New), Yester 57–58, **58**
Newton Hall (Old), Yester 40
Nicholas Groves-Raines Architects 44
Nicholson, Thomas William 213
Nicolson, Thomas 212
Nisbet, Willie 170
Nisbett, Hamilton More 52
Normandy Remembrance Garden, Haddington 164
North Berwick Castle 10–11, **10**
North Berwick Law 16
North Berwick Town Council 151, 160
North British Railway Company 132, 153
Nungate Bridge, Haddington 123
Nunraw Abbey, Garvald 53
Oak Tree Café, Haddington 129
Ogilvie, James 11
Olivestob *see* Bankton House, Prestonpans
One O'Clock Gang, The 178
Ormiston Castle 14
Ormiston Hall, Ormiston 47, 50, **50**
Orr, Robert 89
Oswald, Thomas 36

Our Lady of Loretto Chapel, Musselburgh 198
Palace, Haddington 25–26, **26**
Parkyns, George 202
Paterson, Colonel Gavin 181
Paterson, James 33
Paterson, Thomas 101
Paterson, William 101
Patrick, Earl of March 208
Patrick, Earl of Northumberland 8
Pavilion, Cockenzie *see* Inkbottle, Cockenzie
Pearson, Sir Arthur 157–158
Peddie & Mackay, Dick 57
Pembroke, Earl of 10
Pencaitland House, Pencaitland 41, **41**
Pencraig Hill 16
Penkaet House *see* Pencaitland House
Penston Aerodrome, Gladsmuir 18
Philip, David 170
Picture House, Haddington 179, **179**
Pigeon Square, Tranent 75–77, 192, **76**
Pilkington, Frederick Thomas 139
Pinkie St Peter's Primary School, Musselburgh 211
Pius, Antoninus 3
Platcock Rocks, North Berwick 144
Playhouse Cinema, Dunbar 184
Playhouse Cinema, North Berwick 184–186, **185**
Pococke, Richard 31, 208
Polish Army 25, 31
Pollard, Dr Tony 36
Polson, Mr 222
Polwarth, Lady 160
Pond Hall Action Group 184
Pond Hall, Port Seton 183–184, **183**
Ponderosa, Prestonpans 67
Poplars, Aberlady 84
Pordage, Ernest 138
Porteous, Thomas 108
POW camp, Amisfield 226–227, **226**
POW camp, Gosford 225–227
Premier Property Group 129
Preston House, Prestonpans 36–40, **37**
Preston Lodge High School, Prestonpans 31, 193–194, **194**
Preston Tavern, Prestonpans 163
Preston Tower, Prestonpans 12–14, **13**
Preston, Simon 33
Preston, Thomas 212
Prestongrange Bowling Club 83
Prestongrange Coal and Iron Company Ltd 67, 119
Prestongrange Colliery 119
Prestongrange Mining Museum 94, 225
Prestongrange Silver Band 127
Prestongrange Welfare Institute, Prestonpans 181
Prestonlinks Colliery Band 182
Prestonlinks Welfare Institute, Prestonpans 182, **182**
Prestonpans Co–operative Society, Cuthill branch, Prestonpans 127
Prestonpans, Battle of 42, 47
Prestoungrange Gothenburg Public House 40
Prestoungrange, Baron Gordon 39
Priests' Town 80
Primary School, Tranent 196–197
Prince of Wales 134
Pringle, James 126

Pringle's, Haddington 126–127, **127**
Proffit, John 65
Public School, Prestonpans *see* Grey School, Prestonpans
Public School, Tranent 192–193, **192**
Puddock Wull 75
Q-sites 18–19
Queen Victoria 121, 149
Racecourse, Gullane 166
RAF Maintenance Unit 214
Ragged School, Haddington 187
Ramsay Pit 113
Ranco Motors 114, 161
Randolph, Countess Agnes *see* Black Agnes
Randolph, Thomas 3
Red Douglases 6
Red School, Prestonpans 196
Redcroft Hotel, North Berwick 154–155, **155**
Reformation, Scottish 203
Reid, Admiral Sir Peter 25
Reid, James 113
Reid, John Pringle 46
Reid, Marion 106–107
Reid, Robert 83
Reid, William 106
Relief, Tranent 65
Rennie, Mr 138
Reynolds, George 197
Rhodes Farm, North Berwick 156, 161
Richardson, James S. 25
Richardson, Marjory 107
Richardson, Robert 212
Richmond, Sir Ian A. 3
Rifle Arms, Haddington 170
Roberts, W. 162
Robertson, John Home 149
Robertson, Provost John 184, 196
Rodger, Tam 82
Roman Fort, Inveresk 3
Romans 4
Rough Wooing 1, 14, 204, 207
Rowan, Major Gilbert 182
Roxburghe Lodge Hotel *see* Roxburghe Marine Hotel, Dunbar
Roxburghe Marine Hotel Company 142
Roxburghe Marine Hotel, Dunbar 53, 141–143, **142**
Roxburghe, Duchess of 141
Royal Engineers 25, 58
Royal Hotel, North Berwick 134–136, **135**
Royal Hunting Lodge Hotel *see* Royal Hotel, North Berwick
Royal Observation Corps 15
Rugby Club, North Berwick 161
St Andrew Blackadder Church, North Berwick 152, 200–201, **201**
St Andrew's Monastery, Dirleton 198
St Ann's Chapel, Haddington 198
St Baldred's Chapel, Bass Rock 12, 198
St Clair family 23
St Clement's Chapel, Tranent 198
St Dennis's Chapel, Skateraw 198
St Dunstan's 84, 157–158
St Gabriel's RC Primary, Prestonpans 197
St James's Chapel, Musselburgh 198
St John the Evangelist (chapel) 25

St John's Chapel, Drem 198
St John's Chapel, Haddington 198
St John's Chapel, Herdmanston 198
St Katherine's Chapel, Haddington 198
St Laurence's Chapel, Haddington 198
St Laurence Leper Hospital, nr Haddington 85, **85**
St Martin of Tours Roman Catholic Church, Tranent 62, 213–214, **213**
St Martin's Chapel, Haddington 198
St Mary's Chapel, Dunglass 198
St Michael's Church, Inveresk 205–206, **205**
St Michael's, Gilmerton 218
St Nicholas's Chapel, Samuelston 198
St Ninian's Chapel, Haddington 198
St Patrick's Chapel, Gullane 198, 199
St Peter's Church School, Musselburgh 210–211, **210**
St Peter's Episcopal Church, Musselburgh 210–211, **210**
St Rule's House, Dunbar 53
Salt pan, Torness 102
Salt pan, Woodbush, near Dunbar 102
Salt Preston 80
Saltworks, Prestonpans 102–103
Salvation Army 83
Salvation Army, Prestonpans 189
Sands, John 216
Sandybed House, Haddington 33
Save the Outdoor Pool (STOP), North Berwick 152
Sayers, Ben 139
Sayers, Bernard 155
Schaw, Dr James 36
Schaw's Hospital, Prestonpans 38, 188–189, **189**
School Board, Tranent 77, 192
School of Arts, Haddington 187
Schwediaur, Dr 78
Scott & Paulo 180
Scott Morton & Co. 59
Scott, Sir Walter 7
Scott, Tom 184
Scottish Brick Corporation 107
Scottish Caravan Club 161
Scottish Civic Trust 143
Scottish Development Agency 150
Scottish Oils & Shellmax 129
Scottish Reformation 187
Scottish Salt Company 103
Scottish Skateboarding Association 17
Scratcher, Prestonpans 176–177, **176**
Seacliff, Whitekirk and Tyninghame 53–55, **54**
Seafield Brick and Tile Works, Belhaven, Dunbar 100, 107–108, **108**
Sea-fish hatchery, Dunbar 109–110, **109**
Sergeant Majors' quarters, Haddington xiv
Seton Castle 73
Seton, George see 4th Earl of Winton
Seton, George see 5th Earl of Winton
Seton, Tranent 65
Setts, Haddington 227–228, **228**
Seymour, Edward 28
Sharp, Archbishop 12
Sharpe, Sir William 33, 36
Shearsmith family 129
Signal Stations 16
Silver Arrow 162

Simpson, George 149
Simpson, Sir James 75
Sinton, Mrs 146
Sinton, Provost 149
Skid Hill 16
Skirving, Adam 216
Slaughterhouse, Haddington 122
Sligo, George 53
Smallpox Hospital, Haddington 87–89, **88**
Smeaton Colliery 129
Smeaton Village, Inveresk 68
Smeaton Welfare Institute, Inveresk 181
Smith & Co., George 222
Smith, Archbishop William 213
Smith, Gavin Hamilton 211
Smith, Rev. William 211
Snowdon, Miss 154
Society for the Preservation of Rural Scotland 216, 218
South of Scotland Electricity Board 178
Spa, Belhaven 136–138, **137**
Sprigg, George 129
Stair Park, Tranent 60–62, 214, **61**
Stair, Lord 205
Stanfield, Colonel Sir James 29, 95
Stanfield, Philip 29
Stanley Butler Steamship Company 145
Star Inn, Haddington 168
Starforth, John 192
Stark's joiners and undertakers 114
Steamboat Pier, North Berwick 143–145, **144, 145**
Steedman, Hansen and Dykes 144
Steele, Davy 81
Steven, Alexander 50
Stevenson, Anthony R.G. 57
Stirling, Mr 168
Stitches see Willie Nisbet
Stoneyhill, Musselburgh 35–36
Strain, Robertson & Thomson 109
Struthers, Dr 197
Stuart, Prince Charles Edward 47, 79, 211
Summerlee and Mossend Iron and Coal Company Ltd 67, 94
Sun Foundry, Glasgow 222
Sutherland, John 141
Swan, Annie S. 154
Swan, D.B. 200, 203
Swedaire see Dr Schwediaur
Sweet 178
Swimming Club and Humane Society, North Berwick 151
Swimming Pond, Dunbar 146–147, 149, **147**
Swimming Pond, North Berwick 151–152, **151, 152**
Swimming Pool, Port Seton 182–184
Swinton's House, Haddington 168
Tantallon Castle, North Berwick 5–7, 203, **6**
Tantallon Hall, North Berwick 84
Tantallon Hall, North Berwick 156, 157, 160, 161, **160, 161**
Tay Bridge 108
Taylor, John 44
Taylor, Peter 213
Telfer, Margaret 79
Telford, Mrs 170
Tennis Club, North Berwick 161

Tennis Lodge, Dunbar 86
Territorial Force/Territorial Army 16, 33
Tesco 126
Texaco 129
Texal (warship) 76
Texal Square, Tranent 76
Thatched House Tavern, Musselburgh 163
Third Provident Investment Company 107
Thomson & Co. 104
Thomson, Jason J. 17
Thomson, Mr 146
Thorn Tree, Prestonpans 216–218, **217**
Thrieplaw 206
Thurston House, Innerwick 52–53, **52**
Timmer Brig, Aberlady 171
Tindall, Frank xi, 25, 44, 67, 69, 99, 115, 130, 227,
 229
Todd, William James Walker 155
Todrick family 35
Torness Nuclear Power Station, Innerwick 178,
 229–230, **229**
Town Hall, Tranent 112
Tramway, Levenhall, Musselburgh 222, 224, **224**
Tramway, Musselburgh 222, 224, 225, **225**
Tramway, Port Seton 222, 224
Tramway, Prestonpans 222, 224
Tranent and Elphinstone Community Council 197
Tranent Co–operative Society 62
Tranent Massacre 75
Tranent Parish Church 207–208, **208**
Tranter, Nigel 15
Traprain Law 4
Treaty of Edinburgh 4
Treaty of Haddington 204
Treaty of Union 22
Trevelyan Hall, Pencaitland xi
Tron, Haddington 121
Tuberculosis 89
Turner, H. McD. 155
Turner, James 107
Tweeddale, Marquis of 190
Underground Chamber, Prestonkirk 19–20, **19**
Upper Birslie Plantation 103
Usher, Francis James 28
Verne, Jules 135
Vert Hospital, Haddington 31
Victoria Ballroom, Dunbar 177–178, **177**
Victoria Bridge, Haddington 122, 123, 126
Victoria Harbour, Dunbar 9
Vlandy, Maurice Paul 155
Volunteers 16, 17
Volunteers, Haddington 122
Votadini 4
Walcott, Mackenzie 202
Walker, William Gladstone 136
Wall, A.B. 214
Wallyford House, Inveresk 46–49, **48**, **49**
Ward & Fraser 98
Ward, Christine 150
Ward. John 150
Ware, Isaac 31
Warrender, George 45
Wars of Independence 1
Water Fountain, Tranent 221–223, **223**

Watson and Holmes 95
Watson, Bailie 168
Watson, Hamilton 104
Watson, Robert Boyle 95
Watson's Pottery, Prestonpans 104
Watt, Francis 74
Weatherhead, Bailie 183
Wedderburn, Peter 45
Wedderspoon, A.C. 221
Weir, Alison 73
Welsh, Dr John 168
Wemyss, 10th Earl of 78, 170–171, 173
Wemyss, 11th Earl of 31, 216
Wemyss, 7th Earl of 46
Wemyss, Lord (1898) 173
Wemyss, Michael 10
Wesley, John 212
West Barns Links 175
West Hope Park, Haddington 173
West Links, North Berwick 132, 138, 141
West Port Dispensary 138
Whale Inn, Cuthill 164–165, **165**
Whatton Lodge, Gullane 84
White Horse, Dunbar 163
White School, Prestonpans 196
White Swan Inn, Haddington 170
White, A. & Co. Ltd 94
White, Andrew 113
White, Dr 136
White, Henry C. 160
White, James M. B. 137–138
Whiteadder Reservoir 117, 190–191
Whitecross & Sons, Peter 59
Whitecross, J. & R. 139
Whitecross, Peter 127
Whitehead, Mr 167
Whitehead's Club 167
Whitelaw, John 189
Whittingehame 64
William the Lion, King of Scots 25, 204
Willow Cathedral, Oldhamstocks 218–219, **219**
Wilson & Sons 157
Wilson, Jan 129
Wilson, Robert 193
Wingate, General Sir Reginald 87
Winkle, Andrew 106
Winkle, Joseph 106
Winterfield Links 176
Winterfield Mains 138
Winton, 4th Earl of 207
Winton, 5th Earl of 65
Wisdom, Norman 177
Wishart, George 14, 47, 205
Witchcraft 200
Women's Auxiliary Army Corps 18
Woodhall Coal Company Ltd 113
Woodhall Colliery, Pencaitland 113
Yardbirds, The 178
York Buildings Company 65, 78
York, Duke of see King James II of England
Yorke Lodge, Dunbar 86–87, **86**
Young, Patrick 164
Younger, Major 199